Patricia A. Gallagher

BLACK AND WHITE
PHOTOGRAPHY

A BASIC MANUAL

BLACK AND WHITE PHOTOGRAPHY

A BASIC MANUAL

Second Edition, Revised

by Henry Horenstein

Drawings by Carol Keller

LITTLE, BROWN AND COMPANY

Boston · Toronto · London

Also by Henry Horenstein

Beyond Basic Photography: A Technical Manual

Second Edition

Library of Congress Cataloging in Publication Data

Horenstein, Henry.
 Black and white photography.

 Bibliography:
 Includes index.
 1. Photography. I. Title.
TR146.H793 1983 770'.28 82-24967
ISBN 0-316-37313-3
ISBN 0-316-37314-1 (pbk.)

HC: 10 9 8 7 6 5 4 3 2
PB: 20 19 18 17 16 15 14 13 12

Designed by Janis Capone

C-W

Published simultaneously in Canada
by Little, Brown & Company (Canada) Limited

Printed in the United States of America

This book is for Lew.

ACKNOWLEDGMENTS

So many people were involved in preparing this book.

Dick McDonough initiated both editions of the book, and I owe him many thanks.

Margaret Harris helped immeasurably with the first edition, and this new version still reflects much of her clear and insightful work.

Thanks also to Carol Keller, who did all the new drawings; to all those who contributed photographs: Bill Burke, Bobbi Carrey, Barbara Crane, Jim Dow, Sharon Fox, Russell Hart, Allen Hess, Marjorie Nichols, Elaine O'Neil, Neal Rantoul, Eric Roth, J. Seeley, John Sexton, Frank Siteman, and Jim Stone; and to Archive and The Picture Cube photography agencies, as well as to the American Folklife Center and the Farm Security Administration collection, both of which are housed at the Library of Congress.

Several people read parts of the manuscript and offered their expert advice in the revision process, in particular Russell Gontar, Allen Hess, Teri Keough, Neal Rantoul, and Elaine O'Neil.

Russell Hart and Stanley Rowin printed many of the photographs.

Teri Keough, Robbie Murphy, and Nancy Palmer provided much needed editorial help.

Lan Degeneres, Emma, Jenny, Sue Kirchmyer, Ben Rosenberg, Lew Rosenberg, and Joann Rothschild posed for illustrations.

Sheri Blaney, Barbara Crane, Carl Fleischhauer, and Anne White also lent their support in various ways.

Thanks also to Mary Tondorf-Dick, my editor, who has been enthusiastic and supportive; Peggy Freudenthal for her patience and skill in copyediting; Janis Capone for a lovely and clear design; Peter deAngeli for an elegant cover; and Mary Allen and Caroline Patterson for their help throughout.

Kim Mosley at St. Louis Community College prepared an excellent workbook for the first edition as an aid to students using the book as a text. It is available directly from Kim at 1515 Hialeah Place, Florissant, Missouri 63033.

And the following helped the first edition happen: Claire Nivola, Pam Edwards, Sean Wilkinson, Linda Burnett, Stephen Frank, Paul Krot, Dick Liebowitz, Peter Macomber, Leslie Arnold, and Barbara Pitnof. Many thanks to all of them as well.

CONTENTS

BLACK AND WHITE PHOTOGRAPHY

A BASIC MANUAL

CHAPTER 1 | AN OVERVIEW

This manual is intended to be a basic guide to black-and-white photography. As such, it starts at the beginning and assumes the reader has no prior understanding of the subject. Use of a reasonably sophisticated camera (one with adjustable f-stops and shutter speeds) as well as an in-camera or separate light meter is also assumed, though "box" or "instamatic" camera users will find that the workings of simple and complex cameras are much the same.

The text follows all the necessary steps from the beginning of picture-taking (such as loading the camera, focusing the lens, and tripping the shutter), through developing film and making prints, to the final presentation steps of spotting and mounting. The illustrations and captions highlight important points in the text. It may be useful to examine the appropriate equipment or material (such as camera, film, meter, or enlarger) while reading the text.

The Negative: How Light Affects Film

Photographic film consists of a transparent plastic *base* (or support) that holds a light-sensitive *emulsion*. The emulsion consists of gelatin and silver-halide crystals. (*Silver halide* is a collective term for the combination of silver with a halogen element, such as bromine, chlorine, or iodine.) The gelatin acts primarily to bind the crystals to the plastic base, while the silver-halide crystals trap light.

Light acts like a glue to bind the silver crystals together. Upon exposure to light, these crystals "clump" together. At first this change is invisible, but during chemical development the silver clumping is converted into a buildup of visible black metallic silver, referred to as *density*. Unexposed crystals are removed from the film in the chemical process. Different proportions of silver density on the film make up the photographic image.

Thus two separate and distinct changes take place: an invisible change, when film is exposed to light, creating what is sometimes referred to as a *latent* image; and a visible change, when exposed film is developed chemically, and those areas struck by light are rendered as densities of black metallic silver.

In a camera, film is exposed by light reflecting off the subject.

In a camera, film is exposed by light reflecting off the subject. Since light-colored subjects reflect light and dark-colored subjects absorb light, more light will reflect back to the film from white (or light) parts of the subject than from black (or dark) parts. Those areas of the film that receive the most light will undergo proportionately more silver clumping, and will produce the greatest density. Thus light areas of the subject become *dense* (or dark) on the film, while dark areas of the subject appear *thin* (or light).

Film that has been exposed and developed becomes a *negative*, since the lights and darks are rendered as the reverse of the original subject. Most negatives show a variety of silver buildup or density. The gradations of densities depend on the relative amounts of light that reflect back to the film. A white sweater will reflect more light than a yellow dress, so the white will create more silver buildup, and appear more dense on the negative. Both will be dark, but the white sweater will be darker.

4

The original subject.

A negative of that subject is a re-versed image. The light areas are dense (dark) and the dark areas are thin (light).

A positive print from the negative so it looks like the original subject — light areas are rendered light and dark areas are rendered dark.

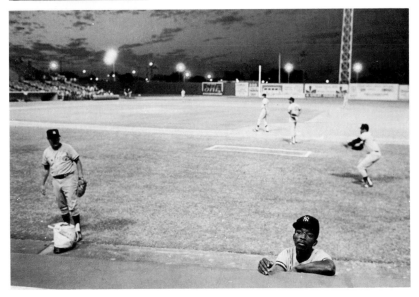

Controlling Film Exposure

A good negative has detail in both the shadow (light) and highlight (dark) areas.

An important function of the camera is to allow film to be exposed to the correct amount of light. Accurate film exposure results in a negative with a full range of densities: from light to dark. *Thin* (clear or light) parts of the negative are called *shadow areas*, since they represent dark subject areas; *dense* parts of the negative are called *highlight areas*, since they represent light subject areas.

In a good negative the shadow areas are thin, but not completely transparent. Some density is required to render detail. The highlight areas in a good negative are dense, but not totally black. Too much density could mean no highlight detail.

The correct exposure is controlled in-camera with a lens and a shutter. The *lens* focuses light. It has an opening called an *aperture*, which is adjustable on most cameras to allow varying amounts of light to pass through to the film.

The *shutter* is a shield that protects film from light. It opens to let light pass only when a shutter button is pressed. The amount of time the shutter remains open is called the *shutter speed*, and is adjustable on most cameras.

So a certain amount of light, controlled by the aperture, passes through the camera lens and exposes the film for the amount of time for which the shutter remains open. The correct conjunction of these factors creates a well-exposed negative. Lens, shutter, and exposure are all discussed in greater detail later in the text.

The Print: Reversing the Negative

Photographic film and paper react to light in much the same way. Whereas film has a light-sensitive silver-halide and gelatin emulsion on a clear plastic base, photographic paper has a light-sensitive emulsion on a white paper base. The emulsions are similar, but not exactly the same. With paper as with film, exposure to light causes an invisible clumping (or binding) of silver crystals, which darken when chemically developed. The greater the exposure, the greater the binding, and the darker the paper becomes when processed. Unexposed or lightly exposed areas of printing paper remain white or light. The chemical process removes the unexposed (thus the unbound) silver-halide crystals.

Photographic prints are made by exposing paper to light projected through a negative. The amount of light that reaches the paper varies with several factors, including the density of the negative. Dense negatives will block more light than thin negatives, and require a longer print exposure.

More important, all negatives have a range of densities. Thin

6

(shadow) areas of a negative allow more light to reach the paper than dense (highlight) areas. Since those areas of the paper receiving most light print dark, and vice versa, the negative image is reversed in the developed print. Thin areas of a negative are rendered as dark areas in the print; dense areas are rendered as light areas. Therefore, the print reproduces the original subject, rendering a *positive* image.

Most prints are made with the use of an *enlarger*, an instrument that projects light through a negative and a lens on the enlarger that focuses the image onto photographic paper. In some ways, the enlarger is to the printing process what the camera is to the negative-making process.

Exposure of paper to light can be controlled by several factors, but as with film exposure, the quantity of light reaching the paper and the duration of time for which that light strikes the paper are the two critical factors. Enlarging lenses, like camera lenses, have apertures that can be adjusted to allow more or less light through to expose the paper. The duration of time for which the light strikes the paper can be controlled by turning the enlarger light on and off, leaving the light on for a longer or shorter period of time, much as adjustable shutter speeds on cameras control the length of time film is exposed.

This introduction is a simple overview of the photographic process. A good photograph is largely dependent on good exposure in both the picture-taking and printing stages. However, many other factors contribute. The specifics of how to achieve desired results are covered in detail in the following chapters.

CHAPTER 2 | THE CAMERA BODY

The camera body is a light-tight container with several functions:

- It stores film.
- It advances film to allow different exposures.
- It provides a system of viewing and focusing the subject.
- It contains a lens (sometimes removable) through which light exposes the film, a shutter that controls the length of time of that exposure, and often a light meter to aid in determining the correct exposure for each light condition.

This chapter describes the above functions of the camera body. Keep in mind that the body does not act independently, but in concert with the lens, shutter, and light meter to expose film. Succeeding chapters will cover these matters in greater detail.

Storing Film

Cameras are classified according to the type of film they hold. For example, a camera using 35-millimeter film is called a 35-millimeter camera. There are many types of film sold, many providing different negative sizes, also called *film formats*. Here are some common film formats:

35-millimeter film is packaged in roll form, protected by a metal cassette. This film measures 35 millimeters wide, and is available in rolls long enough to produce a variety of exposures, usually 20 or 36. Larger rolls, called *bulk film*, are sold for loading into reusable cassettes (see Appendix Two). The actual size of the negatives produced by 35-millimeter film is 24 × 36 millimeters or 1″ × 1½″. (*Half-frame* cameras use 35-millimeter film, but provide twice as many negatives that are half the size of those produced by full 35-millimeter cameras.)

Cameras using 35-millimeter (and smaller) film are sometimes referred to as *small-format cameras*.

Roll-film cameras, such as those accepting film sizes 120 or 220, were once popular with amateur photographers, but are used most often now by serious amateurs and professionals. The term "roll film"

Film formats

Left:
A 35-millimeter negative.

Right:
35-millimeter packaged in a metal cassette.

Left:
A roll-film negative.

Right:
Size 120 roll film wrapped in a paper backing.

Left:
A sheet-film negative.

Right:
Size 4″ × 5″ sheet-film holder.

is confusing; most film is packaged in rolls, but this type is protected by a paper backing, somewhat longer than the film, which is wrapped along with the film around a spool.

The film format with roll films depends on the particular camera used. A square negative measuring $2\frac{1}{4}'' \times 2\frac{1}{4}''$ is most common, but several other formats are also available, such as $2\frac{1}{4}'' \times 1\frac{7}{8}''$, $2\frac{1}{4}'' \times 2\frac{3}{4}''$, and $2\frac{1}{4}'' \times 3\frac{1}{4}''$. Size 120 roll film produces 12 exposures with a $2\frac{1}{4}'' \times 2\frac{1}{4}''$ camera, 8 exposures with a $2\frac{1}{4}'' \times 3\frac{1}{4}''$ camera, and 10 exposures with a $2\frac{1}{4}'' \times 2\frac{3}{4}''$ camera. Size 220 is considered a professional film; it is double the size of 120, so produces twice as many negatives. Some roll-film cameras accept odd-size films, such as 127 and 620, but these are less common.

Cameras using roll film are often called *medium-format cameras.*

Sheet-film cameras are used only by serious amateur and professional photographers. Sheet films provide 1 exposure per sheet, and for use must be preloaded into special film holders that fit into the back of the camera. Common sheet-film formats are: $4'' \times 5''$ and $8'' \times 10''$, though other sizes are available, such as $3\frac{1}{4}'' \times 4\frac{1}{4}''$ and $5'' \times 7''$.

Cameras using $4'' \times 5''$ or larger films are referred to as *large-format cameras.*

Instamatic, snapshot, sub-miniature, and *instant cameras* vary widely as to types, models, and sizes. Some take film packed in rolls; others take film packaged in cassettes. Film sizes include 110, 126, 127, and 16 millimeter. Instant cameras produce small prints directly without a usable negative (though Polaroid makes a black-and-white material that produces both an instant negative and positive). While most of these cameras are useful (and some are complex and expensive), many lack important features such as accurate exposure and fine focusing control.

Loading and Advancing Film

Film is loaded for use through the rear of the camera, or the *camera back.* Usually the back is on a hinge and swings open for loading (though some camera models open in other ways).

The film cassette or roll is loaded onto one side of the camera back, then stretched across the rear of the camera (with the dull, or *emulsion,* side of the film facing the lens), directly over and flat up against a rectangular or square cut-out hole, onto a *take-up spool.* The size and shape of this hole determine the film format; the hole is located between the lens and the film, and allows a certain amount of the light that travels through the lens to strike the film. A 35-millimeter camera has a rectangular hole the size of a 35-millimeter negative — 24×36

Parts of a 35-millimeter camera

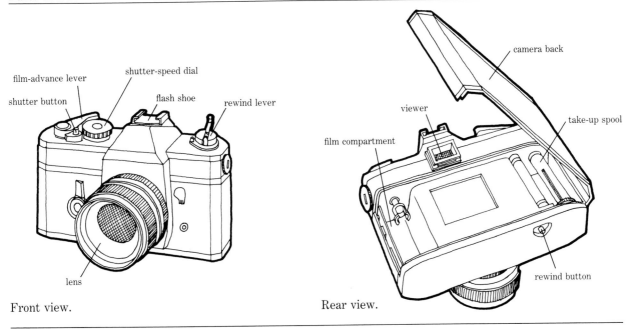

Front view.

Rear view.

millimeters, or $1'' \times 1\frac{1}{2}''$. A $2\frac{1}{4}'' \times 2\frac{1}{4}''$ roll-film camera has a square hole that measures $2\frac{1}{4}'' \times 2\frac{1}{4}''$.

Built into most camera bodies is a means for advancing the film after exposure to allow future exposures. A *film-advance lever* is connected to the take-up spool. When this lever is cocked or turned, the take-up spool also turns, and picks up and advances the loaded film from the opposite side of the camera. The advance mechanism automatically stops when just enough film has passed to permit another exposure on the roll of film. (With some simple or old cameras, the advance mechanism must be manually stopped.)

Once an entire roll has been exposed, the film must be prepared for unloading. After the last exposure is made, 35-millimeter film is rewound into its original cassette. This is done by depressing (or turning) the *rewind button*, located on the bottom of most cameras, and rotating the winding lever, located above the cassette, clockwise until the film unravels off the take-up spool and reenters the cassette. When the film has returned to the cassette, there is a noticeable lack of resistance. The cassette containing the exposed film can then be removed from the camera.

With roll-film cameras, the advance lever is cocked or turned several times after the final exposure to guarantee that all the film is advanced onto the take-up spool. Then the camera back is opened and the film removed. Roll film must be secured to keep the film from being exposed by moistening the loose tape attached to the paper backing of the film, and affixing it around the tightly wound spool.

Sheet-film cameras do not advance film (though some can be fitted with roll-film backs). A special holder, fitted with a single sheet of film on each side, protected from light by a removable shield called a *dark slide*, is inserted into the camera back. The dark slide is removed to allow the film to be exposed. Then the slide is replaced and the holder removed. Each exposure requires the same procedure.

Viewing and Focusing the Subject

All but the simplest camera bodies include both a viewing and focusing system. A viewing system provides the means of seeing how the photograph will be framed; in other words, what the film will record. A focusing system provides a method of creating a sharp image on the film.

Cameras are classified according to their viewing and focusing systems. For example, a single-lens reflex camera is one that has a single-lens reflex viewing and focusing system. Here is a list of common systems, followed by explanations of how each works:

viewfinder
single-lens reflex
rangefinder
twin-lens reflex
view and press

Viewfinder cameras have a simple plastic or glass viewer and no adjustable focusing system. The viewer is located just above or to the side of the lens, and indicates approximately what the final photograph will look like (though some *parallax* problems — the difference between what the eye sees through the viewer and what is actually recorded through the lens — are apparent in the processed negative or print). Focus is generally predetermined by the manufacturer.

With few exceptions, this type of camera is inexpensive and simple, offering little or no exposure control. Many "snapshot" cameras, such as simple Instamatics and Polaroids, can be classified as viewfinder cameras.

Single-lens reflex (SLR) cameras allow viewing and focusing the subject directly through the lens. The photographer sees exactly what

Viewfinder camera
Simple viewer and no adjustable focusing.

Single-lens reflex (SLR) camera

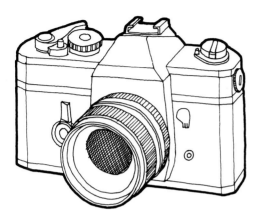

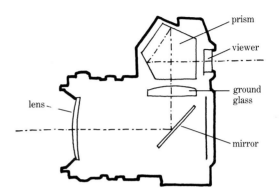

Through-the-lens viewing and focusing. Light reflects off the subject, through the lens, off a mirror, and upward to a ground glass. The image is focused on the ground glass by turning the lens. It is viewed by looking through an eye-level viewer to a prism that reflects the image from the ground glass.

the lens records. (Actually, many SLR viewers "cut off" a very small part of the image on its edges.)

Since the film is loaded directly behind the lens, a complex mechanism is required to bypass the film, and allow through-the-lens viewing. After all, it is impossible to look through the film.

This "bypass," or *reflex*, mechanism uses a mirror and a prism to redirect light. A mirror at an angle to the film is positioned in front of the film and behind the lens. Light coming in through the lens meets this mirror, and is reflected upward onto a ground-glass surface. In a few SLR models, the photographer looks down on the ground glass to view and focus the image. In most, an eye-level viewer, containing a prism, is located over the ground glass. The prism has several mirrored surfaces that reflect light from the ground glass through a viewer, so the photographer sees the ground-glass image at eye level. Either way, with a single-lens reflex camera, the photographer sees exactly what the lens sees!

The mirror in back of the lens prevents light from reaching the film. (The shutter also blocks light, but more on shutters in chapter 4.) It has a hingelike mechanism, and when the picture is taken, the mirror swings upward and allows the film to be exposed. It snaps back into place immediately after the exposure.

It is the nature of all lenses to turn images upside down. In the SLR, the mirror and prism placements turn the image right-side up again for easier viewing.

Focusing a single-lens reflex camera is simple. The ground glass is located at the same distance from the lens as the film is from the lens. If the image appears sharp on the ground glass, it will also appear

Rangefinder camera

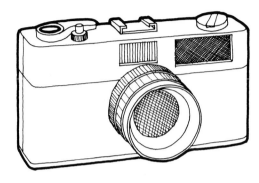

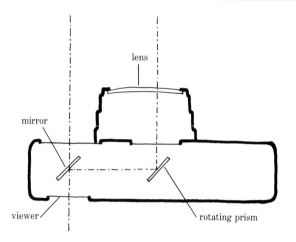

Viewing and focusing through a viewfinder. Light reflects off the subject and enters the camera through both the viewer (on the top left) and the piece of glass (on the top right). A prism located behind the glass rotates on a pivot as the lens is turned to focus the image. The image from this prism reflects to a mirror positioned behind, and then through the viewer. So, there are two superimposed images — one reflecting through the viewer and the other from the prism on the right. When the two images come together, as the lens (and mirror) are turned, the image is in focus.

sharp on the film. As the lens is turned for focusing, the image on the ground glass (and the film) becomes either sharper or less sharp.

The means for judging the focus of the image varies with the type of ground glass used. Several types are available. With some, out-of-focus images appear as blurry or fuzzy and in-focus images appear sharp with clearly delineated lines, much as one's eyesight might go in and out of focus. Other types of ground glass use a screen pattern, where unsharp images are rendered as tiny dots that reduce in size and disappear as the image is focused. A popular type of ground glass employs a split-image screen, where a line in the middle of the viewer divides the image (or part of the image) in half. When it is out of focus, part of the subject appears to be split in two; when it is in focus, the two halves line up. Many modern cameras have a ground glass that combines two or three of these types.

In recent years, the single-lens reflex camera has become extremely popular. It is versatile, easy to use, and accurate. Most but not all single-lens reflex cameras use 35-millimeter film.

Rangefinder cameras do not have through-the-lens viewing and focusing. A glass viewer is located on the top of the camera, to the left of the lens. With most rangefinders, this viewer is *parallax corrected*; that is, it is aligned with the lens by the manufacturer to eliminate the difference between what the viewer sees and the lens records. (Despite this correction, some rangefinder cameras do have parallax problems, especially when focused at close distances.) A rectangle within the viewer indicates the subject that the lens records.

Twin-lens reflex (TLR) cameras

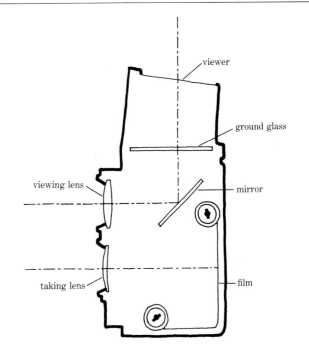

Viewing and focusing through the top lens. Light reflects through the viewing lens (on top) to a mirror and up onto a ground glass for viewing and focusing. The image is exposed onto film by the taking lens (on the bottom).

The term *rangefinder* refers to the focusing system. A piece of glass is located above the lens, to the right of the viewer. A prism is positioned behind this glass, and is coupled with the lens so that it rotates on a pivot as the lens is turned to focus the image. Light reflecting off the subject reaches the prism, and is reflected by it to the left, toward the viewer. A fixed mirror, located within the viewer, reflects the image from the prism back through the viewer, so that the image off the prism is superimposed onto the image seen through the viewer.

As the lens is focused, the prism pivots and the two images come together. A double image indicates an out-of-focus subject; a single image indicates a focused subject. Usually the double images are not seen in the entire viewer, but only in a small area located at the center of the viewer.

In recent years, rangefinder cameras have become less popular. However, they are accurate, reliable, and, often, more reasonably priced than single-lens reflex cameras of comparable quality. Most rangefinder cameras use 35-millimeter film.

View camera

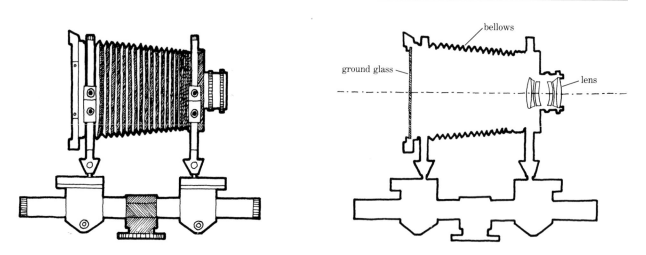

Viewing and focusing directly through the lens. Light reflects through the lens directly on a ground glass. The image is focused by expanding or contracting the bellows that is positioned between the lens and film.

Twin-lens reflex (TLR) cameras have two lenses, one placed over the other. On top is a *viewing lens*, through which the image is viewed; on the bottom is a *taking lens*, through which film is exposed to light. Most TLRs are parallax corrected, so the viewing lens sees what the taking lens records.

A mirror is located behind the viewing lens at an angle to the film, and reflects light traveling through this lens up onto a ground glass for viewing and focusing the image. The film is located behind the taking lens and at the same distance from this lens as the viewing lens is from the ground glass. The lenses are mounted together, so that as the camera is focused (usually with a knob on the side of the camera body), they move simultaneously. When the image from the viewing lens is rendered sharp on the ground glass, the image from the taking lens will be rendered sharp on the film.

A focusing hood fits around the ground glass of most TLRs to block extraneous light and help make the viewing screen brighter. A spring-mounted magnifier is sometimes built into the hood for critical focusing.

A disconcerting fact about the TLR viewing and focusing system is that the photographer looks down on the ground glass at a reversed image. The left side of the subject appears to be on the right, and vice versa. Sophisticated TLRs offer an accessory prism that fits on top of the ground glass, and allows eye-level viewing that corrects this reversed image.

Press camera

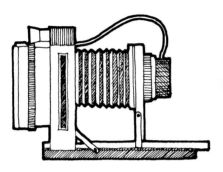

"Portable" view camera.

Twin-lens reflex cameras use 120 or 220 roll film, and generally produce a 2¼″ × 2¼″ negative.

View cameras have through-the-lens viewing and focusing (somewhat like an SLR but without mirrors), and use sheet film. The image is viewed on a ground glass located directly behind the lens. The lens is mounted on a *lens board*, which is attached to the camera back by a *bellows* — a light-tight, collapsible cloth or cardboard tube. A ground glass is mounted on the camera back. As the bellows is contracted or expanded, the lens moves toward or away from the ground glass, thus focusing or blurring the image. When the image has been viewed and focused, the camera back is opened and a sheet-film holder slid into place behind the lens to make a single exposure.

View cameras mostly use large-format film. The most common format is 4″ × 5″, though several other sizes are available. An accessory roll-film back is available for some view cameras to adapt the camera for use of size 120 or 220 film.

View cameras have direct through-the-lens viewing since the film is not placed behind the lens until it is ready to be exposed. Since view cameras do not use mirrors, the image will appear upside down on the ground glass. A focusing hood or cloth must be fitted around the ground glass to block extraneous light, which would make the image on the glass pale and difficult to focus.

View cameras provide many advantages. Large-format negatives produce prints that are sharp, with much detail and little grain (more on grain later). Also, in a view camera, the relationship between the lens and film can be adjusted for several useful purposes, such as to increase the amount of subject focus and straighten out converging lines when photographing up at a tall building. Furthermore, view cameras can accept a wide variety of accessories, lenses, and film formats.

A major drawback of the view camera is its bulk. It is large and cumbersome, and needs a tripod to hold it, thus making fast or candid photography impractical.

Press cameras are portable view cameras. They contain a range-finder-type focusing system for quick use, and can also be used on a tripod for viewing and focusing on a ground glass.

CHAPTER 3 | THE CAMERA LENS

The camera *lens* is located on the front of the camera body with film positioned directly behind it. When the shutter opens, light travels through the lens and exposes the film.

On some camera models, the lens is *fixed*, attached directly to the camera body. On other models it is removable, or *interchangeable*. Cameras with interchangeable lenses are normally more expensive and more versatile than cameras with fixed lenses. Interchangeable lenses can be replaced with a variety of lenses that serve a variety of purposes to be discussed in detail later in this chapter. With a few exceptions, viewfinder, rangefinder, and twin-lens reflex cameras have fixed lenses, while single-lens reflex, view, and press cameras have interchangeable lenses.

The camera lens controls four functions:

> **image focus**
> **quantity of light reaching the film**
> **image area**
> **depth of field of the image**

Image Focus

Focus refers to the relative sharpness of an image. Optically, light is focused at the point at which the light rays passing through a lens converge. In practical terms the photographer does not need to understand optics, only how to make the image sharp.

Most lenses, especially those made for 35-millimeter cameras, are focused by turning a ring on the barrel of the lens that causes the lens to move in (closer to the film) and out (away from the film). Some cameras, particularly view and press cameras, are constructed with a cardboard or cloth *bellows* that can be stretched or contracted to focus an image.

The method of determining focus varies, as discussed, depending on a camera's viewing and focusing system. With some cameras, an image seen through a viewfinder appears fuzzy or blurred when out of focus and sharp when in focus; with other cameras, an image is seen as double when out of focus and as single when in focus.

18

Camera lens

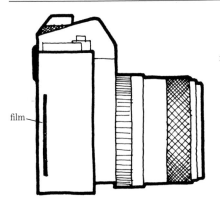

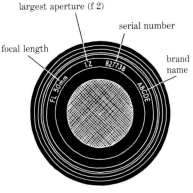

largest aperture (f 2)

serial number

focal length

brand name

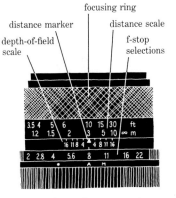

focusing ring

distance marker · distance scale

depth-of-field scale · f-stop selections

film

The lens is located on the front of the camera body with the film positioned directly behind it.

Head-on view of a camera lens and its markings.

Top view of a camera lens.

Quantity of Light

Light must pass through the lens opening or *aperture* to reach the film. The aperture is adjustable on all but the simplest lenses. It can be opened wide to allow more light in, or closed down to keep out light.

The aperture size is critical to good film exposure. In general, when photographing in low light, a large aperture is required to allow enough light to reach the film; when photographing in bright light, a smaller aperture is needed to reduce the amount of light reaching the film.

F-stop is a measurement of the size of the lens opening. Most all camera lenses offer a variety of f-stop settings. These are common f-stops:

> **f 1.4**
> **f 2**
> **f 2.8**
> **f 4**
> **f 5.6**
> **f 8**
> **f 11**
> **f 16**
> **f 22**

The larger the f-stop number, the smaller the lens opening; the smaller the f-stop number, the larger the opening. A lens set at f 2 allows much more light to pass through it than a lens set at f 16.

19

Quantity of light

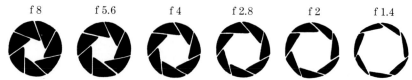

f 22 f 16 f 11 f 8 f 5.6 f 4 f 2.8 f 2 f 1.4

Large f-stop numbers represent small apertures (lens openings), and vice versa.

F-stop numbers are determined by a simple formula. The measured diameter of a lens opening, for example 25 millimeters, is divided into the focal length of the lens, for example 50 millimeters. (Focal length will be discussed later.) The result — 50 millimeters divided by 25 millimeters — is the f-stop, in this case f 2. A smaller diameter lens opening would measure as a larger f-stop number. For example, a 12-millimeter lens diameter with a 50-millimeter lens would be approximately f 4 — 50 millimeters divided by 12 millimeters.

The f-stops in the list above have a special relationship to each other. A change of one full f-stop on either side means doubling or halving the amount of light passing through the lens. F 8 allows twice as much light through as f 11, and half as much through as f 5.6. This relationship is critical.

Not all lenses offer all the f-stops listed. The widest (largest) f-stop on some lenses is f 2 or f 2.8, not f 1.4. A few lenses offer even wider f-stops, such as f 1.2. Sometimes the smallest f-stop on a lens is f 16, not f 22; some lenses offer f 32 or even smaller "stops."

On some lenses, partial f-stops are designated. A setting of f 1.8 allows a bit more light through than f 2, but not twice as much. A setting of 3.5 is a *half-stop* between f 2.8 and f 4; it allows more light through than f 4 and less light through than f 2.8. It is possible to make minor changes in the amount of light that passes through the lens either by using these partial f-stop settings (if they are designated), or simply by setting the lens between two designated stops.

Lenses are rated according to the widest f-stop to which they open. For example, a lens that opens to f 1.4 is called an "f 1.4 lens." Lenses that open very wide are called *fast lenses* because they can expose film more quickly than *slow lenses*. An f 1.4 lens is said to be "faster" than an f 2.8 lens.

Fast lenses are almost always more desirable than slow lenses. Because they can open wide to let more light through to the film, fast lenses are ideal for use indoors or in any low-light situation.

Furthermore, since fast lenses are brighter when wide open, they make for easier viewing and focusing with through-the-lens camera types, such as SLR and view cameras. The wider the maximum

aperture, the more light passes through the lens to both the film and the ground glass, so the brighter and clearer the image is through the viewer.

However, fast lenses are more expensive than slow lenses. An f 1.4 lens may cost as much as $50 to $100 more than an otherwise equivalent f 2 lens. The faster lens is nice, but the extra money might be better saved or spent on a useful camera accessory or simply more film.

Preset (or *manual*) *lenses* must be opened up by hand so the viewer will be bright enough for accurate focusing, then closed down to the required f-stop for shooting. This procedure is slow and inconvenient. All view-camera lenses are manual, as are many outdated and a very few current SLR lenses.

Most single-lens reflex cameras use *automatic lenses* (not to be confused with automatic exposure, explained later). An automatic lens stays open to its maximum aperture regardless of what f-stop setting is chosen. The lens is coupled to the shutter so when the shutter button is pressed, the lens closes down to the aperture at which it is set to make the exposure. Then the lens immediately opens up again to its maximum aperture. An f 2 lens, for example, set at f 11 will remain at f 2 until the picture is taken. It will close to f 11 for the exposure, then open up to f 2 again to allow for bright, easy viewing and focusing.

Rangefinder cameras do not need automatic lenses since viewing is not through the lens. TLR cameras have separate viewing and taking lenses, and do not need automatic lenses either.

Some cameras are programmed for *automatic exposure*, and allow no control of the aperture size. The f-stop is determined and set in the camera automatically. A scale or readout of some sort located inside the viewer indicates which f-stop is being used. More on automatic cameras in chapter 5.

The Image Area

The lens controls the *image area*, or the *angle of view* that the lens "sees" and "records." This image area is determined by the *focal length* of the lens used. Focal length is a measurement of the lens size. The longer the focal length of the lens, the narrower the angle of view; the shorter the focal length of the lens, the wider the angle of view. Focal length is usually measured in millimeters. A 28-millimeter lens is shorter and provides a wider angle of view than a 135-millimeter lens.

The measurement of a lens for focal length is not based on the actual size of the lens per se, but is the distance between the film plane of

Image area

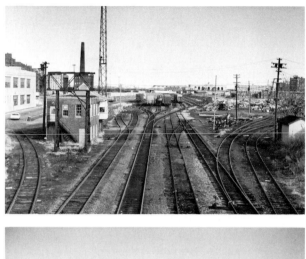

A subject viewed through a normal lens with a focal length of 50 millimeters.

A wider angle of view. The same subject viewed through a wide-angle lens with a focal length of 24 millimeters.

A narrower angle of view. The same subject viewed through a telephoto lens with a focal length of 200 millimeters.

the camera and the optical center of the lens when the lens is focused at infinity. The *film plane* is the plane along which the film rests in the camera body. The location of the optical center of a lens varies with each lens, but is at a location known as the *nodal point* of the lens.

Film format also affects the relationship between image area and focal length. Large film formats require longer lenses than small formats for equivalent angles of view. For example, a 50-millimeter focal-length lens fitted on a 35-millimeter camera produces approximately the same angle of view as a 150-millimeter focal-length lens on a 4″ × 5″ format camera.

The following categories of lenses, producing a variety of angles of view, are available to fit onto cameras that accept interchangeable lenses:

normal
wide angle
telephoto
zoom

Cameras with fixed lenses generally provide a normal lens or a slightly wide-angle lens.

A *normal lens* sees and records the subject much as the eye sees it. Its angle of view is approximately 46°. Typically, a "normal" lens for shooting with 35-millimeter film is about 50 millimeters long. Exact focal lengths vary somewhat with each manufacturer. Normal lenses for 35-millimeter cameras may vary anywhere from approximately 45 to 58 millimeters.

The focal length of a normal lens is approximately equal to the diagonal measurement of the film format used. Therefore, a "normal" focal-length lens for shooting 35-millimeter film is approximately 50-millimeters. A normal-focal-length lens for larger film formats is accordingly longer; an 80-millimeter lens for a 2¼″ × 2¼″ film format; a 150-millimeter lens for a 4″ × 5″ film format; and so on.

A *wide-angle lens* (or *short-focal-length lens*) sees and records a broader angle of view than does a normal lens. Subjects viewed through a wide-angle lens appear smaller than they really are (whereas through a normal lens they seem life-size).

Some common wide-angle-lens focal lengths (for 35-millimeter cameras) include 35, 28, and 24 millimeters, though some are even shorter and wider. Again, the shorter the lens, the wider the view. A 35-millimeter lens has an angle of view measuring approximately 64°, whereas a 24-millimeter lens has an angle of view of about 84°.

Wide-angle lenses are particularly useful when there is not enough

Image area

The angle of view that the lens "sees" and "records" varies with the focal length of the lens. The shorter the lens, the wider the angle of view; the longer the lens, the narrower the angle of view.

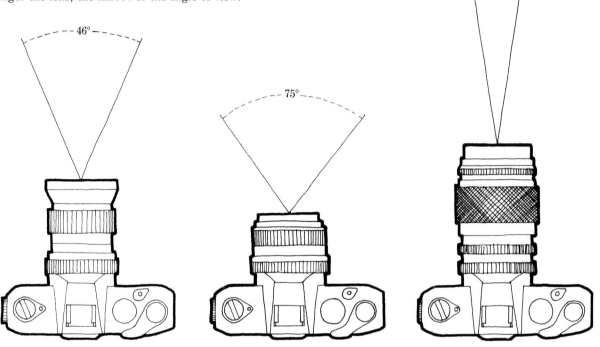

A normal lens with a 35-millimeter camera has an angle of view of approximately 46°.

A short (or wide-angle) lens has a broader angle of view. Pictured here, a 28-millimeter lens on a 35-millimeter camera has a 75° angle of view.

A long (or telephoto) lens has a narrower angle of view. Pictured here, a 135-millimeter lens on a 35-millimeter camera has an 18° angle of view.

room to move back far enough to take in an entire subject, such as with architecture, landscape, and general interior photography.

Wide-angle lenses typically create both distance and image distortion. The distance distortion causes objects to appear farther away and smaller than in real life. The image distortion creates a curved effect; parts of the subject located in the center of the photograph appear fatter than those parts on the edges of the photograph.

The amount of image distortion varies widely with lens size, lens quality, distance from the subject, and angle to the subject. Maximum distortion is caused by the widest lenses, cheapest-quality lenses,

24

closest focus distances, and extreme angles to the subject. Distortion sometimes is so marked that image sharpness and brightness diminish perceptibly, particularly on the edges of the image. Distortion can be minimized by using a moderately wide lens of high quality; by not focusing close to the subject; and by keeping the camera level, shying away from extreme angles.

A *telephoto lens* (or *long-focal-length lens*) sees and records a narrow angle of view. Subjects viewed through a telephoto lens appear magnified, sometimes dramatically.

Some common telephoto lens focal lengths (for 35-millimeter cameras) include 135 millimeters and 200 millimeters, though some are even longer. Again, the longer the lens, the narrower the view. A 135-millimeter lens has an angle of view of approximately 18°, whereas a 200-millimeter lens has an angle of view of approximately 12°.

Since they magnify the subject, telephoto lenses are most useful when it is not possible or desirable to move close enough to the subject, such as with sports action from the sidelines and close-up portraits, without "crowding" the subject.

Telephoto lenses also can create distance and image distortion. Subjects appear closer to the camera than they really are. In addition, the subject field is flattened; background and foreground appear to compress, as though they are closer to each other than they really are. The longer the focal length of the lens, the greater the distance and image distortion.

Telephoto lenses are sometimes large and bulky, therefore difficult to hand-hold. Camera or lens movement during the exposure may cause the final image to be less than razor sharp, so take extra care to steady the camera when using a telephoto lens. A tripod (see chapter 10) is useful to hold a camera steady, especially when using extra-long lenses. A fast shutter speed (not to be confused with a fast lens, see chapter 4) can also reduce the chances of camera movement.

A *teleconverter* is a tubelike accessory that fits between the camera body and the lens. It gives the lens a longer effective focal length, commonly two (2×) to three (3×) times the size of the lens it converts. Teleconverters cost far less than telephoto lenses. However, the image they produce will likely be less sharp and clear. Also, teleconverters reduce the light that passes through the lens by the equivalent of at least one or two f-stops.

A *zoom lens* incorporates a variety of focal lengths into a single lens. The photographer views the subject, then can adjust to a longer or shorter focal length as desired before taking the picture. Most "zooms" are telephoto lenses (such as one incorporating lengths of 80

Teleconverter

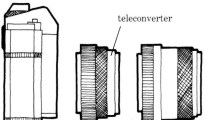

teleconverter

Accessory that fits between the camera body and lens to give the lens a longer effective focal length.

Image distortion

A wide-angle lens creates a curved effect to the photograph. Notice the distortion on the edges of the image.

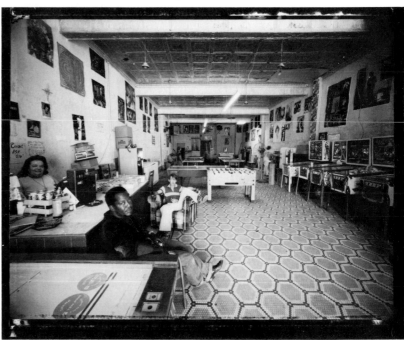

© BILL BURKE/ARCHIVE

A telephoto lens creates a flattened-out effect. The background and foreground appear to be closer to each other than they really are.

to 200 millimeters), but some offer wide-angle options (for example, 35 to 70 millimeters).

Zoom lenses are convenient, compact, and, in a sense, economical. Zooms are initially more expensive than most lenses, but they are less expensive than the variety of lenses they replace. However, the slightly lower optical quality, smaller maximum aperture, and relative bulk of most zoom lenses are disadvantages to be considered.

Angles of view for different focal length lenses*		
Lens Type	Focal Length	Angle of View
Normal	50 millimeter	46°
Wide-angle	35 millimeter	64°
	28 millimeter	76°
	24 millimeter	84°
	21 millimeter	92°
Telephoto	105 millimeters	21°
	135 millimeters	18°
	200 millimeters	12°
	300 millimeters	8°

* This chart is for 35-millimeter film format. Larger formats require longer lenses for equivalent angles of view.

Depth of Field

Depth of field refers to the zone of focus in a photograph or the distance between the closest and farthest parts of the picture that are reasonably sharp. For example, if a lens is focused sharply on an object, say a tree, an area in front of and an area in back of that tree will also be in focus. That area from the front to the back that is acceptably sharp is the depth of field of the photograph.

Depth of field varies with each photograph, and is determined by three controllable factors:

> **lens opening**
> **focus distance**
> **focal length of the lens**

Lens opening. The smaller the aperture used, the greater the depth of field. F 16 creates an area with far greater depth of field than f 2.

Distance. The greater the focus distance (from camera to subject), the greater the depth of field. A lens focused 5 feet away from the

Depth of field

A photograph with a lot of depth of field.

A photograph with little depth of field.

HENRY HORENSTEIN/AMERICAN FOLKLIFE CENTER, LIBRARY OF CONGRESS

HENRY HORENSTEIN/AMERICAN FOLKLIFE CENTER, LIBRARY OF CONGRESS

The zone of focus, or the distance between the closest and farthest parts of the picture that are reasonably sharp. Depth of field works in a ratio of approximately one to two; that is, if an area 2 feet in front of the focused subject is in focus, an area 4 feet behind the subject will also be in focus. Here, the camera is focused at a subject 10 feet away. The area 2 feet in front and 4 feet in back of the subject is also in focus.

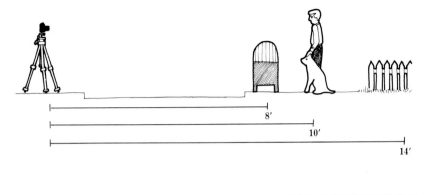

subject creates an image with much less depth of field than a lens focused 15 feet away from the same subject at the same aperture.

Focal length. The longer the focal length of the lens, the smaller the depth of field. A telephoto lens produces an image with less depth of field than a wide-angle lens (assuming the same aperture and focus distance).

A large depth of field is usually desirable, but sometimes *selective focus*, when part of the image is in focus and the background or foreground is blurred, is more effective. For example, a sharply focused portrait of a person will stand out much more dramatically against an out-of-focus house than it would against a sharply focused house. Within limits, the photographer has the ability to vary the aperture, distance, or focal length, either to maximize depth of field or to focus selectively.

To maximize depth of field, focus at a point approximately one-third of the way into the subject area. For example, to photograph a car from the front to the back so that the entire car will be sharp, focus on the front windshield. In practice, depth of field works so that the sharp area in front of the focused subject is smaller than the sharp area in back of that subject by a ratio of approximately 1 to 2. Say the camera lens is focused on a man located 10 feet away from the camera. If the area 2 feet in front of the man is in focus, the area 4 feet in back of him will also be in focus — a ratio of 1 to 2 (2 feet to 4 feet).

Controlling depth of field

Lens opening: the larger the aperture, the smaller the depth of field.

Distance: the farther the camera-to-subject distance, the greater the depth of field.

Focal length: the longer the focal length of the lens, the smaller the depth of field.

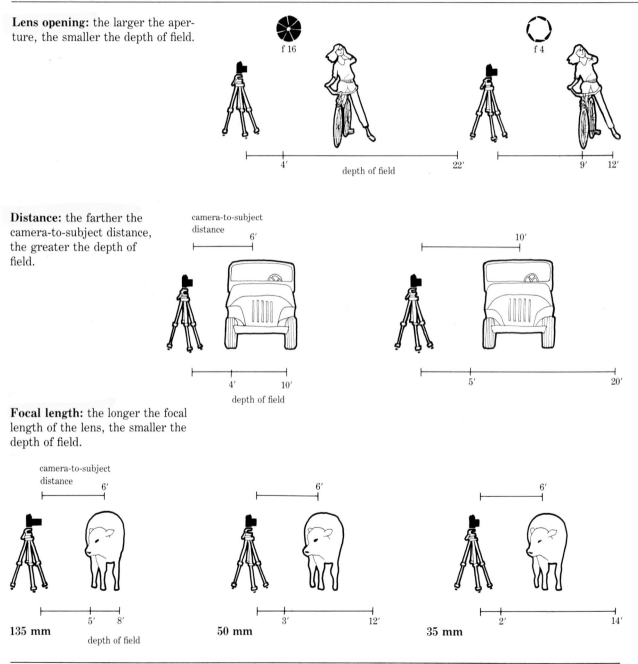

Selective focus

Part of the image is in focus and the background is blurred.

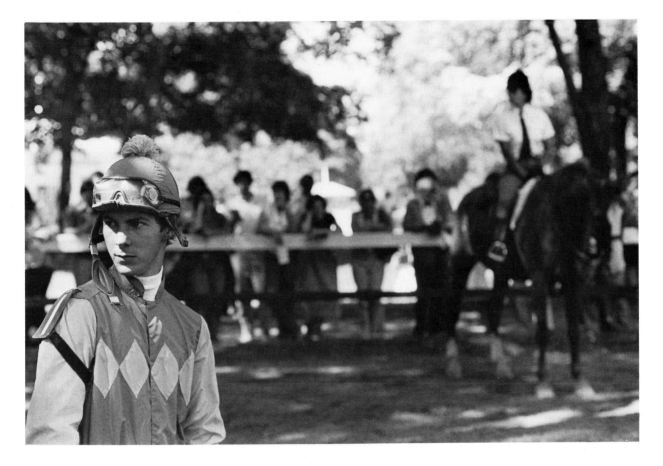

A

Lens set at f 2.

Same subject, lens set at f 16 for more depth of field.

B

Subject focused close to the camera, 3 feet away.

Same subject focused farther from the camera, 20 feet away, has greater depth of field.

C

Subject taken with a telephoto lens, a focal length of 200 millimeters.

Same subject taken with a wide-angle lens, 24 millimeters, has greater depth of field.

32

Depth of field varies with

A. Lens opening
The smaller the aperture, the greater the depth of field.

B. Distance
The farther the focusing distance, the greater the depth of field.

C. Focal length
The longer the focal length of the lens, the smaller the depth of field.

In some situations, it is important to know exactly what the depth of field will be before taking the picture. Here are three methods of previsualizing depth of field: using the preview setting on the camera, reading the depth-of-field scale on the lens, and focusing in zones.

Preview setting. Depth of field can be previsualized easily when using cameras with through-the-lens viewing and focusing systems, such as single-lens reflex and view cameras. When the aperture is opened (set at the lower numbered f-stops), the depth of field visibly decreases; when it is closed (set at the higher numbered f-stops), the depth of field visibly increases.

With SLRs fitted with automatic lenses, the aperture remains wide open until the shutter button is pressed. Therefore, the depth of field usually appears minimal, since it represents the image sharpness at the widest opening of the lens regardless of the preset f-stop. To compensate for this, most SLRs have a *preview setting* (or manual switch) to allow previsualizing depth of field at any f-stop.

The preview setting is usually located on the camera body next to the lens or on the barrel of the lens. When the setting is activated, the aperture closes down to its preset f-stop for viewing what the depth of field will be at that aperture. For example, an f 2 lens set at f 11 will generally show a minimal depth of field — what it would be at f 2. When the preview setting is switched on, the lens will close down to f 11 for previsualizing the depth of field at what it would be with the lens set at f 11.

Under dim lighting conditions, especially at small f-stops, the depth of field may be difficult to judge because the viewfinder will be dark.

After using the preview setting, turn it off, refocus the subject if necessary, and take the picture.

Depth-of-field scale. A distance and depth-of-field scale located on the lens indicates in feet and meters how much of the image will be in focus at each f-stop setting.

The *distance scale*, usually located on the lens, turns as the image is focused and indicates how far away the focused subject is from the camera. That distance is indicated by a marker located on the lens opposite the distance scale. If the focused subject is 10 feet away, "10" on the distance scale will line up with the marker.

Surrounding the distance marker on both sides is the *depth-of-field scale*; it incorporates the standard f-stop designations and reads:

16' 8' 4' ▲ 4' 8' 16'

To discover the depth of field at any focusing distance, when the lens is set at any f-stop, match up the focus-distance measurement with the marker and look at either side of the marker for the parameters of the depth of field at each f-stop. The distance figures opposite the two f-stop designations indicate the front and rear distances from the film that will be in focus at that f-stop.

For example, a focused subject 10 feet away will register on the distance scale opposite the marker at 10 feet. To discover the depth of field when set at f 8 at that distance, look at the distance scale opposite "8" on both sides of the marker. On one side, it indicates 8 feet, and on the other side 14 feet. So the depth of field at f 8, when focused at 10 feet, ranges from 8 to 14 feet away from the camera. At smaller f-stops, such as f 11 or f 16, the depth of field increases; at larger f-stops, such as f 5.6 and f 4, it decreases.

The distance scale can be used to guarantee an adequate depth of field when sharp focus is critical. First, determine the distance from the camera of the closest and farthest points in the subject that require sharpness by focusing on each point and reading the distance scale on the lens. Say that the closest point needing sharp focus is 5 feet away from the camera, and the farthest point is 11 feet away. Set the focus on the lens at 7 feet — a mid-point according to the 1-to-2 ratio (2 feet in front and 4 feet in back of the focus point). Check the depth-of-field scale on the lens to see what f-stop is needed to provide a depth of field from 5 to 11 feet. If f 11 is needed, use f 11 or a smaller aperture, such as f 16 or f 22.

Depth-of-field scale

To determine the depth of field of an image at a given f-stop, read the distance scale against the depth-of-field scale. The latter scale has a range of f-stops on either side of the focus distance (camera to focused subject) marker. Above, at a focus distance of 10 feet, the depth of field at f 8 is approximately 8 to 14 feet.

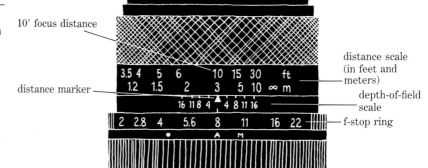

10' focus distance

distance marker

distance scale (in feet and meters)

depth-of-field scale

f-stop ring

34

The depth-of-field scale incorporates all the factors controlling depth of field: lens opening, distance, and focal length. While lens opening and distance vary, the focal length remains constant for each lens. Various focal length lenses have different depth-of-field scales since wide-angle lenses produce greater depth of field than normal or telephoto lenses.

While this scale is useful, it slows the picture-taking process. For candid photography and situations requiring a faster response, zone focusing is more practical.

Zone focusing. Zone focusing refers to making an entire area (or zone) sharp rather than focusing on a specific subject. This guarantees that any subject within that zone will be in focus at all times. Zone focusing is especially useful when the subject is active yet remains within a contained area.

For example, to photograph a child playing in a sandbox, determine the distance of both the front and back of the box from the camera by focusing on each. If the front of the box is 6 feet away from the camera and the back is 12 feet away, set the distance scale and the depth-of-field scale on the lens at settings to guarantee a depth of of at least 6 to 12 feet. Set the focus at 8 feet, according to the 1-to-2 ratio rule — in this case, 2 feet in front and 4 feet in back of the focus distance needs to be sharp. Now refer to the depth-of-field scale to determine the minimum f-stop needed to guarantee a depth of field of 6 to 12 feet. Here, the minimum f-stop is f 8, so set the lens at f 8, f 11, f 16, or f 22.

Once all the calculations are made, zone focusing allows for rapid shooting. The entire zone (the sandbox) will be sharp, eliminating the need to focus specifically on the moving child. Keep the f-stop and distance constant, frame the subject, and shoot.

Guess focusing, a variant of zone focusing, is ideal for candid shooting situations when quickness is essential. Literally, guess the camera-to-subject distance, and set the distance scale on the lens accordingly. Then choose the smallest practical f-stop to maximize the depth of field. If the guess of the distance is close and the aperture small enough, the subject should fall within the parameters of the depth of field, and be acceptably sharp.

If the subject is approximately 6 feet away, set the distance scale on the lens for 6 feet, close down the aperture, then quickly take the picture. The subject will barely notice he or she is being photographed. Sometimes an inaccurate guess will cause an out-of-focus image, but guess focusing generally allows good candid shots that might not have been possible if time were taken to focus more critically.

CHAPTER 4 | THE SHUTTER

Every camera has a *shutter*, a shield located somewhere between the film and the front of the lens. The shutter protects the film from light entering the lens. The photographer chooses when to make an exposure by pressing the *shutter button*, which then opens and closes the shutter.

The shutter has two main functions: it sets the amount of time for which film is struck by light, and it affects the amount of movement rendered in the image.

Controlling Time

The amount of time for which the shutter remains open is critical to the film exposure. A photographic image is created by light traveling through the lens and falling onto the film. The amount of that light is controlled in part by the lens opening. However, light cannot actually reach the film until the shutter opens. Opening and closing the shutter controls the duration of time for which light exposes the film. Together, these controls — aperture and shutter — are the key variables for good film exposure.

The time during which the shutter is open is called the *shutter speed*. In most cameras shutter speed is widely variable, and can be controlled.

Shutter speed must be set according to the prevailing lighting conditions. When the lighting is dim, a long or "slow" shutter speed is required; that is, the shutter must remain open for a time long enough to allow a lot of light to reach the film. When the lighting is bright, a short or "fast" shutter speed is needed so that relatively little light reaches the film.

The choice of shutter speeds is usually made on a shutter-speed dial (except with certain automatic camera models). This dial is usually located somewhere on the camera body (though on some cameras it is located at the base of the lens). Here are the shutter-speed choices typically found on modern cameras:

36

<div align="center">

1

2

4

8

15

30

60

125

250

500

1000

</div>

"1" stands for 1 full second; the other numbers represent fractions: "2" means 1/2 of a second; "125" is 1/125 of a second; and so forth. Shutter speeds slower than 1 second (for example, 2 seconds) and faster than 1/1000 of a second (for example, 1/2000 of a second) are also designated on some cameras.

The relationship between the shutter speeds offered is essential to understanding film exposure. Each setting doubles the time of the setting on one side of it and halves the time of the setting on the other side: "4" (1/4 of a second) represents half as much time, so allows half as much light to reach the film, as "2" (1/2 of a second).

This half-and-double relationship is no coincidence. Remember that f-stop settings have the same relationship. Once again the combination of these factors is critical in determining good film exposure. (More on film exposure in chapter 5.)

(For the remainder of the text, shutter speeds will be referred to by the fraction of a second they represent. So, "1/8" means one-eighth of a second; "1/500" means one five-hundredth of a second; and so forth.)

Some shutters are *mechanical*, run by gears and springs, while others are *electronic*, controlled by circuits and batteries. Mechanical shutters can be set only for the speeds designated by the shutter-speed dial; even if the shutter speed is set between two designated speeds, the gears will lock in at one speed or the other. Some electronic shutters function only at designated shutter speeds, but some provide speeds in between, such as 1/200 (between 1/250 and 1/125). Most cameras with electronic shutters will not work if their battery becomes exhausted; cameras with mechanical shutters will work without batteries.

Most shutter speed dials have "B" and/or "T" settings. Both permit the shutter to remain open for an indefinite period of time. These settings are especially useful in dim lighting conditions, when a shutter speed longer than 1 full second is required for adequate film exposure.

shutter button shutter-speed dial

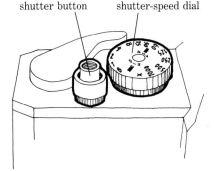

Location of shutter button and shutter-speed dial on top of a 35-millimeter camera.

"B" stands for *bulb*. When set at "B," the shutter remains open as long as the shutter button is pressed down. When the button is released, the shutter closes down. Most shutters have a "bulb" setting.

"T" stands for *time*. When set at "T," the shutter remains open from the time the button is pressed a first time until it is pressed again. The second time the shutter button is pressed, the shutter closes. This setting is found on relatively few modern cameras.

Controlling Movement

If the subject or camera moves while the shutter is open, the result will be a blurred image. A sharp image is needed most of the time, but sometimes a less sharp image may be appropriate to emphasize movement or create a special point of interest in the photograph. At any rate, the photographer can choose to render a sharp or blurred image by adjusting the shutter speed accordingly.

Subject movement may have an effect at any time, but particularly at slower shutter speeds. The faster the movement, the greater the image blur. The motion of a dog walking may be "stopped" by a shutter set at 1/125, yet a speeding car will appear blurred at the same speed.

The direction of the subject movement in relationship to the camera must also be considered. If the subject travels directly across the viewfinder from left to right (or right to left), its movement appears faster than if it travels toward (or away from) the camera at the same speed. Therefore, a faster shutter speed is needed to stop the movement of a subject traveling across the viewfinder than to stop the movement of a subject traveling toward or away from the camera.

Subtle subject movement should also be noted. For example, a strong wind can easily move grass, foliage, or tree branches. On windy days use a fast shutter speed to guarantee a sharp image; or use a slow shutter speed to create blur and emphasize the motion.

A deliberately blurred subject within an otherwise sharp image can be an effective way to show action, movement, or simply to create an evocative image. The shutter speed must be fast enough to keep the stationary parts of the subject sharp but slow enough to make the moving parts of the subject blurry.

Panning means moving the camera during the exposure in the same direction as the motion. A successful "pan" renders the subject in motion sharp, and causes the background to blur. However, panning is difficult since the camera movement must approximate the speed of the subject movement. Use a medium shutter speed, about 1/30 or 1/60, and experiment.

While panning is deliberate camera movement for effect, accidental camera movement is a common photographic problem. If the camera

Controlling movement

Part of the subject is blurred and part is sharp due to a shutter speed that is too slow to stop the action.

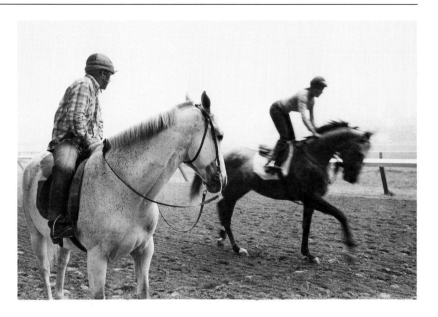

The entire image is blurred due to camera movement during the exposure.

Panning

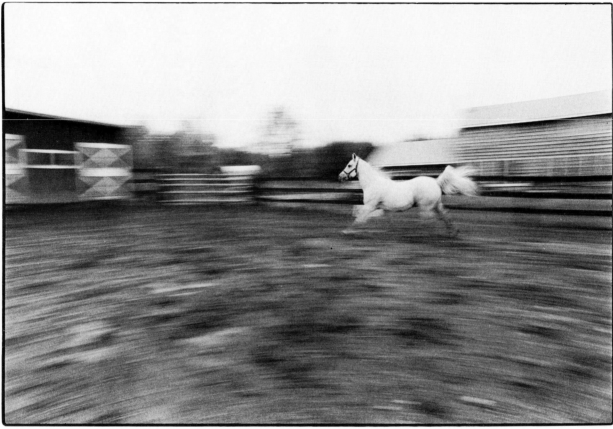

The moving subject is sharp and the background is blurred due to camera movement in the direction of the action during the exposure.

moves during exposure, the entire image will not be rendered as sharp. Too slow a shutter speed is a common cause of blurring from camera movement. Single-lens reflex cameras are particularly prone to accidental movement since they are relatively heavy and contain mirrors that can cause vibration as they flip up and down.

To minimize blurring, hold the camera as still as possible, and try to shoot at a shutter speed of 1/60 or faster. Each person's ability to hold a camera steady varies, but the faster the shutter speed, the less the image blur — for everyone!

When a shutter speed slower than 1/60 is indicated, use a tripod to steady the camera. If a tripod is unavailable, try bracing the camera against a tree or on a table. A beanbag placed between the camera and its brace will help cushion movement.

Types of Shutters

The two common shutter types are:

leaf shutter
focal-plane shutter

Leaf shutter. Located in the rear of the lens, a leaf shutter consists of several overlapping metal "leaves" that open and close in a circular pattern. Leaf shutters are mostly used with rangefinder, twin-lens reflex, and view cameras.

Focal-plane shutter. Located in the camera body, a focal-plane shutter is a curtain positioned behind the lens and immediately in front of the film. When opened, the curtain moves in a horizontal or vertical direction, exposing film one section at a time in rapid succession.

Focal-plane shutters are ideal for cameras with interchangeable lenses, particularly SLRs. Since the camera body incorporates the shutter, there is no need for separate shutters in each accessory lens.

Focal-plane shutters allow faster speeds than most leaf shutters, with 1/1000 or 1/2000 as a common maximum speed. However, they are somewhat more noisy and prone to vibration than leaf shutters. Furthermore, focal-plane shutters are less flexible than leaf shutters when using flash. (See chapter 10 for more details on setting shutter speed when using flash.)

Leaf shutter

Left:
Located in the rear of the camera lens.

Right:
Consists of overlapping metal "leaves" that open and close in a circular pattern.

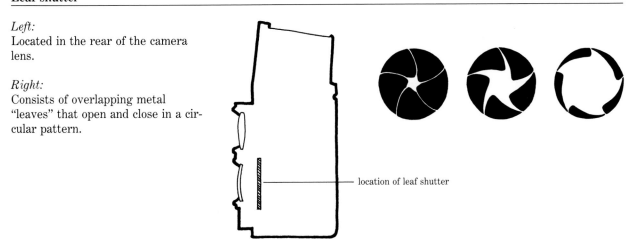

location of leaf shutter

Focal-plane shutter

Left:
Located in the camera body behind
the lens and just in front of the film.

Right:
Consists of a curtain that opens in a
horizontal or vertical direction, ex-
posing sections of film in rapid
succession.

location of
focal-plane shutter

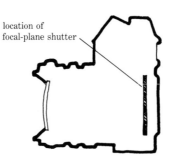

focal-plane
shutter

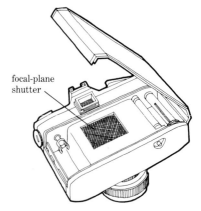

CHAPTER 5 | FILM EXPOSURE

The most important technical step to a good print is a good negative. The key to a good negative is correct *film exposure*, the quantity of light that reaches the film. This point cannot be overstressed. A good negative will produce a good print with relative ease; a bad negative will be difficult and sometimes impossible to print satisfactorily.

Controlling Exposure

A well-exposed negative has good overall density. Both highlight and shadow areas must retain some detail. The highlight areas must be dark but not too dense; and the shadow areas must be light but not too thin. To this end, the correct amount of light must reach and expose the film. Too much light will cause too great a silver buildup on the film, thus a dense negative; too little light will cause a thin negative, lacking silver buildup. (Of course, film exposure creates a latent image only; the film must be developed chemically before that image is visible.)

Three variables control film exposure:

<div align="center">

lens opening
shutter speed
film speed

</div>

The first two have been described earlier, but bear reviewing:

Lens opening. The amount of light traveling through the lens is controlled by the lens opening, or the aperture.

> **The larger the opening, the greater the amount of light that reaches the film.**

Therefore, a brightly lit subject requires a smaller aperture than a dimly lit subject.

The size of the lens opening is measured by f-stop numbers: the larger the f-stop number, the smaller the opening, and the less light reaches the film. Here again are full f-stops:

f 1.4	most light	*large apt.*
f 2		
f 2.8		
f 4		
f 5.6		
f 8		
f 11		
f 16		
f 22	least light	*small apt*

Each full f-stop represents a doubling or halving of the light that travels through the lens. For example, f 11 allows half as much light through as f 8.

Shutter speed. The time for which film is exposed to light is controlled by the shutter speed.

The faster the shutter speed, the shorter the duration of film exposure, and the less light reaches the film.

A dimly lit subject requires a slower shutter speed than a brightly lit subject. Here again are typical shutter-speed settings, representing fractions of a second:

1	most light	*slow*
2		
4		
8		
15		
30		
60		
125		
250		
500		
1000	least light	*fast*

Each setting represents a halving or doubling of the light that reaches the film. For example, 1/8 allows light in for twice as much time as 1/15.

Film speed. The third film-exposure control is *film speed*, or the sensitivity of film to light. *Fast films* receive and record light more readily than *slow films*. (The terms "fast film" and "slow film" should not be confused with "fast" and "slow" as applied to shutter speed or lens.) Imagine two strips of film, one with a fast speed and the other with a slow speed. If both strips are exposed to equal amounts of light, upon development the fast film will produce a greater density than the slow film.

The faster the film speed, the less the required exposure.

A fast film is needed in dimly lit conditions to capture the little light that exists. A slow film is adequate for brightly lit subjects where light is plentiful.

Fast films have emulsions that consist of larger silver crystals than slow films. These crystals, when exposed and developed, clump together to create the density that makes an image. These clumps are frequently visible in the final print. They are referred to as *grain*, and look like fine particles of sand. Grain can make the image appear fuzzy and less sharp. The faster the film speed, the larger (or *coarser*) the grain. (More on grain in chapter 7.)

Film speed is rated by an ASA number. ASA stands for the American Standards Association. The higher the ASA rating, the faster the film speed. Here are ASA ratings for common black-and-white films, along with some guidelines for their use:

- 32 ASA: Slow film; best with brightly lit subjects; produces very-fine-grain negatives.
- 125 ASA: Medium-speed film; best for general outdoor use; produces medium-fine-grain negatives.
- 400 ASA: Fast film; best for indoor or dimly lit subjects, though can be used outdoors; produces acceptable, but coarser, grain than slower films.

(There are other ways to rate film speed. The German system — DIN — is rarely used in the United States. ISO is an international standard that includes both ASA and DIN. For example, 400 ASA film is also rated 27 DIN and 400/27 ISO. For practical purposes, use only the ASA film-speed rating system.)

Combining the Controls

The relationship between f-stop and shutter speed is the key to understanding film exposure. The combination of these two controls determines how much light actually reaches the film. As noted, each designated f-stop or shutter speed doubles or halves the amount of light allowed in by the next designated f-stop or shutter speed. F 11 lets in half as much light as f 8, and twice as much as f 16; a shutter speed of 1/60 lets in light for half as much time as 1/30, and twice as much time as 1/125.

Therefore, f-stop and shutter speed have a reciprocal relationship. If the shutter speed is slowed down (to allow more light to reach the

Grain

The faster the film speed, the coarser the grain.

A print made from a section of a 400 ASA negative; note the coarse grain.

A print made from a section of a 32 ASA negative has finer grain.

film), the f-stop must be closed down (to let less light strike the film) to make an equivalent exposure. The following combinations of f-stop and shutter speed will produce the exact same film exposure:

f 16 at 1/30
f 11 at 1/60
f 8 at 1/125
f 5.6 at 1/250
f 4 at 1/500

Five pictures, shot one after another, of the same subject with these five different exposures will render five negatives of equal density.

How changing f-stops and shutter speeds affects exposure

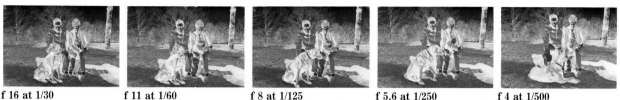

| f 16 at 1/30 | f 11 at 1/60 | f 8 at 1/125 | f 5.6 at 1/250 | f 4 at 1/500 |

Five different negatives taken at the same time with the same exposure achieved by five different combinations of f-stop and shutter speed.

Note that the smaller the aperture, the slower the shutter speed. (Remember, small aperture means larger f-stop number.) With less light passing through the lens, the shutter-speed time needs to be lengthened to compensate. Conversely, the larger the aperture, the faster the shutter speed.

So why choose one combination of f-stop and shutter speed over another? The exposure choice is made according to the needs of the particular picture. If a lot of depth of field is needed, use a smaller aperture (and slower shutter speed), say, f 16 at 1/30, at the risk of a blurred image. If a fast shutter speed is important to stop the action of a moving subject, choose f 4 at 1/500 and sacrifice some depth of field. In effect, the choice of exposure is a trade-off between maximum depth of field and minimum image blur.

Film speed affects exposure as surely as the aperture and the shutter speed. Fast films are more sensitive to light than slow films, so require a smaller lens opening or faster shutter speed. For example, a subject shot with an exposure of f 16 at 1/125 with 400 ASA film will need an exposure the equivalent of two f-stops more light, such as f 11 at 1/60, with 100 ASA film. (Remember that because of the reciprocal relationship of f-stop and shutter speed, many exposure combinations can be chosen. F 11 at 1/60 "equals" both f 8 at 1/125 and f 16 at 1/30, as well as several other combinations.)

The advantage of fast films is that they produce more depth of field or less potential image blur than slow films. But remember that slow films produce images with finer grain than fast films.

The relationship among different film speeds is reflected in their respective ASA numbers. Film rated 125 ASA is approximately four times faster or more sensitive to light than 32 ASA film ($4 \times 32 = 128$). If f 4 at 1/60 is a correct exposure with 32 ASA film, film rated at 125 ASA needs f 5.6 at 1/125 (or f 4 at 1/250, or f 8 at 1/60, and so forth) for an equivalent exposure. The difference between 32 ASA and 125 ASA is the equivalent of two f-stops (one f-stop provides double the exposure, and another provides four times the exposure).

A change of two shutter-speed settings or one f-stop and one shutter speed provides the same results.

Film rated at 400 ASA is almost four times more sensitive to light than film rated at 125 ASA ($4 \times 125 = 500$). The equivalent exposure with the above example and 400 ASA film is between f 5.6 and f 8 at 1/250 (or between f 4 and f 5.6 at 1/500, or between f 8 and f 11 at 1/125, and so forth). Again, faster film requires a smaller aperture or faster shutter speed than slower film.

The reciprocal relationship between f-stops and shutter speeds breaks down at very slow (and extremely fast) shutter speeds. This breakdown is called *reciprocity failure*. When used at speeds of 1 second or slower (and 1/1000 or faster), films respond more slowly to light. Therefore, although f 8 at 1/2 is equal to f 5.6 at 1/4 second, it is not equal to f 11 at 1 second, since at 1 second, reciprocity failure occurs and the film needs even more exposure. In practice, f 8 at 1/2 is approximately equal to f 11 at 2 seconds.

Use the following chart as a general guideline to compensate for reciprocity failure with black-and-white films. The exact compensation required will vary, depending on the film used.

| indicated shutter speed | Either/Or | | and change development time as follows |
	open aperture by	use this shutter speed instead	
1/1000 of a second	no adjustment needed	no adjustment needed	10% more time
1 second	1 f-stop	2 seconds	10% less time
10 seconds	2 f-stops	50 seconds	20% less time
100 seconds	3 f-stops	1200 seconds	30% less time

Note that reciprocity failure is tied to long shutter speeds, so as the speed gets longer, reciprocity failure becomes more pronounced, and extremely long exposure speeds are required. When making an adjustment for reciprocity failure, open up the aperture if possible to avoid these long shutter-speed times.

(Film development is covered in chapter 6. The changes recommended are to compensate for highlight areas of the film. These respond less critically to slow shutter speeds than shadow areas.

However, most film is shot in rolls at various shutter speeds, so a single development adjustment is not practical. Besides, controls in the printing stage can generally compensate for these differences. However, for using sheet film or roll film at a constant very slow or very fast shutter speed, use the above film development changes.)

About Light Meters

A *light meter* measures light and translates that measurement into a workable set of f-stop and shutter-speed combinations, appropriate to the lighting conditions of the subject. As such, it is a guide to using the three exposure controls: lens opening, shutter speed, and film speed.

Meters have a light-sensitive cell to register a reading. These cells in modern meters are battery operated.

For use, the meter must first be set for the ASA rating of the film being used. This setting is made by turning a dial on the meter (or on the camera, if the meter is built into the camera). Then the meter is pointed in the direction of the subject, and reads the light reflecting back off the subject. Some meters, called *incident-light meters*, read light falling onto the subject; they are discussed later in this chapter.

Once the meter reads the light, it indicates an appropriate f-stop and shutter-speed combination. Some types of meter indicate a variety of choices, while others indicate only one. Remember that several combinations are possible. If a meter indicates an exposure of f 8 at 1/60, any equivalent exposure, such as f 5.6 at 1/125 and f 4 at 1/250, will work as well.

Some cameras have built-in light meters and some do not. All camera models can be classified as manual, semiautomatic, or automatic:

Manual cameras. Both the f-stop and the shutter speed must be chosen and set manually with the aid of a built-in or a separate light meter.

Semiautomatic cameras. Either the f-stop or shutter speed is chosen and set, and the camera automatically sets the other control. In *shutter-priority* models, the photographer chooses the shutter speed, and the camera automatically sets the f-stop; in *aperture-priority* models, the photographer chooses the f-stop and the camera sets the shutter speed.

Automatic cameras. Once the film speed is set, the camera chooses the f-stop and shutter speed automatically when pointed at the subject.

Many camera models combine features. A semiautomatic model, for example, may offer an override option so the f-stop and shutter speed can be set manually. Or a camera may offer both shutter priority and full automation.

Each model has advantages and disadvantages. However, serious photographers should retain as much control over film exposure as possible. Remember, good film exposure is the key to a good print. Light meters are not infallible, and sometimes exposure readings need to be interpreted. More on this later, but a manual camera (or a semiautomatic or automatic camera with a manual option) should be used for maximum exposure control.

Light meters are available in many sizes, shapes, and types. There are too many types to be covered in detail, but there are two major categories: through-the-lens meters and hand-held meters.

Through-the-lens light meters. These meters are built into the camera and read the light that passes through the lens. The reading is then translated into an f-stop and shutter-speed combination in a variety of ways, depending on the camera model, such as with matching needles, electronic diodes, or digital readouts.

In a matching-needle system, the viewfinder contains two needles on an edge of the image frame. One needle moves up and down with the intensity of light reaching it; the other needle moves up and down as the f-stop and shutter-speed choices are made. The needles match up on reaching the correct combination for the given subject lighting.

A variation of this system has a single needle that moves as f-stops and shutter speeds are set. The correct exposure is indicated when the needle is centered between stationary markings in the viewfinder.

Light meter types

Hand-held light meter.

Through-the-lens light meter.

Through-the-lens light meter types

(as seen through the viewer)

Left:
Matching-needle. The two needles move as the f-stop and shutter speed are changed. They come together (or "match") when the correct exposure combination is reached.

Right:
Electronic diodes. A readout of the chosen f-stop and shutter speed as they appear through the viewfinder.

Some cameras use electronic diodes instead of needles. One system has three diodes positioned vertically on the edge of the viewfinder. The center diode lights up when the correct f-stop and shutter speed are chosen. The top and bottom diodes indicate under- or overexposure.

Digital readouts in the viewfinder are used in many modern cameras. Sometimes the readout simply displays the f-stop and shutter speed chosen, and sometimes additional information, possibly related to a coupled flash attachment, is provided.

It is easy to get carried away with or confused by camera technology. The wide variety of through-the-lens metering systems seems endless and is ever changing. Most all systems work well. Some photographers find electronic readouts in the viewfinder a serious distraction; others like the clarity they provide. Make choices after trying out different cameras. Camera stores are the best sources of the latest information on the variety of features of the current models.

Hand-held meters. These meters are separate from and work independently of the camera. (Some cameras have light meters attached to the body that function like hand-held models; these attached meters do not read light through the lens.)

To use a hand-held meter, first set the ASA of the film being used, then point the meter at the subject. The meter reads light reflecting back from the subject, and translates that reading into one or more f-stop and shutter-speed combinations.

There are several types of hand-held light meters. Some use a needle to indicate exposure, while others use a digital readout. Here is how a typical hand-held meter works:

A needle on the meter indicates how much light reflects back from the subject. The needle points to a *light-intensity scale*. One end of

51

the scale represents a maximum amount of light, while the other end represents the absence of light.

With many hand-held meters, the light-intensity scale is rated numerically. These ratings vary depending on the meter used. The low numbers represent little light; the high numbers represent a lot of light. The needle responds to light from the subject, and indicates a numerical value on the light-intensity scale. This value can be matched up to a dial with f-stop and shutter-speed combinations located elsewhere on the meter. A marker on the dial can then be matched up to the light value and several f-stop and shutter-speed combinations will be indicated.

Some hand-held meters do not use light values. Instead, the needle points directly to possible f-stop and shutter-speed combinations. Other types of hand-held meters use charts of f-stops and shutter speeds rather than dials.

Digital hand-held meters have no needle. When pointed at the subject, they provide a direct readout of a recommended f-stop and shutter speed or a light value.

Hand-held light meter

When pointed at the subject, the meter reads light and points with a needle to a numerical light value — here, 15½. Once the arrow on the dial is set at that value, several combinations of f-stop and shutter speed are provided — such as f 5.6 at 1/250, f 8 at 1/125, and f 11 at 1/60.

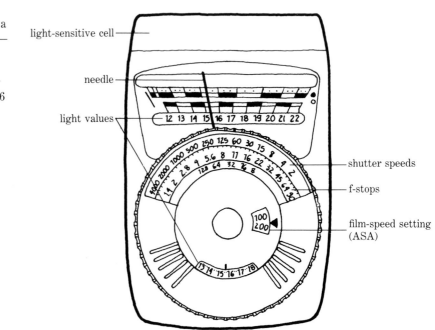

light-sensitive cell

needle

light values

shutter speeds

f-stops

film-speed setting (ASA)

Reflected light

The light that reflects off the subject. To take a reflected light reading, point the meter at the subject.

Incident light

camera
position

The light that falls onto the subject. To take an incident-light reading, point the meter back toward the camera position.

Light meters read either reflected or incident light. Some read just reflected light; others read just incident light; many read both. Reflected and incident meters will produce the same exposure information when correctly used. They vary in how they determine that exposure.

Reflected light is the light that reflects off the subject and bounces back to the meter. To read reflected light, the meter is pointed directly at the subject. Most light meters read reflected light.

Incident light is the light that falls onto the subject. Meters that read incident light have a diffuser attached over their light-sensitive cell. The meter is brought to the subject, and pointed back toward the camera position for a reading.

Some meters are *averaging meters* and some are *spot meters*. The difference is the angle of light each reads. An averaging meter reads a large angle of light, perhaps 30° to 50°, while a spot meter reads a much narrower angle, perhaps 1° to 10°. A few meters offer a choice of either a spot or an average reading.

Some models, called *center-weighted meters*, combine an average and a spot reading. These meters read light through the lens, and assume that the subject area shown in the center of the viewer is of more importance for the purpose of determining exposure than the area on the edges of the viewer. The light from the center is thus "weighed" more heavily than the light from the edges when the meter calculates the recommended exposure.

Actually, the terms "average" and "spot" are a bit deceptive. Both meter types "average" light; that is, they record all the light values, dark and light, in the subject, and average them to arrive at a recommended exposure. A spot meter simply averages light off a smaller section of the subject than an averaging meter. Some photographers prefer a spot-meter reading to guarantee correct exposure for specific parts of the subject. For example, if the main subject is a tree in the middle of the forest, a spot meter is ideal to guarantee an accurate reading of the light reflecting off that tree, regardless of the light reflecting from the rest of the forest.

Modern camera technology is so advanced that nearly anyone can use a through-the-lens meter and get accurate exposures most of the time. So why bother understanding how meters work? Why not simply aim the camera, line up the meter or switch to an automatic mode, and shoot?

First of all, light-meter readings are not always accurate. Meters are only machines; they are dependent on the information fed to them.

Averaging meter

Reads a large angle of light — here, 40°.

Spot meter

Reads a narrow angle of light — here, 5°.

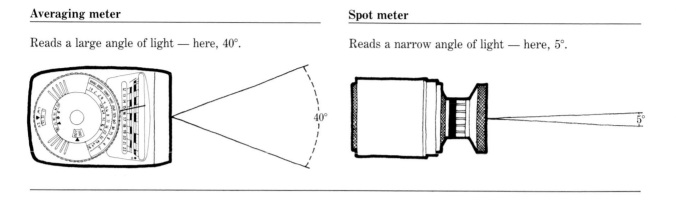

Sometimes that information must be interpreted and adjustments made.

In addition, "accurate" exposure does not always mean the best exposure. Sometimes underexposure or overexposure will provide a more printable negative. (More on this in chapter 7.)

Furthermore, not everyone owns a camera with a through-the-lens meter. Many sophisticated cameras, especially large-format models, have no built-in meter. And many older cameras without through-the-lens meters are still in use.

Some photographers argue that hand-held meters can provide more accurate film exposure. These meters generally provide more information, such as a wider range of exposure choices, than through-the-lens meters. Good hand-held meters are extremely sensitive to light, though most newer through-the-lens meters are also sensitive. Being independent of the camera, a hand-held meter can be brought up close to the subject for precise readings more easily. And some hand-held spot meters can read a far narrower angle of light than through-the-lens models.

The main rule-of-thumb for understanding how light meters work is:

Meters read for a middle gray.

That is, meters average whatever light they read, whether from a dark, light, or gray subject. The average represents the gray, that is, halfway between black and white.

This average reading usually works well enough, since most subjects have approximately equal amounts of dark and light areas. However, when the subject is primarily either dark or light, the meter reading will be inaccurate. Meters do not discriminate among different

subject matter. They are calibrated only to average the light. Therefore, the photographer must do the discriminating.

For example, a meter pointed at a dark (or shadow) area of the subject will read on the low end of the light scale. Since dark areas absorb light, the meter will indicate that little light is reflecting back from the subject. It will recommend an f-stop and shutter-speed combination that allows a lot of light to reach the film to compensate for this relative absence of light. Let's say the subject is a woman with dark hair. If the meter is pointed only at the hair, it might give a reading of f 4 at 1/60.

If, instead, the meter is pointed at a light (or highlight) area of the same subject, it will read on the high end of the light scale, and indicate much more light reflecting back. Light areas reflect light. Therefore, the meter would provide an f-stop and shutter-speed combination geared to compensate by allowing less light to reach the film. A reading made off the woman's white sweater might be f 16 at 1/60.

A meter reading made off the same woman's middle-gray skirt would provide still another reading. Her gray skirt will reflect less light back to the film than her white sweater and more light back than her dark hair. Say this reading is f 8 at 1/60.

So, three entirely different readings are given for the same subject, depending on where the meter is pointed. Both the readings from the dark and light areas would produce inaccurate exposures. Why? Because meters read for middle gray. Most subjects combine enough light and dark areas to simulate that gray. However, when light readings are made largely from either dark or light areas, the resulting exposure will be inaccurate.

Exposure Systems

What follows are several systems for accurate film exposure. Each system works well, in most conditions, for either through-the-lens or hand-held light meters.

> **Take a general reading.**
> **Use a gray card.**
> **Expose off skin.**
> **Read incident light.**
> **Average the shadows and highlights.**
> **Bracket.**
> **Expose for the shadows and compensate.**

Take a general reading. Most of the time a general light-meter reading of an entire subject produces an accurate exposure recommendation. However, before accepting that reading, examine the sub-

A general light-meter reading produces accurate exposure most of the time — when the dark, middle, and light values of the subject roughly average out.

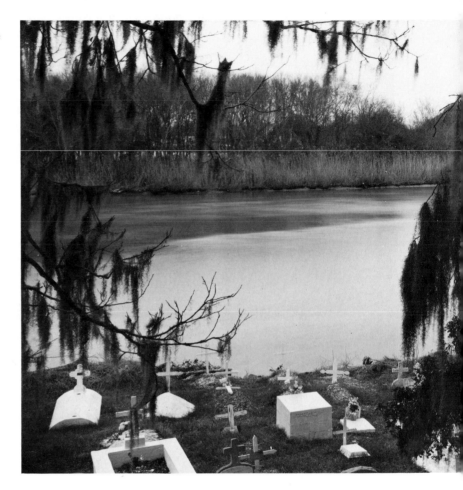

ject carefully. Try to previsualize the image as it will look in black and white. Do dark, middle, and light values roughly average out? If so, use an f-stop and shutter-speed combination from the general reading without correction; if not, make one of the following adjustments to that reading.

For *predominantly white or light subjects*, add more light — by the equivalent of one f-stop or more — than the meter suggests. Either open up the aperture or slow down the shutter speed. If the meter reading is f 8 at 1/500, use instead f 5.6 at 1/500 or f 8 at 1/250. (For especially light subjects, add even more light.)

56

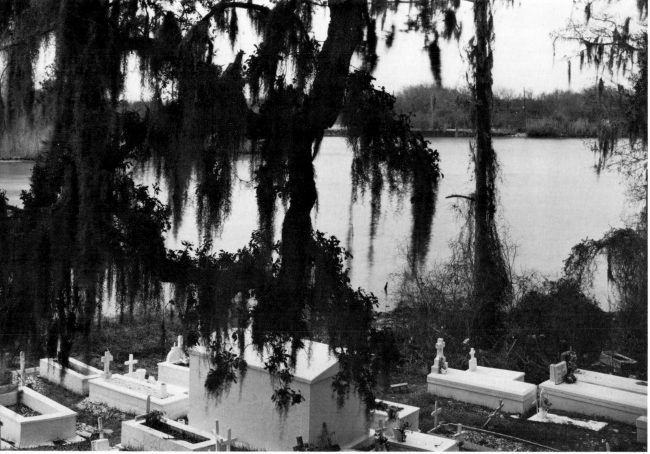

© ALLEN HESS

For *predominantly dark subjects*, cut back on the light the meter suggests; close down the aperture or make the shutter speed faster. If the meter reading is f 4 at 1/60, use instead f 5.6 at 1/60 or f 4 at 1/125. (For especially dark subjects, cut back the light even further.)

Use a gray card. Photographers sometimes use a *gray card* to reflect an average amount of light falling onto the subject rather than the light reflected off specific parts of the subject. A gray card is a small, rectangular piece of cardboard colored middle gray on one side and white on the other. It is inexpensive and available at most camera stores.

Gray card

To take light reading with a gray card, place the card in front of the subject, toward the camera position, and meter off the card.

To use a gray card, place it in front of the subject, and aim it toward the camera position. Take a meter reading off the card only; take care not to cast a shadow onto the card while reading the light. Use the f-stop and shutter-speed combination indicated by the meter without adjustment.

Gray cards are easiest to use with hand-held meters, but can be used with through-the-lens meters. They are most useful in stationary shooting situations, like still-lifes or formal portraits, when there is time to approach the subject, hold out the card, and take the meter reading.

Expose off skin. Skin can be a substitute for a gray card. Take a light reading off the palm of a hand, flattened out and positioned directly in front of the subject, toward the camera position. Or take the reading off the subject's face. Be careful not to cast a shadow onto the hand or the face when taking the reading.

Skin tones vary, and the indicated meter reading will probably need adjustment. For "average" Caucasian skin, add the equivalent of one f-stop more exposure. If the meter reads f 16 at 1/250, use instead f 11 at 1/250 or f 16 at 1/125. Dark skin may simulate a gray card perfectly, so use the meter reading without adjustment. Extremely

dark skin may need as much as one-half to one f-stop less exposure than the meter suggests. If the meter reads f 8 at 1/125, use instead the half-stop between f 8 and f 11 at 1/125, or perhaps f 11 at 1/125 or f 8 at 1/250.

Read incident light. Incident-light meters read light falling onto the subject rather than light reflecting off the subject. They do not read specific dark, gray, or light areas of the subject. As such, they provide an average exposure for the given subject lighting conditions, much like a gray card.

Incident readings are especially useful in extreme lighting conditions, such as on bright sunny days or when either light or dark areas could dominate a reflected meter reading.

Directions for using an incident-light meter were detailed earlier in this chapter.

Average the shadows and highlights. Since meters read for middle gray, the correct exposure will be somewhere between the meter readings for the dark and light areas of the subject. Meter a dark area, then a light area, and average the two readings. If the reading off the dark area is f 4 at 1/60, and the reading off the light area is f 16 at 1/60, use f 8 at 1/60.

Most of the time this exposure system works well enough. However, the dark and light areas metered should be approximately equal in darkness and lightness. Do not average meter readings from a jet black car and mildly tanned Caucasian skin.

Bracket. *Bracketing* means taking exposures on either side of the recommendations of the meter. It is a safe way to guarantee good exposure.

Use any system to determine exposure. If the recommended f-stop and shutter-speed combination is f 8 at 1/60, take an exposure at that setting, but also take an exposure allowing twice as much light to reach the film — f 5.6 at 1/60 or f 8 at 1/30 — and an exposure allowing half as much light — f 11 at 1/60 or f 8 at 1/125.

Bracketing produces several different exposures of the same image. At least one exposure should be ideal.

Bracketing is not always practical, such as with candid or moving subjects, so do not approach it as a crutch. Learn to expose well, and bracket only when practical and with especially important pictures.

Expose for the shadows and compensate. A more exact system for exposing film is to take the meter reading in a dark shadow area of the subject and then make an adjustment to that reading. The area should be the darkest part of the subject where detail is desired in the final print.

Bracketing exposures

The first negative was made with an exposure taken directly from the meter's recommendation — f 8 at 1/125. The second negative was taken with an exposure the equivalent of one f-stop more — f 5.6 at 1/125, and the third negative was taken with an exposure the equivalent of one f-stop less — f 11 at 1/125.

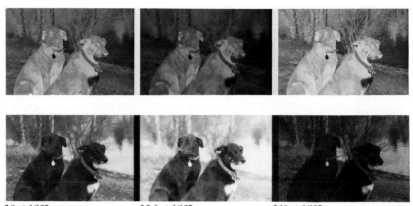

f 8 at 1/125 f 5.6 at 1/125 f 11 at 1/125

The rule-of-thumb is:

**Take the meter reading in the darkest shadow area
and expose for the equivalent of two f-stops less.**

Let's say a dark sweater represents the deepest shadow area where detail is desired. Read off the sweater only. (A spot meter would be helpful.) Suppose the meter indicates f 2.8 at 1/60. Use instead an exposure of two f-stops (or the equivalent) less, such as f 5.6 at 1/60, f 4 at 1/125, or f 2.8 at 1/250.

If the darkest areas of the subject are not particularly dark, the adjustment should be one stop, rather than two. In the above example, use f 4 at 1/60 or f 2.8 at 1/125.

Meter readings off dark areas always suggest too much exposure. Since little light is reflecting back from the shadows, the meter recommends allowing a lot of light in. Therefore, if the shadow area reading is used without adjustment, the silver buildup on the negative will be too dense. By exposing for less light, the amount of silver is reduced, so the shadows will be thin on the negative, but just dense enough to render detail. In other words, the shadow density will be exactly what it should be.

The corrected exposure should guarantee a negative with properly exposed shadows. When the shadows are exposed correctly, the gray and highlight areas should fall right in place, because they will always be rendered as denser than the shadow areas. After all, they reflect more light back to the film than the shadows.

Meter for the shadows

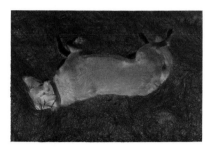

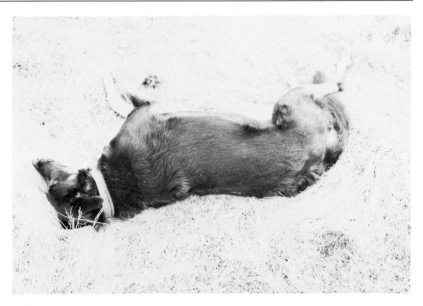

A negative made with an exposure taken in the shadow area of the subject — f 8 at 1/60 — is overexposed. It is too dense.

A print from that negative.

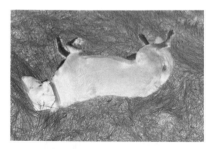

A negative made after exposing for the equivalent of two f-stops less exposure than above — f 16 at 1/60 — is correctly exposed.

A print from that negative.

Problem Exposure Conditions

Difficult lighting conditions can make any exposure system less accurate. Here are solutions to three common problems:

A backlit subject. The subject is *backlit* if the primary light source (such as the sun or a lamp) is aiming at the front of the lens and in back of the main subject. Backlighting causes the subject to be in shadow. Instructions with simple cameras say "stand with your back to the sun to take a picture." This is to avoid backlighting.

A general reading will reproduce the existing lighting. Because the subject is in shadow, it is dark and will lack detail. Sometimes backlighting is desirable because it renders the subject in silhouette or evokes an interesting, mysterious feeling.

However, if good subject detail is needed, the meter reading must be adjusted. Add the equivalent of one or two f-stops to the meter reading (depending on how dark the subject is) to guarantee good subject detail. Say the subject is a man, lit by the sun from behind, and the meter recommends f 8 at 1/125; use instead f 8 at 1/60 or f 5.6 at 1/125. If the sun is especially bright, the man will be especially dark, so add the equivalent of another f-stop of exposure, such as f 5.6 at 1/60 or f 4 at 1/125.

Backlighting

Left:
A subject lit from behind is exposed at the meter reading of f 11 at 1/125. It is in shadow.

Right:
The same subject has greater detail when exposed for the equivalent of two f-stops more exposure — f 8 at 1/60. However, the background is now too bright.

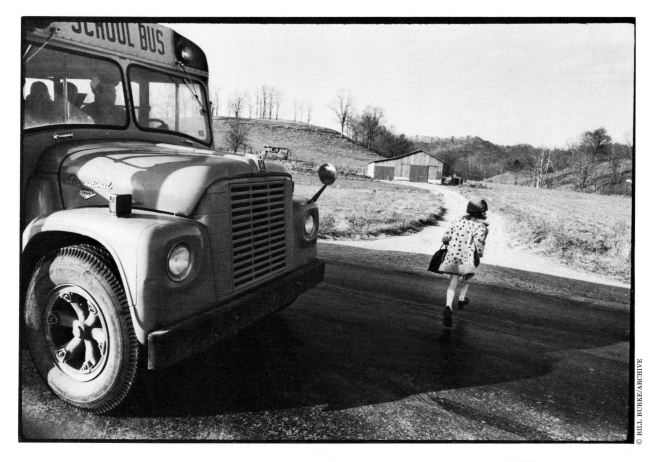

A subject in shadow

If the main subject (here, the girl) is in shadow, and the rest of the picture is in brighter light, add light to a general light-meter reading to guarantee that the main subject will be well exposed. This photograph was taken at an exposure of 1/250 at f 8, even though a general reading suggested 1/250 at f 11.

The problem with increasing exposure in this way is that the background may receive too much light, and become *blocked up* — too dense on the negative and too bright in the print. This problem can be compensated for by using a flash, developing the film for less time, or "burning in" the background during the printing process. These solutions are explained in subsequent chapters.

There is a form of backlighting that occurs when the main subject is in shadow and the background contains brightly lit areas. For example, if the subject is positioned under a tree, in shadow, and the entire image includes brightly lit areas around the tree, the subject is effectively backlit. If the bright background areas take up a small part of the picture, then a normal meter reading will probably be accurate. If the bright areas are more dominant, an exposure increase equivalent to one or two f-stops is needed.

Low-light conditions

Subjects in low light require a fast film, a slow shutter speed, and/or a wide aperture. Sometimes, additional exposure is required since light meters may underestimate the amount of exposure needed. This photograph was taken with 400 ASA film; the meter suggested 1/60 at f 2.8, but the exposure was made at 1/60 at f 2, just to be sure.

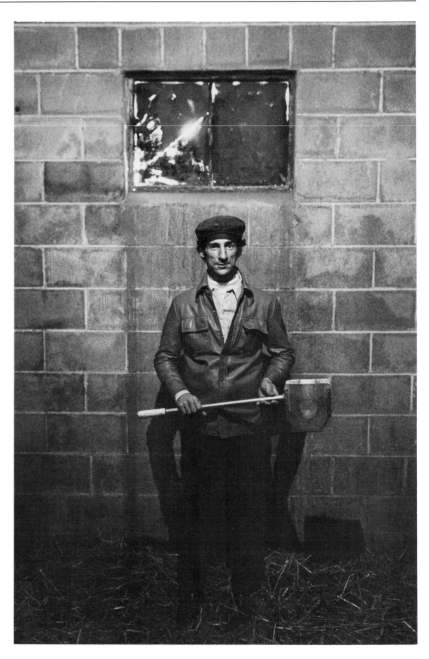

Low-light conditions. Photography in dim light is sometimes referred to as *available-light* photography, and causes a whole set of technical problems. The crux of the matter is how to capture what little light exists.

Inevitably, low-light photography requires a fast film, a slow shutter speed, and/or a wide aperture. As a result, the pictures will be relatively grainy. They may also be blurred and will probably have minimal depth of field. (Slower film can sometimes be used in a camera on a tripod with longer exposures to make less grainy pictures, possibly with greater depth of field.)

To complicate matters, light meters are least accurate under low-light conditions. They frequently underestimate the amount of exposure needed. Additional film development, known as "pushing film"

This picture was exposed at f 2 at 1/30, even though the meter recommended the equivalent of one f-stop less (f 2 at 1/60), to guarantee a good, printable negative.

Subject with mostly highlight areas

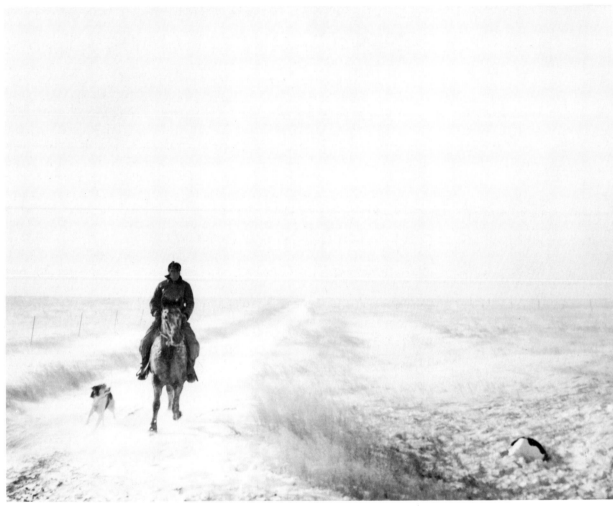

Subjects consisting of predominantly bright tonal values, such as snow or sky, frequently need more exposure than a general light-meter reading suggests. Take a general reading and add the equivalent of one or two f-stops of exposure.

(see chapter 7), can sometimes solve this problem. However, at other times, the light is simply too low and artificial light (such as flash) must be used.

There are few choices available when taking pictures in low light. A fast film, probably 400 ASA, is a must. The shutter speed has to be slow, with 1/30 or 1/60 the likely possibilities unless a tripod is used. The aperture must be wide open, say f 1.4, f 2, or f 2.8. Some combination of these shutter speeds and f-stops will work under many low-light conditions.

If possible, add the equivalent of one f-stop of exposure to the recommended meter reading. Here, overexposure is far better than underexposure because detail in the shadow areas is more likely to be preserved. Besides, indoor light is so variable (for example, a lamp in one place and total darkness in another) that some sort of backlighting is common, so more exposure is desirable. If the main subject is sitting on a couch in a low-lit room, and the meter reads f 2 at 1/60, use instead f 2 at 1/30 or f 1.4 at 1/60.

A subject with mostly highlight areas. If the subject has mostly highlights (such as brightly lit sky, sand, snow, or water), the meter will read too much reflected light and suggest too little exposure. The result will be an underexposed negative. To compensate, add the equivalent of one to two f-stops of exposure to the meter reading.

For example, if the subject is framed by a lot of bright sky and the meter reading is f 16 at 1/250, use instead f 11 at 1/250 or f 16 at 1/125. Extreme cases, such as a skier framed by brightly lit snow, may require still another f-stop of exposure.

CHAPTER 6

The Darkroom

FILM DEVELOPING

A photographic *darkroom* is simply a room with the equipment needed for developing film and making a print. Any room from which light can be blocked can be used, such as a large closet or a bathroom. Window light can be blocked out with dark shades or homemade plywood shutters.

Any table or counter top will hold the developing and printing equipment. Running water is ideal, but not required; water can be brought in and chemicals taken out of the room in pails.

The main problems with home darkrooms are with convenience, cleanliness, and fumes. For purposes of convenience, use space that is not normally used, such as an extra bedroom, a large closet, or a room in a basement. In this way, equipment can be kept in place and not have to be set up, then packed away after each use.

Darkrooms should be kept clean; however, some mess is unavoidable. Spilled chemicals, for example, can leave stains long after a cursory clean-up. Take special care to keep the darkroom area spotless, particularly if it doubles as a living area. Food preparation areas, such as kitchens and pantries, are not recommended for darkroom use.

Photographic chemicals have an unmistakable odor that some find unpleasant or physically irritating. The best darkrooms have ventilation systems. Since this is not practical in most home darkrooms, air out the room regularly. An open window helps, though a window fan is better. (Be sure the fan is aimed out a window or a door to remove the odor from the house, not displace it to another living area.) A darkroom located away from a general living area is best to control this problem.

Many communities have darkroom facilities open to the public or available for rent. Check local schools, universities, libraries, city halls, YMCAs or YWCAs. Try adult education programs or camera clubs. Camera store personnel may be able to provide information about such facilities.

A good rental darkroom eliminates the immediate problems of space, convenience, cleanliness, and odor. It is likely to be better

equipped than most home darkrooms. In addition, a group of interested photographers, with ideas and information to share, may gather around school, community, or rental darkrooms, and make the darkroom time more informative, interesting, and fun.

Equipment Needed

The following equipment is needed for film developing:

> **reel and tank**
> **thermometer**
> **scissors**
> **can opener**
> **clothespins and string**
> **graduates or measuring containers**
> **storage containers**
> **funnel**
> **photo sponge**
> **timer**
> **stirring rod and containers**
> **rubber gloves**
> **negative envelopes**
> **changing bag (optional)**

Reel and tank. Since film is light-sensitive, it must be processed in total darkness. A roll of film is loaded in the dark onto a spiral *reel*, and the reel is placed in a light-tight *processing tank*. The top of the tank contains a *light trap*, an opening that allows developing chemicals to be poured in and out while keeping out light.

Reels and tanks are made of either plastic or stainless steel. Stainless steel is more durable, but some find the reel difficult to use. Plastic reels are easier to use and most models are less expensive.

Reels are sold according to film size, such as 35-millimeter and 120. Stainless reels are made for one size film only. Some models of plastic reels are adjustable and can be used for different film sizes.

Processing tanks can be purchased in sizes that hold one or more reels, thus saving time when processing several rolls of film. Two rolls can be developed at once in a 2-reel tank; 4 rolls can be developed in a 4-reel tank.

Thermometer. The temperature of processing chemicals is critical and must be monitored regularly. For this purpose, a good photographic thermometer is a must. Most models have a wide temperature range (such as 30° to 120° F), and will measure solutions accurately within 1°.

Scissors. A pair of sharp scissors is needed to cut film.

Processing reel and tank

Light-tight tank with spiral reel in-
side. The film is loaded onto the reel
in the dark and placed in the tank.
The lights can then be turned out.
Chemicals are poured into the top of
the tank, which has a light trap to
allow liquids in and keep light out.

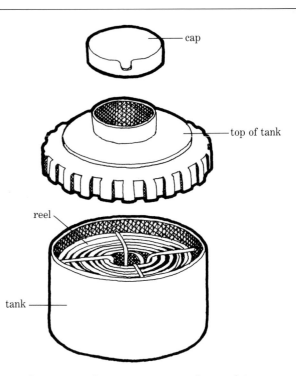

Can opener. A common beer-can opener is used to pry open 35-
millimeter film cassettes.

Clothespins and string. Spring-type clothespins and string can be
used for hanging processed film to dry.

Graduates. Either glass or chemical-resistant plastic graduates or
measuring containers are needed to measure processing solutions. At
least one large (32 to 64 ounce) and one small (about 6 to 10 ounce)
graduate are necessary. The small one should be capable of accurately
measuring 1 ounce or less of solution.

Storage containers. Some photographic solutions are sensitive to
light or air, so storage containers should be dark and kept filled to
capacity. Plastic storage bottles can be squeezed when partially filled
to remove excess air. All containers must be resistant to chemical
contamination.

Funnel. A funnel is helpful for pouring solutions into storage bottles
with thin necks.

Photo sponge. A special photo sponge (or chamois cloth) is used for
wiping wet film after it is hung to dry.

Timer. Developing procedures must be carefully timed, so a timer that accurately measures both minutes and seconds is needed. Special photographic timers are preferable, but a clock or a watch with a second hand will do.

Stirring rod and containers. To mix chemical solutions, use a stirring rod and container. Special stirring rods are available, but a thermometer will also work. The container can also be a graduate or a storage container with a wide opening.

Rubber gloves. Any pair of plastic gloves will protect skin when mixing and handling photographic chemicals, and minimize potential physical reactions to the chemicals. Some people develop skin allergies to processing solutions; others experience dry or chafed skin.

Negative envelopes. Once negatives are processed and dried, they should be protected from damage. Several types of protective envelopes are available. Clear plastic envelopes are excellent, especially for long-term storage, but they are expensive. *Glassine envelopes* made of a translucent paper are less expensive and commonly used.

Changing bag. When a darkroom is unavailable, film can be loaded onto a developing reel by using a *changing bag.* These bags are black sacks that have two holes for arms. The holes allow the entry of film, reel, and processing tank, but keep out light.

Negative envelopes

Translucent glassine envelopes that hold individual strips of film.

Clear plastic envelopes that hold an entire roll of film.

Chemicals Needed

Several chemicals are needed for film processing, and many different brands of each chemical are available. There is a list of most brand names in Appendix Four.

Chemicals are packaged in either powdered or liquid form. The powder must be mixed with water to make a *stock solution* — the form in which chemicals are generally stored. Chemicals that come packaged as liquids are essentially premixed stock solutions. They are more convenient and easier to use and store than powdered chemicals.

Most stock solutions must be diluted with water before use. The usable form of the chemical (whether diluted or undiluted) is called a *working solution*. Most stock solutions store for a longer time than working solutions, though many working solutions can be stored and reused for a while if bottled in dark, filled containers.

These are common film-developing chemicals, followed by descriptions of their functions:

film developer
stop bath
fixer with hardener
fixer remover
wetting agent

Film developer. The primary processing chemical is the *developer*, which reacts with the film to make the latent image visible. The developer works to bind together only the exposed silver crystals and turn them into clumps of dark metallic silver. The greater the film exposure, the denser the silver.

Many different brands of film developers are available, each claiming its own characteristics. For example, some developers work to produce negatives with finer grain than others, while some produce negatives with greater contrast than others (more on contrast later).

Despite their different characteristics, all developers do develop film. Poor negatives are rarely caused by the type of developer used. More likely causes are:

inaccurate film exposure
improper loading of film onto the reel
chemicals mixed incorrectly
wrong processing temperatures or times

Most common negative problems, probable causes, and solutions are listed in Appendix Three.

Stock solutions of developer are prepared and used in different ways, depending on the brand. Some must be diluted with water, while others can be used undiluted. Some develop film quickly, while

others take much longer. "One-use" developers are used one time only, then thrown out; others can be replenished and reused.

A *replenisher* is a chemical used to extend the useful life of a developer. It replaces those chemical components of the developer that are used up during the processing.

The developing time is determined by several factors including the type of film, the type of film developer, the dilution of that developer, and the temperature of the solution. A *time-temperature chart* is provided with most packages of film or developer. (If not available, inquire at a camera store or contact the manufacturer of the film or developer for a chart.) Here is a sample time-temperature chart:

Film type: Kodak Tri-X **Film developer:** Kodak D-76 **Developer dilution:** 1 part D-76 to 1 part water	
Temperature	**Time**
65° F	11 minutes
68° F	10 minutes
70° F	9½ minutes
72° F	9 minutes
75° F	8 minutes

So if the temperature of the diluted developer solution is 70°, the developing time is 9½ minutes. If the temperature of the developer falls between the temperatures listed, adjust the developing time accordingly; at 71°, the developing time is 9¾ minutes.

Stop bath. Developer continues to develop film until it is neutralized by a *stop bath*, which usually consists of a plain water rinse or a mild solution of acetic acid. An acid stop bath helps preserve the useful life of the following bath — the fixer — which is a far more expensive solution than "stop."

Packaged stop baths have different ingredients and must be diluted for use according to the manufacturers' instructions. Plain acetic acid is packaged in liquid form and generally available in two strengths — 28% and 99%. The 28% acid makes a good stock solution. The 99% acid is so strong that it should be diluted for safe storage and use.

To dilute the 99% acid to a 28% stock solution, add 3 parts of 99% acetic acid to 8 parts of water (for example, 9 ounces of 99% to 24 ounces of water makes 33 ounces of 28% acid). The fumes are very strong. Avoid breathing them directly when mixing.

The 28% stock solution must be diluted down to a milder acid for use as a working solution of "stop." To do so, mix 1 part of 28% acid to 20 parts of water: for example, 2 ounces of 28% to 40 ounces of water, for 42 ounces of working solution.

Stock solutions of acetic acid will store for a long time. Working solutions can be used for several rolls of film; 1 quart can develop about 20 rolls of 36-exposure, 35-millimeter film. Some manufacturers sell an indicator stop bath that changes color when exhausted.

Fixer. After the stop bath, film must still be protected from light or the unexposed silver will become exposed and darken. *Fixer* (or *hypo*) removes the unexposed silver from the film and allows the film to be viewed in room light.

The terms hypo and fixer are sometimes used interchangeably. Actually, hypo is the primary fixing agent, but most fixers consist of other chemicals as well.

Fixer comes packaged in either a powdered or liquid form. Powdered fixers act in 5 to 10 minutes; most liquid fixers are rapid fixers, and require less than half as much processing time.

Film fixers should contain a *hardener*, a chemical that toughens the film emulsion and makes it more scratch-resistant. Most powdered fixers contain a hardener, while a separate hardening solution, generally packaged with the fixer, needs to be added to most liquid fixers.

Fixer can be stored and reused for several rolls of film. One quart of working solution of fixer, properly stored, can be used for about 20 rolls of 36-exposure, 35-millimeter film.

The fixing time should be extended as the fixer becomes used. If in doubt about the freshness of a solution, squeeze a few drops of a chemical called *fixer check* (or *hypo check*) into the used fixer solution. If a white precipitate forms, the fixer has gone bad and fresh fixer should be used.

Fixer remover. Fixer must be washed out of the film or it will eventually cause the film to deteriorate. However, a long water rinse is required to do an adequate job of washing. A quicker and better wash is possible with a presoak in a *fixer remover.* Fixer remover (also called *hypo remover, clearing bath, hypo eliminator,* and other names) converts the fixer in the film into a compound that is easy to wash out, thus providing a quicker and more efficient wash than a plain water rinse.

Use a fixer remover after the fixer for a short time (about 2 minutes with most brands). Then rinse the film with constantly changing running water for approximately 5 minutes. Fixer remover can be reused for approximately half the amount of film as fixers.

Wetting agent. When the film is washed and hung to dry, water may cling to its surface and leave streaks or spots. A brief treatment in a solution of *wetting agent* reduces the surface tension of the film, and allows water to flow more rapidly from the film without clinging to it. The stock solution of wetting agent is highly concentrated and must be diluted heavily with water for use.

Setting Up the Chemicals

Processing film is a straightforward procedure. Three solutions — developer, stop bath, and fixer — do all the important processing work. The rest of the steps involve washing and drying the film.

Each brand of chemical is prepared differently, so check the package for specific instructions. For example, a 1-quart package of powdered film developer must be mixed with enough water to make a total of 1 quart of stock solution of developer. The instructions on the box may say: "To use the developer, mix 1 part stock solution with 1 part water." Such a package would yield 1 quart of stock solution but 2 quarts of working solution of developer.

Before starting the process, set up three containers of working solutions — one each of developer, stop bath, and fixer. Graduates make excellent containers for this purpose. Be sure to mix enough of each solution to fill the processing tank fully. Most 1-reel tanks hold approximately 8 ounces of solution; 2-reel tanks hold about 16 ounces.

Film can be processed with solutions measuring over a wide range of temperatures. The ideal is 68° to 70° F, though 65° to 75° is usually acceptable. The higher the temperature of the solutions, the quicker the processing times. However, warm or hot solutions, particularly when coupled with great temperature variation from solution to solution, can lead to excess negative graininess or *reticulation* (a condition that appears as cracks in the film emulsion).

Setting up the chemicals

Before starting, set up three containers of working solutions of developer, stop bath, and fixer.

developer stop bath fixer

All processing solutions used for the same batch of film should be close to the same temperature, though this is not always possible. There are many ways to maintain equal temperature. When mixing stock solutions with water, measure the temperatures constantly and

Reticulation

Hot or variable film-processing solutions can make the film emulsion appear cracked.

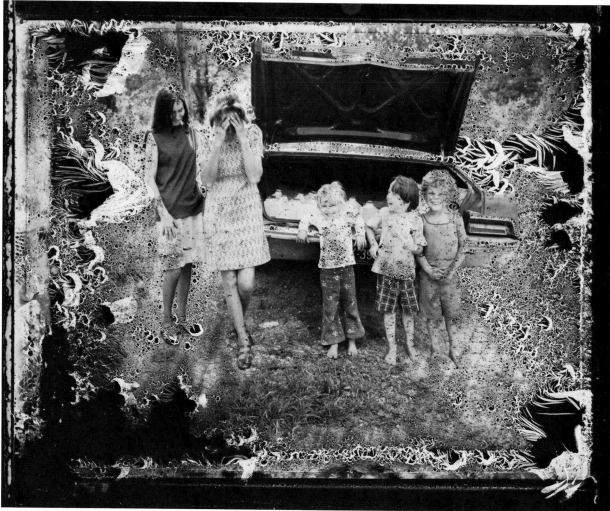

© BILL BURKE/ARCHIVE

adjust each by using hot then cold water. Powdered chemicals frequently need to be mixed with hot water to make a stock solution, so will need extra time to cool down. After mixing, let the solutions stand unused for a while until they all reach the same temperature. Or place all the containers of working solution in a tray or dishpan filled with water at 70° to help even out the temperatures.

Like any chemical, processing solutions should be handled with caution. Read the hazard warnings printed on chemical packages. When mixing and using the chemicals, avoid inhaling the fumes as much as possible. Process by an open window or use a fan to exhaust fumes from a room (many bathrooms and kitchens have built-in exhaust fans). Take all reasonable precautions.

In addition, use rubber gloves when handling chemicals to protect skin. Rashes and other skin irritations are common enough to warrant concern.

Loading the Film

The hardest part of the film-developing process can be loading the film onto the spiral developing reel. Once loaded, the reel is placed in a processing tank, and the chemical solutions poured in and out until the film is fully processed.

The reel is used to guarantee that the chemical solutions reach all parts of the film evenly. When properly positioned on the reel, no section of the film touches any other section.

The tank is a light-tight container that holds both the film (on the reel) and the processing chemicals. Processing tanks consist of a container and a cover. The cover fits tightly on the container. It incorporates a light trap so that processing solutions can be poured into the tank through an opening on top of the tank cover without letting in light. The opening can then be closed off with a cap on most models of tanks.

The film must be loaded onto the reel in total darkness (or inside a changing bag), since it is sensitive to light. Be sure to practice with an unexposed roll of film in room light before trying to load exposed film for the first time. It is a difficult and awkward process.

Step inside a darkroom and lock the door, if possible, so that no one will enter inadvertently and expose the film. Shut off the room lights and check for light leaks. If there are leaks, close them off with whatever is available, such as tape and cardboard or towels.

The steps for loading film onto a reel are as follows:

1. *Remove the protective cover.* For 35-millimeter film, use a can opener to pry open the flat end of the metal cassette. (The other end

has a spool sticking out of it and is more difficult to pry open.) Then pull the film out of the cassette, and toss the cassette aside. The film is wound tightly on a spool, so tends to unravel rapidly once out. To keep the film from unraveling, cup the ends of the spool in the palm of one hand.

Roll film, such as 120 size, is packaged along with a protective paper backing. This backing protects the film from exposure. The film and the backing must be separated for loading the film onto the reel. To do so, slit the tape on the outside of the paper, and slowly start to unroll the backing. The film will roll out naturally, independent of the backing. Once loaded on the reel, the film must be detached from the backing by removing the tape that holds them together.

2. *Cut the leader.* The loading process requires that the end of the film be straight. At the beginning of a roll of 35-millimeter film there is a curved *leader* that must be cut off with scissors before the film can be loaded onto the reel. Try to keep the edge as straight as possible. This step is unnecessary with 120 and other roll films, since they come packaged with a straight end.

3. *Roll the film onto the reel.* This procedure varies with the type of reel used. The aim is to lay the film into the grooves of the spiral so that no part of the film touches any other part of the film. Touching sections will not develop fully.

Stainless-steel reels consist of two spiral, wire disks with their centers attached to each other by a wire post. The disks contain grooves that hold the film.

(These instructions assume that a right-handed person is loading the film. Left-handed people should reverse the directions as they refer to "left," "right," and "clockwise.")

The reels work only in one direction. To identify that direction, place the reel upright on a table or counter. Both spiral disks have a prong (or flat edge) at their outside point, where the spiral ends. These prongs should point to the right (remember, to the left for left-handed people), or the film cannot be rolled correctly onto the reel.

To roll the film, hold the reel in the left hand. It is easier if the reel is placed on a table or counter top to steady it. With the right hand, place the straight end of the film directly into the center of the reel. The center post has some sort of clip, wire, or other device to hold the film in place. The film should be pinched ever so slightly between the thumb and forefinger as it is put into the center of the reel. (The film is the same width as the distance between the spiral disks, so it must be curved slightly to enter properly.) Try to avoid touching the film anywhere but on its edges.

Loading the film onto the reel

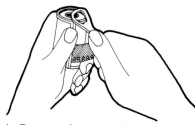

A. Remove the protective cover. Here, a can opener is used to pry open the metal cassette that holds a roll of 35-millimeter film.

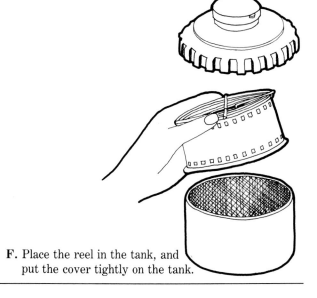

leader

B. Cut off the film leader. Make sure the cut is straight.

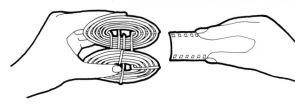

C. Begin to roll the film onto the reel. Keep the film pinched slightly between the thumb and forefinger.

D. Turn the reel counterclockwise, and it will pick up the film and load almost automatically.

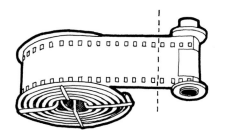

E. Cut the end of the film off its spool.

F. Place the reel in the tank, and put the cover tightly on the tank.

Once the film is firmly set in the center of the reel, turn the reel counterclockwise (clockwise, if left-handed). The first turn is most important to guarantee that the film is aligned correctly in the reel. Once that turn is made, keep the reel on the table and continue to turn it counterclockwise. Make sure the film remains pinched in the same curved position, and move only the reel. It is not necessary to move the film, since the turning reel will pick up the film smoothly. Keep reel, film, and hand as steady as possible. Each edge of the film will fall properly into separate grooves on the spiral.

Plastic reels load more easily. These reels consist of two spiral disks that contain grooves and connect to each other in the center by a tube. Each disk moves independently back and forth on the tube, like a ratchet. The straight edge of the film is loaded from the outer edge of the spiral disks, rather than from the center of the disks as with stainless-steel reels. Both disks have slotted openings on their outer edges; these openings should be lined up to allow the film to enter the grooves.

Place the film in the plastic grooves, under the ball bearings located at the outer edge of the spiral. Then turn the reel back and forth with both hands and the film will "catch" and move toward the center of the reel. One disk moves back, while the other moves forward in an alternating pattern. The reel neatly picks up the film, and loads almost automatically.

Work slowly and steadily. Do not try to rush the loading process. Also, make sure the reel is completely dry before loading. Wet reels are difficult to load.

In the dark, an experienced hand can usually feel when the loading is going wrong. The film will move unsmoothly to one or the other side of the reel; or it will bend too much. An edge of the film may crinkle and cause the film to jump a groove. Or, on a plastic reel, it may get stuck and not move at all. If it feels wrong, do not continue loading the film. The problem is likely to get worse. Stop, unwind the film, and try again.

4. *Cut off the end.* Once the loading is completed, the film must be cut off from its spool. It is held on the spool by a piece of tape. Take a pair of scissors, and make the cut as close to the spool as possible to keep from cutting off exposed film by mistake.

5. *Place the reel in the tank.* Place the loaded reel in the processing tank and put the cover tightly on the tank. If the cover is the type that screws onto the tank, be sure it screws on straight.

The room lights can now be turned on, and the developing process started.

Summary: Film Processing*			
Step	**Time**	**Comments**	**Capacity****
1. Developer	Varies; refer to time-temperature chart.	Monitor temperature carefully; 68° to 70° is best, but range of 65° to 75° is acceptable; agitate by rotating and inverting tank for first 30 seconds, then for 5 seconds of every 30 seconds thereafter.	"One-use" type should be discarded immediately after use; others can be replenished and used for many rolls.
2. Stop bath	15 seconds	Agitate constantly; use a mild acetic acid or plain water rinse at same temperature as developer.	20 rolls of 36-exposure, 35-millimeter film per quart of working solution, if using an acetic acid bath; otherwise, change water with each batch of film developed.
3. Fixer	5 to 10 minutes with regular fixers; 2 to 4 minutes with rapid fixers.	Agitate for half the fixer time; use at same temperature as developer.	20 rolls of 36-exposure, 35-millimeter film per quart of working solution.
4. Fixer remover	2 minutes	Optional step, but highly recommended; agitate for half the fixer-remover time at same temperature as developer.	10 rolls of 36-exposure, 35-millimeter film per quart of working solution.
5. Wash	5 minutes if treated first in fixer remover; 20 to 25 minutes if not treated in fixer remover.	Use constantly changing water at same temperature as developer; pour out water from tank periodically to guarantee a water change; keep film on reel and in tank during wash for maximum efficiency.	
6. Wetting agent	30 seconds	Do not agitate; use at same temperature as developer; keep film on reel and place reel in wetting agent.	Many rolls; discard periodically.

* These times and capacities are intended as guidelines. They vary according to the brands used and the conditions of use. Refer to manufacturer's instructions before proceeding.
** A roll of 36-exposure, 35-millimeter film is approximately equal to 2 rolls of 20-exposure, 35-millimeter film, 1 roll of size 120 film, and 2 sheets of 4″ × 5″ film.

The Developing Process

Chemical solutions are poured in and out of the processing tank in the following order: developer, stop bath, and fixer. The processed film is then washed, preferably with a fixer remover and a short water rinse. Finally, the film is treated with a wetting agent and hung up to dry.

Read over these steps until totally familiar with them before beginning. This process needs to be timed, and should move smoothly from step to step, so make sure all of the solutions and containers are easily accessible. Follow these steps:

1. *Take the temperature of the developer, and determine the correct developing time* at that temperature by referring to the time-temperature chart for that developer/film combination. For best results, keep solution temperatures as constant as possible throughout all the processing steps, including the water wash.

2. *Pour the developer into the processing tank,* holding the tank at an angle to facilitate pouring. Start timing the development as soon as all the developer is in the tank.

3. *Gently tap the bottom of the tank against a table, counter, or sink* to dislodge any air bubbles that may have formed in the solution. If the tank has a cap, cover the opening with it. (The cap must be removed and replaced with each step.)

4. *Agitate the tank* for the first 30 seconds of development. To agitate, gently rotate the tank in a circular direction, then invert it. Repeat the rotation and inversion for the full 30 seconds. (Some plastic tanks have no caps on the top, so should be rotated only and not inverted to keep the solution from spilling out.) When the 30 seconds are up, stop agitating. For the remaining time in the developer, agitate the tank for about 5 seconds out of every 30 seconds. Over-agitation can cause the film to become overdeveloped or streaked at its edges.

5. *Start pouring the developer out of the tank* approximately fifteen seconds before the developing time is up. If the developer is a "one-use" type, discard the used solution. If it is reusable, store the solution in a clean bottle and mark it "used developer." After the film has been processed, replenish the used developer with a replenisher solution according to the directions packaged with the replenisher.

6. *Pour the stop bath into the tank* as soon as all of the developer is poured out. Use either a plain water or mild acetic acid bath.

7. *Agitate the tank* continuously for a total of 15 seconds, rotating and inverting the tank, as described in step 4.

8. *Pour out the stop bath* just before the 15 seconds are up, and save the solution for reuse.

9. *Pour in the fixer.*

The film-developing process

Take the temperature of the developer.

Pour the developer into the tank.

Tap the tank gently to dislodge air bubbles.

Agitate the tank by rotating it and inverting it for the first 30 seconds of development, and 5 seconds of every succeeding 30 seconds.

Pour the developer out of the tank.

A running-water wash. The film is still on the reel and the reel is still in the tank.

Hang the film to dry. Place a clothespin on the bottom of the film to keep it from curling. (Optional) Wipe the film with care, using a photo sponge or chamois soaked with diluted wetting agent.

10. *Agitate the tank* for at least one-half the recommended fixing time. Most regular fixers work in 5 to 10 minutes; rapid fixers work in 2 to 4 minutes.

11. *Pour out the fixer* and save it for reuse. (Before reusing the fixer, test its usefulness with a fixer-check solution.) Once the time in the fixer bath is up, the reel can be removed and the film unwound for viewing. Unwind only a few frames, and handle the wet negatives with care. Rewind the film onto the reel before proceeding to wash the film.

12. *Add a fixer-remover solution* to help facilitate the film-washing process. The time is generally about 2 minutes, depending on the brand of fixer remover used. Agitate for at least half that time. Some manufacturers recommend a short water wash prior to treatment in the fixer remover.

13. *Pour out the fixer remover.* Some brands can be stored and reused.

14. *Wash the film* by removing the top of the processing tank, and allowing water to run directly into the tank. Keep the film on the reel and in the tank for best results, so all parts of the film are washed with equal efficiency. Pour out the water in the tank every 30 seconds or so to guarantee a complete change of water. A plain water wash takes about 20 to 25 minutes. A wash preceded by a fixer remover takes about 5 minutes and washes the film more thoroughly.

Keep the temperature of the wash water as constant as possible, consistent with the processing temperatures, ideally at 68° to 70° F. If the water temperature from the faucet varies significantly, fill a bucket of water at the same temperature as the processing solutions. Then pour water from the bucket into the open tank, close up the tank, and agitate for 30 seconds. Pour out the water, refill the tank from the bucket, cover and agitate the tank for 30 more seconds. If treated first in a fixer remover, the film should receive a thorough wash — at a constant temperature — with a total of ten changes of water.

15. *Pour the wash water out of the tank* once the wash is complete.

16. *Take the developing reel out of the tank and place it gently in a container of diluted wetting agent.* Do not agitate. It may cause streaking on the surface of the film. Keep the film in the wetting agent for approximately 30 seconds.

17. *Take the reel out of the wetting agent, carefully remove the film from the reel, and hang the film to dry* in a dust-free environment. Handle the film by its edges to avoid damaging it as wet film is especially susceptible to gouging and scratching. Use a spring-type

clothespin to hang the film from a taut piece of string hung like a clothesline. Place another clothespin on the very bottom of the film to keep the film from curling.

18. (Optional) *Gently wipe the film from top to bottom on both sides with a photo sponge or chamois*, soaked with diluted wetting agent. This helps the film to dry more quickly and with less streaking. Be sure the sponge or cloth is clean, or it might scratch the film. Film takes about 1 to 4 hours to dry, depending on the temperature and humidity of the environment.

19. *Store the film as soon as it dries* to keep it clean and scratch-free. Carefully cut the roll of negatives into strips of five or six frames each (depending on the size of the storage envelopes used), and slip the strips into protective envelopes, one strip in each. Use either plastic or glassine envelopes.

CHAPTER 7 | THE NEGATIVE

A good negative is the key to a good print. Well-exposed and well-developed negatives print easily, while poorly exposed and poorly developed negatives print with difficulty. In most cases, average film exposure and normal development produce highly printable negatives, but sometimes manipulation of exposure and development can produce even better negatives.

The basics of film exposure and development have been covered. Now it is important to understand how negatives can be further controlled, manipulated, and evaluated. This chapter covers these issues.

Adjusting Negative Contrast

Contrast is the difference between highlight and shadow areas. *High-contrast* subjects have dark shadows and bright highlights, such as occur on a bright, sunny day, and are said to be *hard*. Normally exposed and normally developed negatives taken in this kind of lighting will also be high contrast and produce prints of high contrast.

Low-contrast subjects are gray, lacking either very dark shadows or very bright highlights, such as on cloudy days or with shaded light, and are said to be *flat*. Normally exposed and normally developed negatives taken in flat light will be low in contrast and produce low-contrast prints.

Negative contrast can be controlled by manipulating film exposure and development. The key to this control is understanding how exposure and development work.

The shadow areas of the negative are controlled by exposure — the amount of light that reaches the film. The highlight areas are affected by exposure but controlled primarily by the developing time — the amount of time the film is allowed to react with the developer. Thus the rule of thumb:

**Expose for the shadows;
develop for the highlights.**

The shadows represent areas of little exposure. Dark parts of a subject reflect less light back to the film than bright parts of a subject.

Subject lighting

High-contrast subjects have dark shadows and bright highlights.

Low-contrast subjects are gray, with neither dark shadows nor bright highlights.

© ALLEN HESS

Because they receive so little light, the shadows form much more rapidly on the negative during development than do highlights. If the normal developing time for a roll of film is 10 minutes, then the shadows form fully in about half that time, or 5 minutes. The remaining 5 minutes of development affect mostly the highly exposed areas — the highlights.

**The longer the developing time,
the denser the highlights.**

Shadows, because they are determined by the film exposure, are not affected much by changes in developing time. If the film is developed for 15 minutes, rather than 10 minutes, the highlights continue to become denser. The shadow density still does not change appreciably (it is already fully formed), so the increased development means a change in the difference between the highlight and shadow density. This difference — or the contrast — becomes more pronounced, so:

**The longer the film developing time,
the greater the contrast of the negative.**

If the developing time is shortened, say to 7 rather than 10 minutes, the highlight areas become less dense. Since the shadow density would still remain constant, the difference between the highlight and shadow density is reduced, and the contrast of the negative is decreased.

**The shorter the film developing time,
the lower the contrast of the negative.**

So the contrast of the negative can be controlled by changing the amount of time the film is kept in the developer. More time increases the contrast; less time decreases the contrast. However, negative contrast can be altered even more dramatically by manipulating both film exposure and development.

**To decrease contrast: overexpose and underdevelop the film.
To increase contrast: underexpose and overdevelop the film.**

In most cases, all that is needed is a minimal exposure and development adjustment. Each film-and-developer combination works a little differently, but here are some general guidelines:

**To reduce contrast:
Overexpose by the equivalent of one f-stop and underdevelop by 20%, or in extreme cases:
Overexpose by the equivalent of two f-stops and underdevelop by 40%.**

The longer the film developing time, the greater the contrast of the negative

All three negatives were exposed for the same length of time. Note that the shadow areas of all three have approximately the same density, regardless of development times. Only the highlight areas are appreciably affected. The greater the development time, the denser the highlights and the greater the contrast.

A negative developed for 10 minutes, the manufacturer's recommended time.

A negative developed for 6 minutes.

A negative developed for 20 minutes.

A print from that negative.

A print from that negative. Note the decreased contrast.

A print from that negative. Note the increased contrast.

To increase contrast:
Underexpose by the equivalent of one f-stop and overdevelop by
50%, or in extreme cases:
Underexpose by the equivalent of two f-stops and overdevelop by
100% to 150%.

Of course, one of the problems with manipulating film development is that an entire roll of film must be under- or overdeveloped, so try to shoot all the frames on the roll in similar lighting conditions. Otherwise, develop for the frames that are most important, and accept the fact that the rest of the roll will be under- or overdeveloped. (A major advantage of sheet film is that each sheet can be developed separately, at different times, for different contrast requirements.)

Here are some specific examples of changing film exposure and development:

Overexpose and underdevelop. On a bright, sunny day, the lighting is high contrast. The shadow areas of the subject will be quite dark and the highlights will be especially bright. In order to decrease this contrast, overexpose and underdevelop the film.

With high-contrast light, dark (shadow) areas of the subject are rendered thin (lacking in density) on the negative because relatively little light is reflecting back to the film from these areas. Extra film exposure is needed to build up the density to render more shadow detail. So overexpose the negative.

If the meter indicates an exposure of f 16 at 1/500, overexpose by the equivalent of one f-stop: f 11 at 1/500, or f 16 at 1/250.

With high-contrast light, bright (highlight) areas of the subject are rendered dense on the negative because a lot of light is reflecting back to the film from these areas. When the film is overexposed, the highlights become even denser. Dense highlights can *block up*, or become so dark that they print with little or no detail.

To decrease highlight density, underdevelop the film. If normal developing time is 10 minutes, underdevelop by 20%, so develop for 8 minutes.

The resulting negative will have less extreme shadow and highlight density. As a result, it will print more easily and with less contrast than if normally exposed and developed.

Underexpose and overdevelop. In flat lighting, such as on a cloudy day or after a rainstorm, the lighting is low contrast with lots of grays and few (if any) very bright or dark areas. To increase this contrast, underexpose and overdevelop the film.

With low-contrast light, shadow areas of the subject are not very

Manipulating film exposure and development

A negative given normal exposure and development — f 8 at 1/125 — developed normally for 10 minutes.

Negative of the same subject that has been overexposed by the equivalent of one f-stop — f 5.6 at 1/125 — and underdeveloped by 20% — 8 minutes.

A negative of the same subject that has been underexposed by the equivalent of one f-stop — f 11 at 1/125 — and overdeveloped by 50% — 15 minutes.

A print from that negative.

A print from that negative shows decreased contrast.

A print from that negative shows increased contrast.

dark, so will be rendered too dense on the negative. To reduce that density, underexpose the negative. Less exposure means thinner shadows (which, in turn, will print darker).

If the meter indicates an exposure of f 8 at 1/125, underexpose by the equivalent of one f-stop: f 11 at 1/125 or f 8 at 1/250.

With low-contrast light, areas of the subject are not very bright, so will be rendered too low in density on the negative. When the film is underexposed, the highlights become even less dense.

To increase highlight density, overdevelop the film. If normal developing time is 8 minutes, overdevelop by 50%. Use 12 minutes.

The increased development will not appreciably affect the shadow detail (which is determined by exposure), but it will increase highlight density. Therefore, the difference between shadow and highlight density — the contrast — will increase, which will make for a more printable negative.

When film is to be overexposed or underexposed, it may be easier just to change the ASA setting on the meter, rather than try to remember to compensate with each exposure. For the equivalent of one f-stop more exposure, cut the ASA in half (400 to 200; 125 to 63; 32 to 16). The extra exposure is like assuming the film speed is slower, or less sensitive to light than it really is.

For one stop less exposure, set the meter at double the ASA rating of the film (400 to 800; 125 to 250; 32 to 64). Giving less exposure is like assuming that the film is faster, or more sensitive than it really is.

Some camera models have exposure compensation settings that make it easy to over- or underexpose quickly. Cameras with this feature have a dial with numbers such as +1, +2, −1, and −2. Each number represents the equivalent of one f-stop change. Set the dial at +1, and the film will automatically receive twice as much exposure; set the dial at −2, and the film will automatically receive the equivalent of two f-stops less exposure.

Pushing Film

Pushing film means overdeveloping to simulate increased film speed. For example, film rated at 400 ASA can be pushed to a rating of 800 or 1600.

In effect, pushing film is the same as underexposing and overdeveloping; however, the term is usually applied when shooting under low-light conditions. Generally, film is not pushed to increase negative contrast (though that is a result), but to render enough density on the

Pushing film

Because of the low-light conditions, to make this picture, the film was "pushed" — underexposed and overdeveloped.

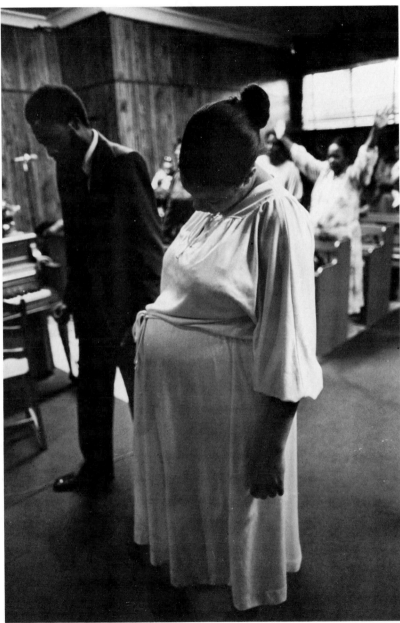

Pushing film

Both these negatives have been shot on 400 ASA film rated at 1600. At 400 ASA, the light-meter reading was f 2 at 1/15. At 1600 ASA, the reading suggested the equivalent of two stops less exposure: f 2 at 1/60. So, at this reading, the film is underexposed and must be "pushed" for enough contrast to make a good print.

A negative exposed at f 2 at 1/60 and developed normally for 10 minutes.

A print from that negative has low contrast.

Pushing film

A negative exposed the same way
— f 2 at 1/60 — but overdeveloped
by 100%, or 20 minutes.

A print from that negative has
higher contrast and prints more
easily.

negative for photographing in low-light situations, or to allow for increased depth of field or a faster shutter speed to meet the requirements of a picture.

Photographing in low light. When photographing indoors (or anywhere there is low light), it will be difficult to allow enough light to reach the film for a good exposure. The lens may be opened wide, say to f 2. The shutter speed may be set as slow as it can be (and still allow for hand-holding the camera), say to 1/60. Yet the light meter may still indicate that f 2 at 1/60 does not allow enough light in for a good exposure.

The solution is to "fool" the light meter by setting it at a higher film speed. For example, set 400 ASA film at 800. The higher number tells the meter that the film is faster, or more sensitive to light than it really is (by the equivalent of one f-stop), and therefore needs less exposure. At a rating of 800, the meter may indicate that f 2 at 1/60 will provide an adequate exposure. If so, take the picture at that setting, and overdevelop (or push) the film by 50%.

A major problem with pushing film is that the film will actually be underexposed. After all, increasing the ASA setting on the meter does not increase the sensitivity of the film to light. It just causes the film to receive less exposure. In low-contrast light, film may be underexposed deliberately to reduce shadow density, which might otherwise be rendered too dense in the negative. But under low light, chances are that the shadows will not be illuminated enough to register even adequate density on the negative. Therefore, in most cases, pushing the film reduces or eliminates shadow density (and detail) in the negative and ultimately in the print.

When pushing, the film must be overdeveloped to keep the negative from becoming so thin and flat (from the combination of low light and underexposure) that making a decent print is impossible. Added development means more highlight density, thus increased contrast for a more printable negative.

Allowing for more depth of field or a faster shutter speed. Even if a meter reading of f 2 at 1/30 at 400 ASA is adequate to make a well-exposed negative, f 2 might not provide enough depth of field for the subject. By pushing the film to 800, the lens can be closed down to provide more depth of field. Use f 2.8 at 1/30 at 800 ASA. If the film is pushed farther, the lens can be closed down again to f 4 at 1/30 at 1600 ASA.

If subject or camera movement, not depth of field, is the concern, push the film to make the shutter speed faster. Instead of f 2 at 1/30 at 400 ASA, try f 2 at 1/60 at 800 ASA, or f 2 at 1/125 at 1600 ASA.

The general underexposure and overdevelopment guidelines given earlier apply when pushing film. For example, to push 400 ASA film:

new film speed rating	underexpose by	overdevelop by
800 ASA	one f-stop or one shutter speed setting	50%
1600 ASA	two f-stops, two shutter speed settings, or one of each	100% to 150%

To push films with a rating other than 400 ASA, double the rating for each time the exposure is halved. For example, 125 ASA film, underexposed by the equivalent of one f-stop, should be rated at 250 ASA, then overdeveloped by 50%.

Obviously an entire roll of film must be pushed at the same time.

Special extra-active, "high-speed" developers are made for pushing film. These work by simulating increased development times, so that normal developing times with these developers are like increased times for normal developers. Follow the developing times provided with these developers, not the above guidelines for increasing development. Appendix Four provides a list of brand names of some of these products.

The following are potential disadvantages to pushing film:

· Shadow detail will be lost owing to underexposure.
· Contrast is increased owing to overdevelopment.
· Grain size is also increased owing to overdevelopment.

These should be considered before deciding to push a roll of film. However, since pushing film may make the difference between actually getting the picture and having to pass it up, these technical deficiencies may simply have to be accepted.

Grain

Grain refers to the tiny, sandlike particles visible in some prints. It is an inherent part of film emulsions, and is caused by the clumping together of silver crystals after film is exposed and developed. Grain is small and not really noticeable in the negative, but it is magnified and sometimes quite obvious in an enlarged print.

In general, grain is not desirable. It tends to make the image appear less sharp and clear. However, sometimes grainy photographs are effective; they can seem soft, fuzzy, or even romantic. In these specific cases, coarse grain can be used as a tool, but it should be used sparingly.

Some negatives have *fine grain*, barely noticeable, while others have *coarse grain*, obvious and obtrusive. Here are some of the many factors that affect how grain appears in the final print:

film used
film developer used
negative density
processing temperatures
enlargement
negative size

Film used. The faster the film speed, the coarser the grain structure. A film rated at 400 ASA is useful in low-light situations, but expect negatives with coarser grain than when using film rated at 32 ASA.

Film developer used. Most manufacturers classify their developers according to whether they produce fine, moderate, or coarse-grained negatives. All other factors being equal, fine-grain developers produce negatives of the finest grain. Some fine-grain developers produce finer grain than others.

Grain

A detail from a negative enlarged many times shows what grain looks like: tiny, sandlike particles.

98

Negative density. The denser the negative, the coarser the grain. Dense negatives are the result of overexposure or overdevelopment, so the greater the exposure and development, the coarser the grain. For example, pushed film tends to have coarser grain than normally developed film.

Processing temperatures. Grain size is increased when warm film processing temperatures are used — negatives processed at 78° will tend to have coarser grain than those processed at 68° — or when the processing and wash temperatures are not kept consistent throughout. To minimize grain, try to keep all solutions at approximately the same temperature throughout all the processing steps.

Enlargement. Grain is magnified as a negative is enlarged, so the greater the print size, the more apparent the grain. An 8″ × 10″ print shows coarser grain than a 5″ × 7″ print of the same negative.

Negative size. Small-format negatives need to be enlarged more than large-format negatives to make the same size print. Therefore, grain tends to appear coarser on prints made from small negatives than on prints made from large negatives. A 35-millimeter negative needs to be enlarged much more than a 4″ × 5″ negative to make an 8″ × 10″ print, so the print from the 35-millimeter negative will have coarser grain.

Evaluating the Negative

Learning to read or evaluate a negative can be very helpful. Are the exposure and development correct? How will it be rendered as a print? With low or high contrast? With good or poor shadow or highlight detail? For guidance, refer to the rule:

**Expose for the shadows and
develop for the highlights.**

To evaluate film exposure, look only at the shadow areas of the negative. Ignore the highlights. If the shadows appear dense, the negative has been overexposed. If they appear thin, the negative has been underexposed. A well-exposed negative has the minimum density necessary to render full shadow detail. Shadows should be light, but not clear.

To evaluate film development, ignore the shadow areas of the negative and look only at the highlights. Well-developed negatives should be dense but not opaque. If the highlights are thin, the film has been underdeveloped and the negative will lack contrast. If they are too dark, the film has been overdeveloped and will likely have a lot of contrast.

Film development is a little harder to judge than exposure because highlight density is inevitably affected by film exposure. Underexposed negatives will have both thin shadows and thin highlights; overexposed negatives will have both dense shadows and dense highlights. So if a negative is either underexposed or overexposed, it is harder to tell whether it has been correctly developed.

The judgment of what constitutes good shadow and highlight density takes experience. Use the accompanying illustrations as a guide, and continue to check and evaluate negatives on a regular basis.

It is worth repeating that a good negative is critical for a good print. Film exposure is the most important factor, but film development is also important. Sometimes exposure and development should be altered to obtain the best possible negative. After all, the better the negative, the better the print. It is well worth the extra care needed to understand and use the controls available to reach that end.

CHAPTER 8 | MAKING THE PRINT

Equipment Needed

Prints are made from negatives in a darkroom. However, making prints requires a larger and more expensive investment in equipment and materials than developing film. Here is a list of both necessary and useful tools for printing:

> **enlarger**
> **enlarging lens**
> **enlarging timer**
> **focusing magnifier**
> **processing trays**
> **print tongs**
> **safelights**
> **easel**
> **brush or air blower**
> **film cleaner and soft cloth**
> **print washer**
> **print drier**
> **paper safe (optional)**
> **paper trimmer**
> **graduates, funnels, and storage bottles**
> **print squeegee**
> **piece of glass**
> **towel**

Enlarger. An enlarger makes prints from negatives in sizes greater than the negative size. For example, a 35-millimeter negative measures approximately 1″ × 1½″, yet it may be "enlarged" to a print measuring 5″ × 7″, 8″ × 10″, or larger.

Enlargers are available to handle different size negatives. If an enlarger uses negatives as large as 4″ × 5″, it is referred to as a "4″ × 5″ enlarger," but it can handle smaller formats as well. A "35-millimeter enlarger" can handle that size and smaller negatives.

Enlargers can be formidable in appearance, but are simple to operate. A long post holds the *enlarger housing*, which in turn holds a light bulb, condenser (or diffuser), negative carrier, bellows, and lens. At its bottom, the post is attached to a baseboard.

A negative.

A print from that negative.

Parts of an enlarger

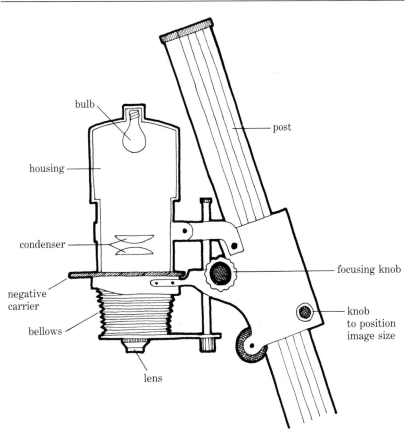

bulb

post

housing

condenser

focusing knob

negative
carrier

knob
to position
image size

bellows

lens

Light from the bulb travels through the condenser, negative, and lens to project the image of the negative onto the baseboard. Light bulbs have a "hot spot" in the center; that is, the projected light is brighter in the center than on the outside of the bulb. To spread the light evenly before it reaches the negative, a *condenser* (a glass lens) or a *diffuser* (a translucent piece of glass or plastic) is located between the light source and the negative. Condensers produce a higher-contrast print than diffusers.

The negative is positioned in a *negative carrier*, which fits into the enlarger below the condenser or diffuser. Most carriers are two pieces of metal or plastic that hold either a full strip of negatives or a single negative, flat and in place. The carrier has a cut-out the size of a negative. Each negative format used requires its own carrier. Some

A negative carrier holds the negative flat and in place.

carriers have glass covering the negative while others are "glassless." Glass carriers must be handled with care, cleaned constantly, and kept from being scratched.

A bellows is located under the negative carrier. It is used to focus the image. As the bellows is expanded or contracted, the lens moves closer to or farther from the baseboard until the image is sharp.

As the enlarger housing is moved up the post away from the baseboard, the projected image size is increased. As it moves down, the image becomes smaller.

Enlargers can be locked in place once the projected image is of the size and sharpness desired. Depending on the enlarger used, cranks, knobs, or dials are positioned next to the housing and the bellows, and are turned to adjust the projected image and lock it in place.

Enlarging lens. An enlarging lens works somewhat like a camera lens to focus the image and control the light. Sometimes a lens is packaged with an enlarger, and sometimes it must be bought separately.

The lens must be matched to the size of the negative being enlarged. The recommended focal length for an enlarging lens is the same as the focal length of the normal lens on the camera used. For a 35-millimeter negative, use a 50-millimeter enlarging lens. For a 2¼″ × 2¼″ negative, use an 80-millimeter enlarging lens; and for a 4″ × 5″ negative use a 150-millimeter lens.

All camera and enlarging lenses have a certain *covering power*, that is, the amount of even illumination that a lens projects. In general, the longer the focal length of a lens, the greater its covering power. A 50-millimeter lens is too short to project enough covering power to enlarge a 4″ × 5″ negative; the corners and edges of the negative will receive too little illumination and will be "cut off." An 80-millimeter lens will "cover" a 2¼″ × 2¼″ negative, and it will also "cover" smaller negative sizes, such as 35-millimeter. (However, the projected image size from a long lens will be smaller than that from a shorter lens, so shorter lenses are best for making large prints. For example, an 80-millimeter lens cannot make as large a print from a 35-millimeter negative as a 50-millimeter lens can.)

Like camera lenses, enlarging lenses are classified according to their maximum aperture. An f 4 enlarging lens allows more light through it than an f 5.6 enlarging lens. More light means that the projected image will be easier to see and focus, and that the exposure time can be shorter. (More on printing exposure later on.)

Enlarging timer. A timer is needed to regulate the amount of time for which a print is exposed. Any clock or watch with a second hand

Covering power

This print was made from a
2¼″ × 2¼″ negative with a 50-
millimeter lens. The lens did not
project enough even illumination for
that size negative, so the corners of
the print are "cut off."

can be used, but special enlarging timers are more accurate and convenient.

These timers connect directly to the enlarger. When set and activated, they automatically turn the enlarger on and off. Repeating timers are the best kind. They repeat the preset exposure, unless changed, over and over, thus providing consistency from print to print.

Focusing magnifier. A magnifier enlarges the projected image to facilitate more accurate focusing. The image can be focused without a magnifier, but the results are less likely to be sharp. A *grain magnifier* enlarges the grain patterns of the projected negative, allowing even easier accurate focusing.

colored filter

A safelight illuminates the darkroom.

Processing trays. Trays hold the chemicals for print processing. At least four trays are needed. The size should be chosen according to the anticipated print size. Standard tray sizes are: 5″ × 7″, 8″ × 10″, 11″ × 14″, and 16″ × 20″.

Print tongs. Tongs should be used instead of bare fingers to handle wet enlarging paper and carry it from tray to tray. Separate tongs should be used for each tray of chemicals, so at least three tongs are needed.

The main purpose of tongs is to minimize chemical contact with skin, thus eliminating contamination. Fingers wet with one chemical may cause print staining when dipped into a second chemical, or when touching clothes, negatives, and equipment. In addition, some people develop skin allergies to the chemicals.

Safelights. Enlarging paper is sensitive to most colors of light, so special colored *safelights* are used to illuminate the darkroom. Most safelights are simple 15- to 25-watt light bulbs, protected by a housing, and covered by a colored filter, usually red or amber.

Safelights should be positioned at least 3 or 4 feet away from the enlarger and developer tray. In a small darkroom, one safelight should be sufficient; a larger room may require two or more.

Easel. An easel holds printing paper flat and in place under the enlarger. It consists of two parts: a base on which the paper is laid and positioned, and a hinged top piece with crossing metal "blades" to hold the paper flat. The desired image size of the print is set by adjusting the metal blades along a ruled molding on the edges of the top piece of the easel.

Easels are available in many sizes according to the largest size printing paper they will accommodate. An 8″ × 10″ easel holds

An easel holds printing paper flat and in place under the enlarger.

ruled molding

base

blades

8″ × 10″ or smaller paper. For most purposes an 8″ × 10″ or 11″ × 14″ easel is adequate. Some easels are made for one size only; others hold several sizes but are not adjustable. Most easels produce white borders on all four edges, but some create prints without borders.

The best (and most expensive) easels have four adjustable blades. They allow a wider variety of centering and border possibilities than less expensive models.

Brush or air blower. Dust that accumulates on negatives should be cleaned off before beginning the printing process. Otherwise, the dust will show up on the final print. There are several inexpensive tools available to eliminate dust, such as a soft, wide brush, a rubber squeeze blower, or a simple ear syringe. Canned air under pressure is popular and effective for removing dust, but it is expensive, and needs periodic replacement.

Film cleaner and soft cloth. Dirty negatives may require a serious cleaning. Film can be rewashed in water, but chemical film cleaners are quicker and easier to use. A soft wipe, such as a chamois cloth, antistatic cloth, or lens tissue, should be used with the cleaning solution.

Print washer. A tray or washer must be used for print washing. Specially made print washers are available in a variety of models. A simple processing tray, preferably a large one with a special *tray siphon* (described later), will also do the job.

Print drier. Prints can be dried electrically or by air. Large, expensive driers are highly efficient, but most people working on their own need a less costly solution. Some options include a portable electric drier, a blotter book, a clothesline and clothespins, or a homemade drying screen (plastic screening material stretched taut over a wood frame).

Paper safe. A paper safe is a light-tight box that holds and allows easy access to unexposed printing paper. It is a nice convenience, but not a necessity.

Paper trimmer. Printing paper sometimes needs cutting. Special paper trimmers cut squarely and accurately. If necessary, a pair of scissors or a utility knife and straightedge will do the job.

Graduates, funnels, and storage bottles. Similar equipment to that used for film developing is necessary for measuring and storing chemicals. Extra bottles are needed to store used chemicals separately — those used for prints from those used for film.

Print squeegee. A flat, rubber blade or rubber roller, called a *squeegee*, is needed to squeeze excess water from a washed print to facilitate drying. A soft, rubber sponge can also be used.

Piece of glass. Two pieces of glass are needed: one for contact printing (explained later) and the other for holding the print while it is being squeegeed. Each piece should be larger than the largest size printing paper used. Plexiglas may also be used when squeegeeing prints.

Towel. Clean, cloth towels or rolls of paper towels are needed to keep hands dry during the printing process. Hands should be rinsed off and dried regularly to minimize chemical contact with skin.

Printing Papers

Like film, printing paper consists of a light-sensitive silver-halide emulsion on a base or support material. Film uses a base of clear plastic, while printing paper uses a base of white paper.

Common printing paper sizes are: 5″ × 7″, 8″ × 10″, 11″ × 14″, and 16″ × 20″. A box of paper may contain 10, 25, 50, 100, 250, or 500 sheets of one size and type. The greater the quantity, the lower the per-sheet cost.

The major considerations in choosing from the wide variety of printing papers made are as follows:

base type
weight
tone
surface
contrast

Check at camera stores for samples of prints made on the various paper types.

Base type. Printing papers are available in fiber and resin-coated bases. *Resin-coated (RC)* papers are coated on both sides of the paper base with a thin layer of clear plastic.

RC papers are more convenient to use than fiber-based papers. They expose more quickly than fiber-based, and they take far less time to process, wash, and dry. Upon drying, RC papers tend to curl less than fiber-based papers.

The convenience of RC papers makes them particularly tempting for the beginner or the person who has little time to work in the darkroom. More advanced workers should try out different types of paper, and may end up preferring fiber-based paper.

Weight. Printing papers are classified according to the thickness of their base, either as single, medium, or double weight. RC papers are usually medium weight; fiber-based papers are either single or double weight.

All weight paper produces the same image, but heavier papers

crease and damage less easily and dry flatter, with less wrinkling or curling. However, double-weight paper is significantly more expensive than single-weight paper.

Tone. Tone refers to the color bias of the printing paper. Some papers are *warm tone*, tending toward brown, while others are *cold tone*, more neutral black. Some warm-tone papers literally produce prints of brown and white tones. Cold-tone papers usually have a purer, cleaner white base; warm-tone papers have a creamier, off-white base. For practical purposes, the difference between many cold- and warm-tone papers is subtle.

Print developers also affect the tone of the print, so for maximum effect they should complement the type of printing paper used. While most all print developers work with all printing papers, try to process cold-tone papers in a cold-tone developing solution. Use a warmer developer for warm-tone papers.

Surface. Most papers are available in a wide variety of surfaces, most commonly: glossy, lustre, semi-matte, and matte. The glossier the surface, the sharper the appearance of the image.

Contrast. Contrast refers to the difference between the light and dark tones in a print. Low-contrast (soft or flat) prints are gray, with few bright or dark areas; high-contrast (hard) prints are mostly light and dark, with fewer gray areas.

Most brands of paper are available in many different grades of contrast. To a great extent, the contrast of the final print is controlled by the grade of paper used.

Each paper manufacturer has its own system of grading papers, but in all cases low numbers represent lower contrast than high numbers. Here is a typical scale of paper grades:

> **#1 = low contrast**
> **#2 = average contrast**
> **#3 = slightly high contrast**
> **#4 = high contrast**
> **#5 = very high contrast**

Some paper brands offer a #0 (very low contrast) and some offer a #6 (extremely high contrast).

Variable-contrast papers change contrast grade when exposed under the enlarger with special filters. These papers are economical since only one batch of paper and one set of filters need be purchased to achieve a wide range of contrast, usually from #1 to #4 grade. Half grades are also available (#1½, #2½, and #3½), providing still finer contrast control. When used without a filter, a variable-contrast

Print contrast

Print contrast can be controlled by using graded papers or filters (with variable-contrast papers): the higher the number the greater the contrast.

A print made on a #1-grade printing paper.

A print made from the same negative on a #2-grade printing paper has increased contrast.

A print on a #3-grade paper has even greater contrast.

A print on a #4-grade paper produces the greatest contrast.

paper is approximately the equivalent of an average-contrast-grade paper.

Filters are available in complete sets or as individual squares of colored gelatins. Once purchased, they can be reused almost indefinitely. Some enlargers incorporate a place to position the filters between the light source and the negative; otherwise the filters must be positioned under the enlarging lens with a filter holder.

Although it can be controlled by paper grade (or filters), print contrast can ultimately be affected by a number of other factors. Some of these factors are: negative contrast, type of print developer, dilution of print developer, and developing time. More on these factors later on.

Printing Chemicals

Processing chemicals for prints are basically the same as those used for processing film. The one exception is the developer. Film and paper developer perform the same function (developing the latent image), but their chemical composition is slightly different so it is necessary to buy separate film and paper developers.

Stop bath, fixer, and fixer remover are all the same for film and for paper. Dilutions and times may vary, so be sure to check package instructions. When storing these chemicals, differentiate between processing solutions used for film and those used for paper.

Set up four trays for the printing process. If the darkroom has a large enough counter (or sink) space, position the trays in a line, and work from left to right with developer, stop bath, fixer, and water, in that order. The trays should be filled to approximately one-half capacity. For an average work session, fill a 5″ × 7″ tray with about 16 ounces of solution; an 8″ × 10″ tray with 32 ounces; an 11″ × 14″ tray with 64 ounces; a 16″ × 20″ tray with 1 gallon; and so forth. For a short printing session, use less solution to save money.

Four trays set up for printing with print tongs.

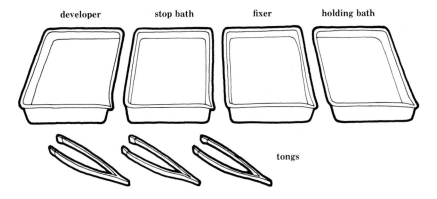

developer stop bath fixer holding bath

tongs

Chemicals deteriorate at different rates depending on many factors, such as the brand used, the freshness of the solution, and the number and size of the prints processed. As a very general guideline, process no more than the equivalent of twenty to twenty-five 8″ × 10″ prints (forty to fifty 5″ × 7″ prints; and so forth) in each quart of working solution of every chemical, except for fixer remover. Process approximately half as many prints in the fixer remover — ten to fifteen 8″ × 10″ prints.

Diluted developer and stop bath, once used, should not be stored for reuse; developer exhausts too rapidly, and stop bath, though it will keep, is cheap and should be used fresh to help extend the capacity of the fixer, which is significantly more expensive. Diluted fixer and some fixer removers can be reused, if they have not processed too many prints, and if they have been stored in tightly capped bottles. Fixer check can be used to determine whether the used fixer is exhausted.

All solutions should be mixed and diluted according to the manufacturers' instructions. These can vary widely.

Always use an acid bath for processing fiber-based prints. The acid should be diluted to a mild solution, the same as for film developing. A plain water stop bath is adequate for resin-coated papers.

Some fixers require a lot of dilution, while others are used undiluted. A hardener is incorporated into some types of fixer, and must be added separately to others. RC papers, like film, scratch easily, so a hardened fix is required to protect the emulsion. Fiber-based papers are more scratch-resistant, and can be processed safely with or without a hardener. Prints that are not hardened dry flatter and are easier to wash thoroughly and spot (touch up) than hardened prints. Also, prints that are to be subjected to heat (in the process of drying or mounting) should be hardened for protection.

Some photographers use a two-bath fixing system for processing prints. Two trays of fixer are set up, rather than one. Fixer from the first tray exhausts more rapidly than fixer from the second, so when it is discarded, the second fixer is used as the first, and a new second fixer solution is mixed. Two-bath fixers are a good method to guarantee efficient print fixing, since the second bath will always remain fresh, even when the first bath is exhausted.

The fourth tray, called a *holding bath*, consists of plain water. After fixing, fiber-based prints are held in water until the end of the printing session (or until the tray fills up), at which point the accumulated prints are washed together. The water in the holding bath needs changing every half hour or so to minimize the accumulation of fixer

in the water. Resin-coated prints should be washed soon after they have been fixed.

Chemicals should be mixed to be approximately 70°. In time, solutions will become room temperature, so the processing temperature is not as easily controllable for prints as for film (unless the room is temperature controlled). However, try not to work in either an extremely cold or hot room.

The Printing Process

Making a print requires a variety of judgments and interpretations, much more so than when developing a roll of film. What follows are the basic printing steps, along with discussion of some of the judgment areas.

Setting Up the Negative

1. *Put a strip of negatives in the negative carrier*, with the negative to be printed framed by the cut-out section. The negative needs to be positioned with its emulsion side (the dull surface) down or the print will have the wrong orientation — the left side of the subject will be rendered on the right side of the print; words will read backward; and so forth. Handle negatives with care, touching them only by the edges, since they scratch and smudge easily.

2. *Then use a blower or a brush to remove dust* that might have accumulated on either side of the negative.

3. *Close the carrier, and fit it tightly in place* in the enlarger housing.

4. *Set the easel for the approximate image size* for the print. The image size is the size of the printing paper minus the borders. For example, a 7½″ × 9½″ size image on an 8″ × 10″ sheet of paper has a 1/4″ border all around. The easel has size scales on its top, bottom, or sides for setting the image size. The blades of the easel are positioned with the aid of the scales so that whatever falls within the area framed by the blades will make up the desired image size. Some easels are nonadjustable and offer only one standard image size.

5. *Place the easel on the base of the enlarger.*

6. *Turn on the safelights, and turn off the room lights.*

7. *Then turn on the enlarger*. The enlarger will project the negative image down to the easel.

8. *Open the aperture of the enlarging lens to its widest f-stop* in order to project enough light to see the image clearly. Now the size of the image must be set and the negative focused.

Setting up the negative

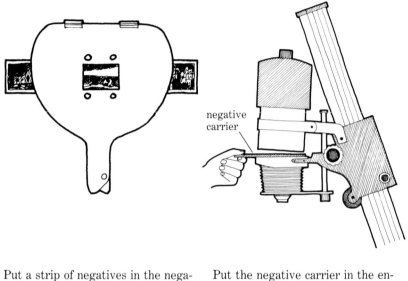

negative
carrier

Put a strip of negatives in the negative carrier.

Put the negative carrier in the enlarger so the emulsion (dull) side of the negative faces down.

9. *To set the image size, move the enlarger housing up and down on its post.* The position of the easel on the enlarger base will need to be adjusted until the projected image is framed tightly by the easel blades. As the housing moves up the post, the projected image becomes larger; as it moves down, the image becomes smaller. Once the desired image size is set, lock the housing in place on the enlarger post.

It is not necessary to print the full negative each time. When only a section of the negative is printed, that negative is said to be *cropped*. For example, if the negative is a portrait of a man from his head to his waist, the enlarger housing can be moved up on the post to project an image of only his head and shoulders. A cropped print may have less sharpness and show coarser grain because of the extra enlarge-

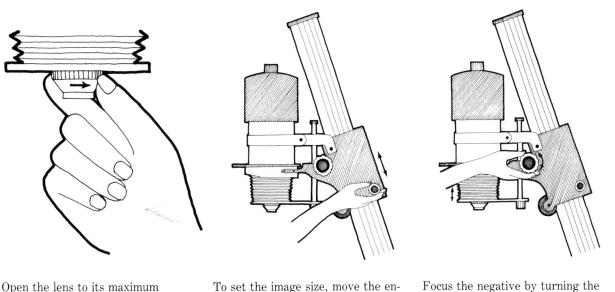

Open the lens to its maximum aperture.

To set the image size, move the enlarger housing up and down the post.

Focus the negative by turning the focusing knob to expand or contract the bellows.

ment it requires, but it might result in a more satisfactorily composed photograph.

10. *Once the image size is set, focus the negative* by turning the focusing knob to expand or contract the bellows. The image size will need minor adjustment at this point, and the easel may need to be moved around. Adjust the size first, then the focus and easel location. Keep readjusting until the projected image is the correct size and in focus.

For fine focusing, place a sheet of printing paper (the thickness of the paper to be used) in the easel, and focus the image onto that paper through a magnifier. The paper is necessary for focusing on the exact same plane as the print (the easel surface is slightly lower than the plane of the paper). A magnifier makes the projected image larger so helps make the focusing more accurate.

Cropping

A print made from a full negative.

A cropped print made from a section of that negative.

116

Understanding Print Exposure

When printing paper is exposed to light projected through a negative, it forms a latent image. Like film, this image is not visible until developed chemically. The more light that strikes the paper, the darker the printed image.

More light passes through the shadow (thin) areas of a negative than through its highlight (dense) areas. Thus more light reaches the printing paper to render shadows than highlights, so when developed, shadows are dark and highlights are light on the print. In effect, the printing process reproduces the light, gray, and dark areas much as in the original subject.

Just how much light (exposure) is needed to make a print depends on the density of the negative. The denser the negative, the greater the amount of exposure needed.

There are two primary factors in controlling print exposure:

aperture of the enlarging lens
print exposure time

These correspond roughly to the controllers of film exposure: the aperture of the camera lens and the shutter. The same relationship exists. If one is increased, the other must be decreased equally for the exposure to remain constant. A print exposure of f 11 at 20 seconds gives the same result as an exposure of f 8 at 10 seconds. The time is cut in half, but twice as much light travels through the lens.

In a camera, correct film exposure is figured with the help of a light meter. In a print, exposure is determined with the help of a test strip. (Exposure meters for prints are available but rarely used.)

Making a Test Strip

A *test strip* is a section of printing paper with several different exposures made from a single negative. It is simple to make, and can save much time and money on wasted printing paper and chemicals. To make a test strip:

1. *Close down the lens aperture* from its wide-open position. Any f-stop can be used for printing, but the middle stops — f 8 or f 11 — are suggested starting points. In the dark, f-stop markings on the lens are hard to see, but most lenses have "click stops," so turn the lens until it clicks to the desired opening. If the maximum f-stop of a lens is f 4, three clicks "closed" down is f 11: f 5.6 → f 8 → f 11.

117

Making a test strip

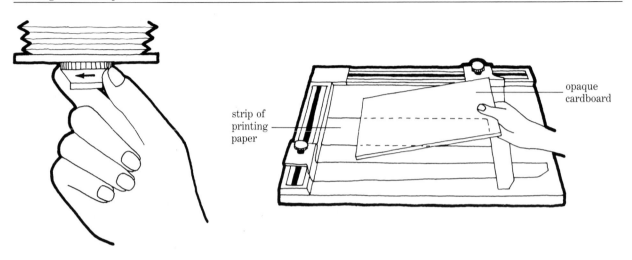

Close down the aperture to a smaller f-stop, say f 8 or f 11.

Cover most of the strip of printing paper with an opaque piece of cardboard.

2. *Take out a sheet of printing paper* from its box or from a paper safe. When opening the box of printing paper, be sure that no light (other than safelight) strikes the paper. Even slightly exposed (or *fogged*) paper will turn gray or black upon development. When closing up the box, be sure the paper is packed with its protective wrapping tightly around it. A paper safe allows easy access to printing paper without having to pack and repack the box over and over.

3. *Cut the sheet of printing paper into three strips.* Only one strip of paper is needed at this point, so put the others safely away for future tests.

4. *Lay the strip of paper in the easel, emulsion side up.* The emulsion is the shiny side of most printing papers.

5. *Use an opaque piece of cardboard to cover most of the strip* of paper — about 80% of it. Cover the strip either horizontally or vertically, depending on which orientation will provide the most information regarding the specific image to be printed. The best strips give good detail in each exposure segment for both light and dark areas of the negative.

6. *Set the enlarging timer* for 3 seconds. Three seconds represents an arbitrary starting point; actual exposure times can vary widely.

7. *Switch on the timer to expose the uncovered area of the strip* for that time. If an enlarging timer is not available, use the second hand of a clock or watch, and switch the enlarger on and off manually. This will work, but it will provide less consistent exposure times than an enlarging timer.

8. *Move the cardboard*, taking care not to move the strip of paper along with it. Leave another 20% or so of the strip uncovered, and expose this and the first section of the strip for 3 seconds. The first section has now received a total exposure of 6 seconds; the second section, 3 seconds.

9. *Move the cardboard two more times*, uncovering and exposing each section of the strip 3 seconds each time. Previously exposed sections will continue to receive additional amounts of exposure.

10. *Remove the cardboard* altogether and expose the entire strip for a final 3 seconds. Now the strip has a latent image with five different sections representing five different exposure times: 15, 12, 9, 6, and 3 seconds. Once developed, the test strip should provide a good guide to the required print exposure for that particular negative.

Developing the Test Strip

The print-developing process is the same for both test strips and for final prints. Average processing times are suggested here, but they vary with different materials and solutions. Refer to the instruction sheets for the printing paper and processing solutions being used for specific recommendations. Processing temperatures are not as critical for prints as for film. Use 68° to 70° if possible, but a range of 65° to 75° is permissible.

1. *Slip the exposed test strip, emulsion side down, into the tray of developer, and agitate it* by rocking the tray gently. Develop RC papers for approximately 1 minute and fiber-based papers for 1 to 3 minutes, agitating for the entire time.

When handling the print, use tongs and grab the paper at its edges. Do not touch the image surface. For the first 20 seconds or so, keep the paper emulsion side down in the tray to ensure that it thoroughly soaks up the developer. Agitate the paper constantly, then turn it over and watch the image form.

Be sure to keep the strip in the developer for the entire recommended time, even if it begins to look a bit dark. Exposure is difficult to judge under safelight illumination. The image appears almost fully after 30 seconds or so, but continues to develop more subtly after that

Summary: Print Processing*			
Step	**Time**	**Comments**	**Capacity*** *
1. Developer	**1 to 3 minutes** for fiber-based papers; **1 minute** for RC papers.	Agitate constantly; dilute according to manufacturers' instructions; develop for at least the minimum recommended time.	Twenty to twenty-five 8″ × 10″ prints (or equivalent) per quart of working solution.
2. Stop bath	**15 to 20 seconds** for fiber-based papers; **5 to 10 seconds** for RC papers.	Agitate constantly; use mild acetic acid bath for fiber-based papers; plain water bath for RC papers.	Twenty to twenty-five 8″ × 10″ prints (or equivalent) per quart of working solution.
3. Fixer	**5 to 10 minutes** for fiber-based papers; **2 minutes** for RC papers. Rapid fixers require less time.	Agitate constantly; if a two-bath fixer is used, fix for half the time in the first bath and the other half in the second, then discard the first bath when exhausted, use the second bath for a first bath, and mix a fresh second bath.	Twenty to twenty-five 8″ × 10″ prints (or equivalent) per quart of working solution.
4. Water rinse	**2 minutes**	Optional	—
5. Fixer remover	**2 to 4 minutes**	Optional, but highly recommended with fiber-based papers; do not use with RC papers; agitate constantly.	Ten to fifteen 8″ × 10″ prints (or equivalent) per quart of working solution.
6. Wash	**5 to 15 minutes** for fiber-based papers if treated first in fixer remover; **1 hour** for fiber-based papers if not treated in fixer remover; **4 minutes** for RC papers.	Agitate; make sure wash water is changing constantly; do not wash more than 10 to 15 prints at a time.	—

* These times and capacities are intended as guidelines. They vary according to the brands used and the conditions of use. Refer to manufacturers' instructions before proceeding.
** The following are approximately equivalent to twenty 8″ × 10″ prints: forty 5″ × 7″ prints; ten 11″ × 14″ prints; five 16″ × 20″ prints.

time. Also, for an accurate test strip, developing time as well as exposure time should be a known and consistent factor.

2. *Lift the fully developed test strip out of the developer* with tongs at one corner of the paper. For a few seconds let the excess developer drain off the bottom corner of the strip.

3. *Put the test strip in the stop bath* for 5 to 10 seconds, if using RC paper, or 15 to 20 seconds, if using fiber-based paper. Agitate it for the entire time. The stop bath neutralizes the developing activity, and produces no visible change in the image.

4. *Remove the test strip from the stop bath* with print tongs, and let the excess solution drain off.

5. *Place the test strip in the fixer.* The fixing time depends on the type of paper used and the freshness of the solution. With resin-coated paper use a time of 2 minutes; with fiber-based paper, use 5 to 10 minutes. Rapid fixers require even less time. Agitate for at least half the fixing time by rocking the fixer tray.

The fixer clears the printing paper of its unexposed silver, and allows the test strip to be viewed under room light. A strip or a print can be looked at after it has been in the fixer for about 30 seconds; if the strip or print is to be saved, it must then be returned to the fixer for the full remaining fixing time. (Before turning on the room lights, be sure all unexposed printing paper is safely stored away.)

6. *Remove the test strip from the fixer* with tongs, and let the excess solution drain off.

7. *Put the test strip in the holding bath* — a tray of plain water — until it is ready to be washed. (Print washing is described in full later in this chapter.) The test strip does not need to be saved; it can be left in the holding bath for reference until the final print from that negative is made, then thrown away.

To view a test strip (or a final print), remove the print from the fixer or water and put it in a clean tray. Turn on an overhead light. For the best viewing, use a 60- to 75-watt incandescent light bulb, not fluorescent. For convenience, the bulb should be positioned above the processing trays. View the print with the tray placed at an angle to, and about 3 feet away from, the light source. The brightness of the light and the angle at which it strikes the print can make a big difference in how the print looks.

The finished test strip will have a range of five exposures; some may be light and some dark. If all five exposures are either too light or too dark, make another test strip. The ideal strip is dark on one end and light on the other.

If the entire strip is too dark, cut back the exposure. Either close

Test strip

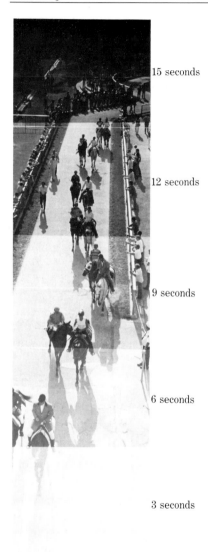

15 seconds

12 seconds

9 seconds

6 seconds

3 seconds

A test strip representing five different exposure times has a good range from light to dark.

A print using the exposure that looks best — 9 seconds.

down the lens — try f 16 instead of f 11 — or shorten the amount of exposure time — use 2-second increments instead of 3.

If the test strip is too light, increase the exposure. Open up the lens — say to f 8 instead of f 11 — or extend the exposure time — perhaps using 5-second increments instead of 3.

The Final Print

Once a good test strip is made, examine it carefully and choose the exposure that looks best. If in doubt, look for important highlight and shadow areas of the image — for example, Caucasian skin or bluejeans — and see if those areas look right. Caucasian skin should be light but not washed out; jeans should be dark, but retain detail.

Sometimes the correct exposure is somewhere between two sections of the test strip. If the 6-second exposure looks too light and the 9-second exposure looks too dark, choose 7 or 8 seconds instead.

Place a fresh, full sheet of printing paper in the easel, and expose it for the time chosen. Do not change the f-stop setting. Develop, stop, and fix the exposed paper in the same way as the test strip. If the two-bath fixing system is used, fix the print for half the recommended time in the first fixer bath, and the other half in the second bath.

In evaluating the quality of this print, consider these factors:

brightness
contrast
burning and dodging

Brightness. Print exposure determines the overall brightness of a print. Too much exposure results in both shadows and highlights being dark; too little exposure leaves shadows and highlights too light.

Brightness is determined by a good test strip. Once an initial print from that strip is made, it may need slight adjustments. If the print is too bright at a 10-second exposure, make a second print at 12 seconds. If it is too dark at 10 seconds, try a print at 7 seconds. Keep adjusting the exposure time, making new prints until the overall brightness seems right.

Contrast. After determining the exposure needed for good print brightness, examine the print contrast and make adjustments if necessary. Contrast refers to the difference between shadows and highlights. High-contrast prints have mostly dark shadows and light highlights, while low-contrast prints are mostly gray, with few solid blacks or whites.

In general, a good print should have both dark and light areas and

123

Brightness

Left:
A print that is too light, having received too little exposure.

Center:
A print from the same negative that is too dark; it needs less exposure.

Right:
A print with the right amount of brightness; it has received neither too little nor too much exposure.

a lot of grays in between. Most dark areas of the print should retain some detail, so as not to become a solid black mass; most light areas should also render detail, and not be a solid white. However, each print bears interpretation. Some prints look best when printed *hard* (with high contrast), and some look best when printed *flat* or *soft* (with low contrast).

Each negative has its own contrast range, which is dependent on several factors, such as subject lighting, exposure and developing time, and the type of film used. In the print, this contrast can be adjusted in any one of several ways.

The primary control for print contrast is paper grade. This factor has been discussed earlier in the chapter, but it bears repeating. Most printing papers are rated according to their ability to render contrast. A #1-grade paper produces a significantly lower-contrast print than a #5-grade paper. A #2 or a #3 represents average contrast with most brands of paper.

Variable-contrast printing papers produce prints of different contrast when exposed through different filters in the enlarger. A #1 filter with variable-contrast paper produces a relatively low-contrast print much as a #1-grade paper does. Used without a filter, variable-

Contrast

Left:
A print with too little contrast; it is too gray overall.

Center:
A print with too much contrast; its shadow areas are too dark and its highlight areas too bright.

Right:
A print with average contrast contains dark areas with detail, light areas with detail, and plenty of grays in between.

contrast papers print as approximately a #2 contrast. Filters are available in half-grades, such as #1½, #2½, and #3½, for fine contrast control.

Contrast grades vary with the paper brand used. A #2 Kodak paper will be different from a #2 Agfa or #2 Ilford paper. However, the grading principle is the same. The higher the number, the greater the contrast.

Note that the amount of contrast achieved from various paper grades is relative to the contrast of the negative to be printed. A negative of average contrast will provide an average-contrast print on a #2- or #3-grade paper. A high-contrast negative may produce a high-contrast print even on #1 paper; a low-contrast negative may need a #5 paper to produce a print of average contrast. However, a

higher paper grade will always produce a print of more contrast from a given negative than a lower paper grade.

Different graded papers and filters can affect print exposure time. With some brands, a #1 paper is more light-sensitive than a #5 paper, so requires less exposure. A #4 filter is darker than a #1 filter, so holds back more light, and requires a longer exposure time.

One sure way to determine the exposure change with different paper grades or filters is to make a separate test strip each time a different contrast filter or paper is used. This may seem like a waste of time, but it is the best and quickest way to determine what the new exposure time should be.

There are factors other than paper grade and negative contrast that affect print contrast. The greater the enlargement, the lower the print contrast. A negative enlarged to 11″ × 14″ produces a print of less contrast than the same negative enlarged to 5″ × 7″

Print contrast can be altered somewhat by making changes in the print developer. For example, some developers, such as Kodak Selectol Soft, produce prints of less contrast than others. And each developer can be used differently to provide more or less contrast. For greater print contrast, use a less-diluted developer (perhaps a stock solution rather than a diluted solution), develop for a longer period of time, or heat up the developing solution. For less contrast, use a more heavily diluted developer or a shorter developing time.

Burning and dodging. A print may have good overall exposure and contrast, but still have areas that are either too bright or too dark. *Burning* is a technique used to selectively add exposure to darken an area of a print. *Dodging* is holding back exposure to lighten an area of a print.

To understand burning, imagine a well-exposed print made at f 11 at 10 seconds. Once developed, the print may look right except for a corner that is too light. That corner can be made darker without affecting the overall brightness of the rest of the print by making another print and adding exposure only to the area that needs darkening.

To "burn in" a section of a print:

1. *Place a fresh sheet of printing paper in the easel, and expose it for the time needed to produce a good overall print;* in the above example, f 11 at 10 seconds.

2. *After the paper has been exposed, place an opaque piece of cardboard just under the lens.* Do not use paper since it will transmit light. Also, do not move the easel or the exposed printing paper in any way.

Burning

A print with good overall exposure at f 8 at 12 seconds. However, the sky is too light.

The same print made at the same exposure, but the sky has received an extra 12 seconds of exposure and is significantly darker.

© JOHN SEXTON

Burning

To burn in an area in the center of a print, use a piece of opaque cardboard with a hole cut out.

3. *Turn on the enlarger again, and move the cardboard so that the projected light falls only on the area of the paper that needs darkening,* such as a corner of the print.

4. *Move the cardboard back and forth slightly while adding extra exposure* to prevent the "burn" from creating a noticeable line on the print. In effect, the print tones must merge together evenly. (Actually, parts of the areas adjacent to the "burned-in" area will receive some additional exposure, but if done correctly, this added exposure will not be enough to affect the print significantly.)

The additional exposure causes only a part of the print to become darker upon development. The amount of burning necessary to make a perceptible change varies with each print, but sometimes it is considerable. To darken an area moderately, try a 40% to 50% "burn" (or 4 to 5 seconds additional exposure for a 10-second original exposure). For a more significant darkening, burn for at least 100% of the original

exposure time (a 10-second burn for a 10-second exposure). It is not unusual to "burn" for four or five times the original exposure (40 to 50 seconds more for a 10-second exposure), or even longer.

To burn in an area in the center of a print, use a piece of opaque cardboard with a hole cut out. First expose the entire paper for the correct time. Then position the cardboard about halfway between the lens and the easel, and turn on the enlarger again. Let light project through the hole to the areas of the print that need darkening. Be sure to keep moving the cardboard so the burning merges evenly with the adjacent areas in the print.

The size of the projected beam of light through the hole can be varied by stocking several pieces of cardboard, each with different size holes, and by varying the position of the board under the enlarger. When the cut-out is close to the lens, the beam of light reaching the paper is broader than when it is close to the paper. (If held close to the paper, the cardboard needs to be large enough so that light doesn't "spill over" and expose the corners and edges of the paper by accident.)

A long initial exposure time is not desirable if substantial burning is indicated. Say the required exposure is f 11 at 20 seconds, and a burn of five times that exposure is needed in an area. One hundred seconds is too long a time to burn in easily. Open the lens to f 8, and cut the exposure time to 10 seconds; then burn in for 50 seconds.

Dodging is the opposite of burning. An area of a print can be lightened selectively by holding back light from that area during the exposure. The rest of the print will not be affected, and will be rendered at the same overall brightness. To "dodge" a print:

1. *Make an initial print that has a good overall brightness.* Let's say that the exposure is f 8 at 10 seconds. Look at the print and determine what areas (if any) are too dark.

2. *Expose a fresh sheet of printing paper for the correct time* (f 8 at 10 seconds).

3. *During that exposure, place an opaque piece of cardboard just under the lens to block light from reaching the dark area(s).* Use the image projected on the easel as a guide to the area to be lightened.

4. *While dodging, move the cardboard back and forth* to prevent a noticeable line from appearing in the final print.

The amount of dodging needed varies from print to print. However, a relatively short dodging time can lighten an area significantly. Dodging for 20% of the initial exposure time (2 seconds out of a 10-second exposure) will make a noticeable difference. Never dodge for more

Dodging

A print with good overall exposure at f 11 at 9 seconds, but the center of the print is too dark.

The same print made at the same exposure, but light was held back for 3 seconds from the center of the print when this print was made, and that area is significantly lighter.

132

Dodging

To dodge an area in the center of a print, use a stiff wire handle with a piece of cardboard taped on.

than half the overall exposure (more than 5 seconds out of a 10-second exposure), because the difference between the dodged and the undodged areas will show up and seem obvious.

An area in the center of a print that is too dark can be lightened with a homemade dodging tool, consisting of a stiff wire handle (a piece cut from a clothes hanger works well) and a small piece of cardboard taped onto the end of the wire. Make up several tools with differently shaped pieces of cardboard (for example, round, square, and oblong) of different sizes.

To dodge with this tool, turn on the enlarger and expose the print for the predetermined time. During the exposure, position the dodging tool so that the cardboard covers the area to be lightened. Remember to keep the tool moving while dodging. The wire handle will not affect the overall print exposure because it is so thin.

A short initial exposure time is not desirable when dodging. An exposure of f 8 at 3 seconds, for example, makes it difficult to dodge accurately. A 1-second dodge is too brief, yet represents 33% of the

total exposure — a significant amount when dodging. It is best to close down the lens and extend the exposure time — say to f 11 at 6 seconds, or even f 16 at 12 seconds — to allow more latitude in dodging times. This way, if the initial exposure is 12 seconds, a 1-second dodge allows a subtle change, whereas a 4-second dodge makes a much more dramatic change.

These final printing steps — burning and dodging — often make the difference between an adequate print and an excellent print. Most prints need either less or more light in certain areas, and many prints need both. After determining the correct exposure and contrast for a print, examine that print carefully to see how it can be further improved. Then burn or dodge, several times in the same print if necessary, until the best possible print is made.

Use a soft lead pencil to note exposure, contrast, burning, and dodging data on each print for future reference. Write gently on the edge of the back of the paper so the mark will not affect the surface of the image on the front. This data may not be exactly repeatable each time the negative is printed, but it will provide useful guidelines.

Washing and Drying Prints

Finished prints must be washed free of fixer, or they will deteriorate in time. A short running-water wash — about 4 minutes — is recommended for resin-coated papers. However, fiber-based papers absorb more fixer so need a much longer water wash, almost a full hour. It is best to presoak fiber-based prints in a solution of fixer remover, and then wash them. Use the fixer remover for about 2 to 4 minutes, then wash the prints for 5 to 15 minutes. These times will vary with the weight of the printing paper (double-weight paper takes longer to wash than single-weight paper) as well as the brand of fixer remover used, and the efficiency of the print washer. Some manufacturers recommend a brief water rinse, about 2 minutes, before using the fixer remover.

RC prints should be washed, then dried, soon after they have been fixed, but fiber-based prints can be stored in the holding bath (a tray of plain water) until the end of the printing session. Change the water in the holding bath every 30 minutes or so to minimize the accumulation of fixer in the water.

To wash fiber-based papers, mix the fixer remover and pour it in a tray. Take prints from the holding bath, drain them briefly, and slide each print one at a time into the fixer remover. Do not put too many prints at once into the fixer remover. Limit this step to approximately

10 to 15 prints. If more prints need washing, do them in additional batches.

When all the prints are in the solution, start the timing, and agitate the prints by constantly shuffling the bottom prints to the top. Use rubber gloves, if available, to minimize skin contact with the chemicals.

At the end of the required time, drain each print briefly, then place them one at a time facedown in the water wash.

To wash either resin-coated or fiber-based prints, use a good print washer that will effect a constant change of water. For example, if fresh water enters from the bottom, it should spill over the top of the washer to drain. Some excellent (and expensive) print washers are available to maximize washing efficiency, but there are inexpensive alternatives.

A good washer can be made using a plain processing tray, a bit larger than the prints to be washed, along with a *tray siphon.* The siphon is an inexpensive plastic device that clips onto the side of a tray. It connects with a rubber hose to a standard faucet. Water from the faucet enters the tray at the top of the siphon, and tray water drains off at the bottom. To help the draining action further, use a hammer and nail to make holes at the sides toward the bottom of the wash tray.

When washing prints, agitate by hand to keep them from sticking together. If the drain action of the washer used is not efficient, manually drain the tray every few minutes and let it fill up again with fresh water.

Once washed, prints should be squeegeed to remove excess water for quicker and more even drying. Place each print, one at a time, facedown on a large, clean sheet of glass or Plexiglas. Actually, any flat, waterproof surface will do. Push a rubber squeegee or sponge over the back of the print. Do not push too hard or the print may crease. Turn the print over, and lightly squeegee the front, taking extra care not to scratch the emulsion. (Some photographers prefer to squeegee only the back of a print.)

Once washed and squeegeed, prints are ready to be dried. Air drying is the simplest and cheapest way. Hang each print by a corner from a clothesline (or piece of string). Or hang two prints, back to back, with four clothespins, one on each corner, to help reduce the tendency of prints to curl. Or lay the prints faceup on a clean counter or table.

Simple drying screens can be constructed for more efficient air drying. Make a frame out of four inexpensive wood strips ($1'' \times 2''$

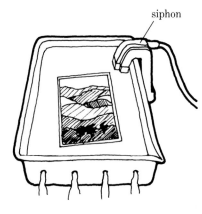

siphon

Washing prints with a siphon and a processing tray with holes punched out at the sides, toward the bottom.

135

Squeegeeing a print on a piece of glass (or other flat surface) to remove excess water. Be gentle when squeegeeing the front of the print to avoid scratching the emulsion.

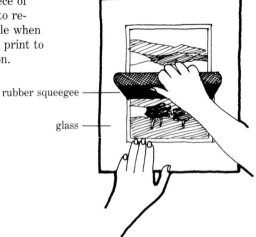

rubber squeegee —

glass —

stock works well), and staple plastic screening (available from any hardware store) to the frame. The screens do not need to be especially strong, since prints weigh so little. The wood can be hammered or screwed together, and metal corner braces used to keep the frame square.

Drying screens can be made to any size to fit space and storage requirements. Several screens can be stacked one on top of another to save space. They should be washed periodically with a mild soap solution.

RC prints should be placed emulsion side up on drying screens; they will air dry in approximately 15 to 30 minutes. Fiber-based prints should be placed emulsion side down to minimize curling; they take much longer to dry, 3 hours or longer. These times will vary with the temperature and humidity of the drying area. To minimize curling, remove the prints from the screens as soon as they are dry.

Print blotters are another inexpensive and easy way to dry prints. They are available in rolls, spiral-bound books, or single sheets.

To use blotters, place each squeegeed print between pieces of the blotter paper until dry. Blotters can be reused often, but must be replaced from time to time. Prints take longer to dry when placed in blotters than in the air. However, blotters take up less room than screens or clotheslines, and are portable in case prints must be moved while still wet.

Air drying

Hanging a print to dry by the corners from a clothesline.

Laying prints on simple drying screens (top view).

plastic screening

prints

wood frame

Many types of electrically heated driers are available for both resin-coated and fiber-based prints. Simple models have a metal heating unit with a cloth cover. Prints are placed between the cloth and the metal plate, and the heat dries them. More expensive models have an electrically rotating drum as a heating unit that pushes prints through and dries them automatically.

Some driers are set up to handle resin-coated papers, and others are not. Air drying is always recommended for RC prints unless a good electric RC print drier is available. A hand-held hair drier can be used for quick drying, but is generally not recommended.

Contact Printing

A *contact print* is a print the size of a negative. A contact print from a 35-millimeter negative measures $1'' \times 1\frac{1}{2}''$; a contact print from a $2\frac{1}{4}'' \times 2\frac{1}{4}''$ negative measures $2\frac{1}{4}'' \times 2\frac{1}{4}''$; and so forth.

A *contact sheet* is a large sheet of paper, usually $8'' \times 10''$ or $8\frac{1}{2}'' \times 11''$, containing a series of contact prints.

"Contacts" are best used as proof sheets. An entire roll of film is contact-printed onto one single sheet of paper. Each contact print is then examined for its value, and only those that look promising need be individually printed, saving much time and money (in wasted chemicals and printing paper).

Contact sheets also provide a useful way to file work by numbering rolls of negatives to correspond to each contact sheet. For example, designate the first roll of negatives as #1, and mark the negative envelopes "1." Then mark the contact sheet of that roll accordingly, as "1." Such a numbering system will become extremely valuable when there are a lot of negatives and contact prints to keep track of.

The back side of a contact sheet can also be used to store additional information, such as where, when, or how the pictures were taken.

Large-format negatives are sometimes contact-printed to make a final print. A $4'' \times 5''$ negative makes a $4'' \times 5''$ contact print that is large enough to view. Because the negative is not enlarged, the print will have maximum sharpness and minimum grain.

To make a contact print:

1. *Position the enlarger housing near the top of its post*, so it projects a wide circle of light when turned on. The aperture setting is optional; start with f 8 or f 11.

2. *Place a fresh sheet of 8" × 10" printing paper, emulsion side up, at the base of the enlarger.* Do not use an easel.

138

Contact prints

A contact sheet of contact prints
from an entire roll of 35-millimeter
negatives. This illustration is re-
duced in size. The original sheet is
8″ × 10″.

3. *Position several strips of negatives emulsion side down in rows on the paper.*

4. *Then gently lower a clean sheet of glass (preferably heavy-weight) over both the negatives and paper* to hold them flat and tight against each other.

5. *Turn on the enlarger for a predetermined period of time.* Try f 8 at 5 seconds. A test strip can be made to determine exposure, using an "average" negative for the test. Over an entire roll of negatives, some may print light and others dark, so simply aim for a good overall exposure.

6. *Once exposed, process the contact sheet like any other print.* If it is too dark, try another sheet and expose for less time; if too light, expose for more time. If the same enlarger, lens, and printing paper are used, the time should stay pretty much the same from contact sheet to contact sheet, assuming reasonably consistent negatives.

Contact prints can also be made without an enlarger. Use a 15- or 25-watt light bulb positioned 3 feet or so above a counter or table. Place the paper, negatives, and glass under the light, and briefly turn the light on to make the exposure.

A Simple Printing System

A print is sometimes difficult to evaluate. Is it too light or too dark? Does it have too much or not enough contrast? With experience these judgments can be made intuitively. The following method will help systematize the process.

For film, the rule is to "expose for the shadows and develop for the highlights," but for prints the opposite is true:

**Expose for the highlights;
adjust contrast for the shadows.**

To use this system, consider only the important highlight and shadow areas of a print. Middle-gray areas tend to "fall in place" and look right if the lights and darks are rendered well on the print.

Expose for the highlights. Print exposure affects the overall print: highlight, middle-gray, and shadow areas. The longer the exposure, the darker the entire print.

With this system, consider a print well exposed only if the highlights (such as light clothes or light skin) look right. Ignore middle gray and shadow areas for judging exposure. If the highlights look good, the exposure is correct; if they seem light, add exposure; if they seem dark, cut back on exposure.

Ignore extreme highlight areas, such as particularly bright snow or sky, when judging exposure. Consider the entire print. Unusually bright areas need burning in after the exposure and contrast have been determined.

What constitutes good highlight exposure is somewhat subjective. For most prints, highlights should be light gray, containing clearly defined detail. Compare the highlights to the white border of the printing paper. They should be darker than that white. If highlights are too light, detail will be lost; if too dark, highlights are no longer light areas, but rather middle grays or shadows.

Adjust contrast for the shadows. Once the proper highlight exposure has been determined, examine the important shadow areas, such as dark hair and dark clothes. Ignore extremely dark areas. These can be dodged out during the print exposure.

In most prints, good shadow areas should be dark, but still retain detail. Shadows that are too dark become solid black; shadows that are too light look gray and "muddy."

Frequently, once the highlight areas are well exposed, the shadows and, therefore, the contrast look right, and no contrast adjustments are needed. However, if the shadow areas are too dark, the print needs less contrast, perhaps a #1 paper grade; if the shadows are light, it needs more contrast, possibly a #4 grade. Added contrast will result in darker shadows.

Final changes. The final step is fine-tuning the print. After adjusting contrast to suit the shadow areas, make sure the highlights of the new print match the original print where highlight exposure was judged to be correct. The contrast change may have lightened or darkened the highlights somewhat, so the new print may need a bit more or less exposure. Or, looking at a print with more or less contrast may make the highlights seem lighter or darker than before. In addition, changing paper grades (or filters) usually alters comparable exposure times, so some fiddling with new times and even additional contrast changes are commonplace.

Fine-tuning a print can be difficult, especially if the negative is technically bad — either dark, light, or with too much or too little contrast. Well-exposed and well-developed negatives are rarely difficult to print.

At all times, keep in mind that the key to evaluating print exposure is in the highlights. If the light areas look good, the print is well exposed. Then, the key to evaluating contrast is in the darkness or lightness of the shadow areas.

Miscellaneous Considerations

· If possible, try to use a range of print exposure times of approximately 10 to 15 seconds. Short times can make dodging difficult because the dodging time must be very short. Long times can make burning times too long and tedious. Also, enlargers can be bumped or moved slightly during long exposures, and cause the printed image to be less sharp than it could be.

· Thin negatives nearly always print flat — with low contrast — so generally need a #3- or #4-grade paper for a higher contrast print.

· Prints generally dry slightly darker than they look when wet. The difference is subtle, but should be considered.

· The larger the print, the more exposure it needs. A negative that needs f 11 at 10 seconds for a good 5″ × 7″ print needs about f 11 at 20 seconds for a good 8″ × 10″ print. Make a test strip to determine the new exposure.

· As discussed earlier, an enlarged negative loses contrast. A negative that prints well on a #2-grade paper at 5″ × 7″ needs a higher grade paper — about a grade #3 — for a print of comparable contrast at 8″ × 10″.

· Always develop prints for at least the minimum time recommended by the manufacturer. Prints pulled from the developer prior to full development may be streaked and will lack solid blacks. If the print is becoming too dark, make another print at a shorter exposure and develop that print fully.

· *Gang-printing* means making several prints from a single negative in one batch. First, establish the exposure, contrast, burning, and dodging needs of a print, then expose several sheets of printing paper one after the other accordingly. (Be sure to place exposed paper out of the way of the enlarger light when working on subsequent prints.)

Once several prints, perhaps six or seven, have been exposed, place each one facedown in the developer, one at a time, so that each print is thoroughly soaked before another is added. Once all the prints are in, start timing the process. Then shuffle the prints from the bottom to the top of the pile. Keep shuffling until the developing time is nearly completed. Pick up all the prints from the solution, drain them briefly, and place each print in the stop bath, then in the fixer one at a time, and repeat the shuffling process. Drain all the prints well before placing them in the holding bath.

When gang-printing, use rubber gloves to protect hands from chemical contact. Also, use oversized trays, if possible, to facilitate the shuffling action.

· *Archival* standards for processing negatives and prints suggest guidelines to maximize the permanence of these materials. Unless

processed, washed, and stored correctly, negatives and prints may fade or deteriorate with time. Just how much time depends on the materials and processes used. The fixing and washing steps are especially critical to preservation.

Museums, archives, and art collections have a particular interest in the archival handling of prints. Most photographers do not need to adhere to such strict archival standards for their own work. They should, however, be aware of the potential problems, and take care to process and wash negatives and prints for the correct amounts of time in fresh solutions, according to the manufacturers' suggestions. Extra care may be indicated for negatives and prints of special value.

CHAPTER 9 FINAL TOUCHES

Once washed and dried, a print can still be improved. This chapter covers several "final touches":

toning
spotting
mounting
framing

Toning

A toner is a chemical solution that changes either the color or the tone of a print. Several types are available. Some turn black-and-white prints to different colors, such as brown, sepia, blue, or red. More subtle toners, such as selenium toner, can be used to affect only the print tone.

A print must be toned while it is wet. A dry print can be resoaked in a tray of water for a few minutes, then toned.

Extra trays are needed to hold the toning baths. Some toners are toxic or foul-smelling, so use a well-ventilated darkroom, or tone near an open window. Use tongs or rubber gloves to handle prints in the toning bath.

Sepia toners usually come in two packages and require separate baths. Prints are treated first in a bleach, which makes the image nearly invisible, then in a redeveloper, which makes the image reappear in a different color.

Liquid toners are usually one-bath solutions. They change the color or tone of a print directly, without a bleaching step.

Toners vary in dilution and method of application. Some, such as Kodak Polytoner, can produce a variety of tones or colors depending on the dilution of the solution and the toning time. Refer to the manufacturers' instructions for dilution and time suggestions, but feel free to experiment. In general, longer treatments in less dilute solutions make for more pronounced results.

Selenium toner is a popular one-bath toner. It produces richer black tones and it helps increase print permanence. On some papers it makes a colder-tone image. Used in strong concentrations, selenium toner

produces a marked red-brown, almost purple, image. In a more dilute solution, the change is more subtle. Here is a popular formula that will improve the quality of a print without altering it too dramatically:

1. *Mix 1 quart of working solution of fixer remover with 2 ounces of selenium toner concentrate.* Pour this mixture into a clean processing tray.

2. *Transfer the print to be treated directly from the fixer to the toning bath.* Do not rinse it in water first. If the print to be toned is dry, soak it for about 2 minutes in a fresh fixer bath, then transfer it to the toner. For best results, use a fixer without a hardener.

3. *Agitate the tray for about 5 minutes*, or until the desired results are achieved. Since the tonal change is subtle, use a duplicate print from the same negative for comparison. The comparison print should be wet, but untoned.

4. Once the toning is complete, *wash the print in the normal manner*, with a fresh fixer-remover bath (with no toner) and a thorough water wash.

Selenium in solution should be handled with care. Avoid direct skin contact by using rubber gloves or tongs when handling prints being toned.

When several prints need to be toned, gang-process them in the manner described at the end of chapter 8. Put each print one at a time in the toning bath, and shuffle them constantly from the bottom to the top of the pile. When the toning time is up, drain each print and wash as directed.

Spotting

Dirty negatives cause some of the most annoying and time-consuming darkroom problems. Grit, dust, and fingerprints on the negative block light from reaching the printing paper, and create dark spots, while scratches cause lines on the finished print.

The best defense against dirty negatives is to dry them in a dust-free environment, and pack them away in negative envelopes immediately after they are dry. In addition, before they are positioned in the enlarger, each negative should be brushed with a soft brush, or blown clean with an air blower or canned air. Film-cleaning solutions are available to help combat tough fingerprint, smudge, and dust problems. Use a soft cloth or chamois with these solutions to avoid scratching the film.

Despite all these precautions, few negatives are totally dirt-free. *Spotting* is a technique for covering up print spots. These spots can be matched and blended to the areas around them with a thin brush and a spotting solution.

Spotting

A detail from a print that needs spotting.

A detail from the same print after it has been spotted.

Spotting is tedious and can be frustrating. It requires a steady hand and much patience. However, a print covered with small scratches and spots is a sloppy print, so the few extra minutes taken for spotting is well-spent time.

The following are needed for spotting:

brush
spotting dye
cotton gloves
blotter
white test strip
saucer and white mixing dish

Brush. Use a good-quality, thin-tipped brush. The smaller the number of the brush, the thinner the tip; a #1 brush is thinner, thus better for spotting, than a #3 brush. A #000 brush is especially thin, and ideal for spotting. An art supply store is the best source for extra-thin brushes.

Spotting dye. Spotting dyes and pigments are available in liquid and dry form. Most are black, but brown and white spotting colors are available. Dry dyes need to be mixed with water for use. Both dry and premixed types become lighter as they are diluted, so a black liquid can be made to match any shade of gray when mixed with water. (Some use wetting agent or saliva in lieu of water.)

Cotton gloves. Fingerprints cause prints to smudge, so use white, cotton, lintless gloves, available at drug or camera stores, when handling prints while spotting.

Blotter. Use a paper towel, sponge, or blotter material to absorb excess spotting solution or water from the brush.

White test strip. A piece of the white border of a print (made with the same paper type as the print to be spotted) is useful for testing the spotting solution before applying it to the finished print.

Saucer and white mixing dish. Use a small saucer to hold water used for diluting the spotting solution, and a plain white dish (or plate) to mix and dilute the spotting solution with the water.

Spotting techniques vary, but all require applying, diluting, and reapplying spotting solutions to match various tones in a print. Here's how to spot:

1. *Position the white test paper next to a spot on the print.*

2. *Soak the tip of the brush with spotting solution.* Use water to liquefy dry spotting dyes.

3. *Then blot the brush gently with blotting paper, and touch the tip of the brush lightly to the test paper.* Do not make a brush stroke, just a small spot mark.

4. *Use the test paper to match up that mark with the tone of the area on the print that needs spotting.* The mark will probably be darker than the area. If so, dilute the solution on the brush with water, blot it, and make another test mark. Do not lick the tip of the brush to dilute the solution.

5. *Apply the brush immediately to the print when the test mark is slightly lighter than the area to be spotted.* A light spot can always be darkened. Again, touch the tip of the brush lightly to the print. If the area to be spotted is larger, make repeated tiny spots in the area until it is filled in. Do not try to fill in a large area by painting it in. If the dye is too dark, wipe it off the print at once, before it dries.

6. *Examine the print for other areas needing a spot of a similar tone.* If there are any, spot them right away before the brush dries.

Repeat this procedure, matching all areas that need spotting. Large dust and scratch spots take a lot of work since they must be filled in slowly with little spots, never painted in. As the brush dries up, more solution must be added, so tones must be matched up again.

Beginning spotters inevitably make marks that are either too dark or too large. Use the spotting solution only when it makes a test mark slightly lighter than seems to be needed. Remember, light spots can always be darkened. Besides, they often appear darker in the context of the entire print. Spots made too dark can generally be removed by soaking the print in water for a few minutes. However, the print must then be dried and respotted.

Again, be patient and use small marks repeatedly to fill in large areas. Don't try to economize with fewer strokes. A sloppily spotted print can look worse than an unspotted print.

High-gloss, resin-coated papers are hard to spot because the surface resists dye penetration. Use a near-dry brush or spotting solutions made specially for RC papers.

Some spotting solutions are packaged in kit form with different bottles or dyes for warm- and cold-toned printing papers. The manufacturers' instructions can be followed for mixing the solutions. (In general, cold-toned prints need neutral-black solutions and warm-toned prints need brown-black solutions.) However, in practice, slight tonal differences in spots rarely show up, so don't worry too much about these distinctions. Use a black spotting solution for black-and-white prints; use a brown solution for sepia and brown-toned prints.

Most of all, be patient. Spotting is a tedious, but necessary, step. Don't ruin a print that took much time and effort to make by rushing and ruining the spotting job.

Mounting

Prints can be mounted on a stiff board for display and protection. The board helps the print to lay flat and provides a good background for viewing the print. In addition, the board acts as a backing to protect the print from nicks, creases, and other damage.

Mount board can be purchased at any camera store, but art supply stores generally offer a more varied selection. Consider the following factors when choosing mount board:

color
weight
surface
quality
size

Color. A white or an off-white shade is the most neutral and commonly used mount board, but black, gray, and other colors are available. Generally, the board should provide a good viewing background; it should not be the focus of attention, which is a strong argument for a white, off-white, or, possibly, a gray board.

Weight. Boards are available in a variety of thicknesses, sometimes rated by "ply." Two-ply board is lightweight, and economical; four-ply board is heavier and sturdier, but more expensive.

Surface. The surface of mount board also varies, from glossy to rough. A surface in between is usually preferred — flat and matte, but not too rough — to provide a neutral and attractive background.

Quality. Excellent-quality mount boards look good and age well, while cheaper boards may discolor and deteriorate in time, or cause mounted prints to stain. So-called rag (literally recycled rags) or acid-free boards are considered best and most stable. However, be sure the print to be mounted is worth the price. Good mount board is expensive. Many prints rate more moderate-priced boards.

Size. Mount boards come in various sizes, and may have to be cut down for use. The cutting can be done by art supply stores at a fee, or at home with a large straightedge (ruler) and a utility knife with a sharp blade. Pick a board size that is compatible with the size of the print to be mounted (refer to the chart on the next page).

Position the print against a sample-size board to ensure that the border size is pleasing. A print with a vertical orientation is usually mounted vertically; a print with a horizontal orientation can be mounted either horizontally or vertically. Sometimes a print is centered exactly in the middle of the board, and sometimes it is positioned to leave equal borders of mount board showing on each side and a somewhat larger border on the bottom than on the top.

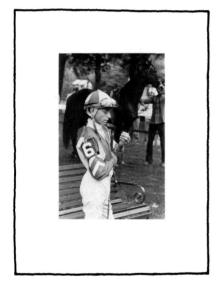

A print centered on a piece of mount board.

Keep in mind that ready-made frames are available in standard sizes, such as 8″ × 10″ and 11″ × 14″. So, if a mounted print is to be framed, odd-size mount board will require custom framing.

These print and board sizes should be used as guidelines:

Print Size	Board Size
5″ × 7″	8″ × 10″
	8″ × 12″
	10″ × 12″
8″ × 10″	11″ × 14″
	12″ × 15″
	12″ × 16″
11″ × 14″	14″ × 17″
	14″ × 18″
	16″ × 20″

An *overmat* is a mount board with a hole (or window) in the middle. The hole is approximately the size of the print, which lays under the overmat, attached to a backing board. Special cutting instruments are made to cut overmats easily and accurately. However, overmats can be cut inexpensively at home with the following equipment:

cutting tool
straightedge
cutting surface
board
tape

Cutting tool. A utility knife, available at any hardware store, will make a good, straight cut. Special mat cutters are available to make a beveled (angled) cut — the preferred way to cut an overmat.

Straightedge. A heavy-duty straightedge or ruler makes it easier to cut overmats. Art supply stores sell stainless-steel straightedges with a rubber backing to prevent slippage. These are ideal, though simple rulers will work.

Cutting surface. A flat cutting surface, such as Masonite or another piece of mount board, is needed to protect table tops from scratching and to provide a smooth area for mat cutting.

Board. Two pieces of board of equal size are needed: an overmat and a backing board. The overmat is visible, so needs to be clean and attractive; the backing board is hidden so can be less presentable.

Tape. The overmat and the print need to be attached to the backing board. Masking tape can be used; white linen tape is more expensive,

Overmatting

A print mounted behind an overmat — a piece of mount board with a hole cut out.

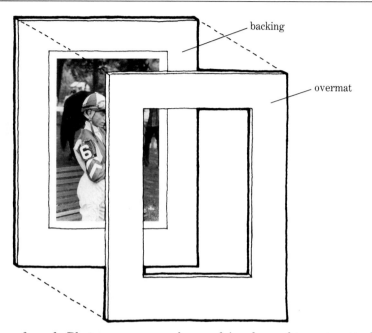

backing

overmat

but preferred. Photo corners can be used in place of tape to attach the print to the backing board.

Miscellaneous. White cotton gloves are useful for handling the print and board during the overmatting. Pencils and kneaded erasers are useful for measuring and cleaning up the board. Fine sandpaper can smooth over rough-cut edges and corners of the window.

Here's how to overmat:

1. *Cut (or buy) two pieces of mount board of the same size,* one for an overmat and the other for a backing. The backing can be of lighter weight than the overmat — for example, a two-ply backing with a four-ply overmat.

2. *Position the print on the backing board.*

3. *Measure the image size of the print* (the size of the printing paper minus the white borders). Say it is 7″ × 9″ (on 8″ × 10″ printing paper). Subtract these dimensions from those of the mount board, say 11″ × 14″. For a vertical print with the above dimensions, centering (on a vertical board) works out to a 2″ border on each side, and a 2½″ border both on the top and on the bottom. Or, it might look better to push the print up a bit, still leaving 2″ borders on each side, but a 2¼″ border on top and a 2¾″ border on the bottom.

4. *With a straightedge and pencil, draw an outline of the dimensions of the image on the back side of the overmat.* Reduce the dimensions of the image by 1/8″ both horizontally and vertically to account for possible errors, so if the image size is 7″ × 9″, make it 6⅞″ × 8⅞″ instead. With more experience, this compensation may not be necessary. Measure carefully, making and connecting several dots for each dimension.

5. *Lay the overmat on the cutting surface, measured side up, and cut out the window.* Hold the straightedge firmly or secure it to the table with masking tape, so it does not move during the cut. Use a utility knife with a sharp blade for a straight cut, or a special mat cutter for a beveled edge. Press the cutting tool firmly down along the straightedge to guarantee a smooth, even cut. Be sure to cut the corners of the window cleanly, at a sharp 90° angle.

6. *Use fine sandpaper to smooth out the rough edges of the cut-out board.*

7. *Hinge the overmat to the backing board* by butting the top side of each up against the other; use the back side of the overmat and the front side of the backing board. Lay a strip of tape across the length of the boards to attach them. Linen tape is best. It must be moistened for use, and burnished thoroughly to secure the tape to the board. Masking tape is also acceptable. Close up the two boards and align them to each other before the tape has time to bind firmly.

8. *Position the print between the two boards* so that the image fits directly behind the cut-out window. Once it is in place, put a weight (such as a small book or wallet) on the print to keep it from moving, using a piece of paper between the print and weight to protect the print.

9. *Open the overmat, and attach the print to the backing board* with tape (preferably linen tape) or photo corners.

10. *Close up the overmat*, and the job is complete.

Dry-mounting is a method of attaching a print directly to mount board. The bond is made with *dry-mounting tissue*, a thin paper that becomes sticky when heated. The heat is provided by a *dry-mounting press*, or, if necessary, a simple clothes iron. Like overmatting, dry-mounting requires a cutting tool, straightedge, cutting surface, and cotton gloves. A paper trimmer can be used instead of a utility knife and straightedge for trimming the print borders. The following special equipment is used for dry-mounting:

dry-mounting press
protective sheet

Dry-mounting

A print dry-mounted onto a piece of mount board with a piece of dry-mounting tissue.

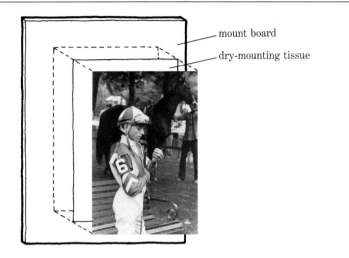

mount board

dry-mounting tissue

**tacking iron
dry-mounting tissue**

A tacking iron.

Dry-mounting press. This expensive piece of equipment resembles a large flatiron and can be opened and closed tight to provide an even source of heat. It has a thermostat to regulate its temperature. Presses can be found at many art studios and group darkrooms, but if unavailable, a clothes iron will suffice, especially for mounting small prints.

Protective sheet. A sheet of kraft paper or other thin smooth paper or board must be used in the dry-mounting press to prevent prints from directly touching the heating plate. The sheet should be the same size as or larger than the heating plate.

Tacking iron. A special hand iron, with a rounded, narrow tip, is used for tacking dry-mounting tissue to the back of a print and to the front of the mount board. A tacking iron is not expensive, but a clothes iron, carefully used at low temperatures, can be used instead, if necessary.

Dry-mounting tissue. Special heat-sensitive tissues are made by many manufacturers in a variety of sizes. Buy tissue in the size of the largest prints to be dry-mounted. It can always be cut down for use with smaller prints. Tissue is available for both fiber-based and resin-coated printing papers. Be sure to use the right type for the print to be mounted.

A finished print

This 11″ × 14″ print, shown in reduced size, has an image size of 8″ × 12″; it was first spotted, then mounted on 14″ × 18″ mount board.

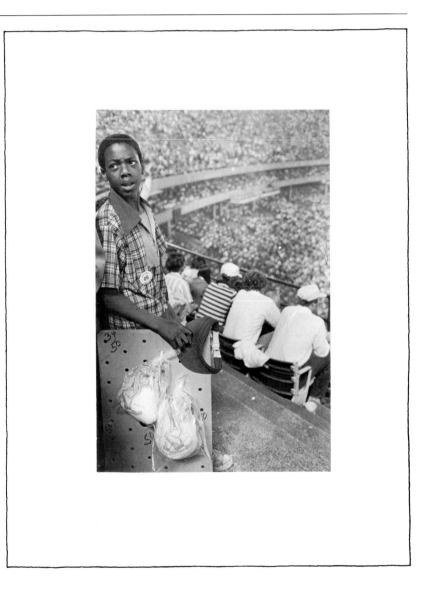

The following directions assume the availability of a dry-mounting press:

1. *Set the temperature on the press.* Use 180° for mounting resin-coated prints or 250° for fiber-based prints.

2. *Plug in the tacking iron, and set its thermostat* at a medium setting. Wait several minutes for both the press and the iron to heat up.

3. *Remove excess moisture from both the print and the mount board.* To do so, place each in the heated press separately for about 1 minute. Position the print and board under a protective sheet in the press to keep them from being scorched.

4. *Take the print and place it facedown on a clean, flat surface.*

5. *Lay a sheet of dry-mounting tissue, the size of the print (or larger), on the back of the print.*

6. *With a short, continuous stroke, move the heated tacking iron across the middle of the tissue.* Since the tissue becomes sticky when heated, it will adhere to the print at the spots that are touched.

7. *Turn over the print and cut off the white border*, using either a paper trimmer or a utility knife (with a sharp blade) and straightedge. Since the dry-mounting tissue and the print are attached, they will be cut at the same time, and they will be the same size. Make the cuts carefully so they will be even and square, and do not slip into the image itself.

8. *Center the trimmed print (with the attached tissue) on the mount board.* The same rule of thumb as for overmatting applies: position the print either directly in the center of the board or a little up on the board. Use a ruler and light pencil marks to measure the borders with great care.

9. *Once the print is positioned, put a weight on it to keep it in place.* Use a clean piece of paper between the print and the weight to protect the print surface.

10. *Lift up one corner of the print, leaving the tissue lying flat in place on the board, and apply the tacking iron gently to the corner of the tissue to attach it to the mount board.* Being careful to hold the print (and tissue) perfectly flat against the board, "tack" the diagonally opposite corner of the print also. Now the tissue is attached, both to the print in the middle and to the board at two corners.

11. *Remeasure the print* now that it is attached to the mount board to be sure the borders are square. If they are not, remove the tissue at the corners, reposition the print, and tack down the corners again.

12. *Place the print and the attached board in the dry-mounting press.* Be sure that the protective sheet is positioned between the

To dry-mount a print

A. Use a tacking iron to attach the dry-mounting tissue to the back of the print.

B. Cut off the white border of the print with a utility knife and straightedge (or a paper trimmer).

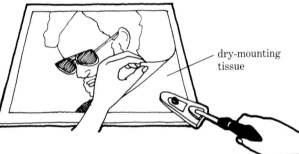

dry-mounting tissue

C. Center the trimmed print on the mount board.

D. Lift up a corner of the print and tack the dry-mounting tissue to the mount board.

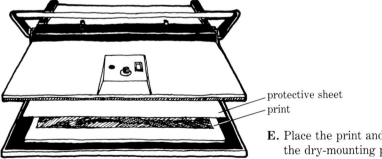

protective sheet
print

E. Place the print and mount board in the dry-mounting press.

heating plate of the press and the board. Close the press for about 30 seconds, or until the print is affixed firmly to the board.

13. *Take the mounted print out of the press and lay it under a flat, heavy object, such as a large book, until it cools off.* The surface of the print should be protected at all times by a clean sheet of paper or board.

14. *Bend the board gently to test the binding.* If the print is not affixed firmly, it will begin to lift off the board, so put the print and board back in the press for a longer time.

A clothes iron can be used in lieu of a dry-mounting press, but with less efficiency. The iron should contain no water, and its thermostat should be set at a low temperature. Preheat both the print and the board by covering each completely with a sheet of kraft or other paper, and ironing them in a circular motion for about 2 minutes on each side. After tacking the dry-mounting tissue to the back of the print, trim the print borders and center the trimmed print on the mount board. Tack two diagonal corners to the mount board, and cover the print and board with a protective sheet. Then, iron them for several minutes until the print and board are firmly bonded together. Start the ironing motion at the center of the print and move out to each corner to guarantee an even bond.

Prints can be *flush mounted*; that is, dry-mounted without the board showing. The procedure is slightly easier than for dry-mounting since the border of the print does not need to be trimmed until the print and board are bonded together. Also, the print does not need to be centered precisely on the mount board.

To flush mount, attach dry-mounting tissue to the back of the print, then position the print anywhere on the mount board. Tack one corner of the tissue to the board, and place the print and board in the dry-mounting press to attach them. Then the border of the print can be cut off together with the mount board using a utility knife and straightedge (or heavy-duty paper trimmer), and the print is mounted with no borders showing.

A dry-mounting press can be used to flatten fiber-based prints that have curled up after drying. Place the print in the press for 30 seconds or so, and let it cool off under a heavy, flat object. Be sure the print is covered by a protective sheet at all times — in the press and under the weight.

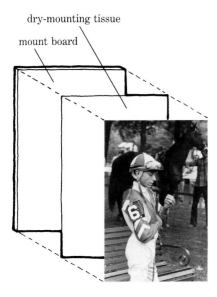

dry-mounting tissue

mount board

A flush-mounted print has no mount board showing.

Framing

Frames protect prints and enhance their appearance. They can be purchased ready-made in standard sizes, or custom-made at a frame shop.

The choice of a frame is both an economic and aesthetic consideration, but the purpose of the frame is to show off the photograph, not to show off the frame. Simple frames made of thin wood or metal moldings usually work best. Use plain colors, such as white, gray, black, gold, or silver.

Prints should be overmatted before being placed in a frame. In that way, the surface of the photograph will be protected from directly touching the glass in the frame. Alternatively, special frames are available with separate slots for the glass and the mounted print to prevent the glass and surface of the print from touching.

CHAPTER 10 | CAMERA ACCESSORIES

Budding photographers are often equipment-minded, constantly asking about this camera or that lens. Some find their main interest becomes equipment and materials; others get confused by the options. What follows is a description of many important and widely used camera accessories. Consider the options, but don't get carried away. It is the person, not the equipment, who ultimately makes a good or a bad photograph.

Filters

Filters are used in front of the camera lens to protect the lens or to effect a variety of tonal changes in the print. Most filters are made of glass, though sheets of gelatin or acetate filters are also available.

Glass filters are cased in a metal or plastic rim. The rim is attached directly to the front of the lens with either a screw or bayonet mounting system. A *screw mount* requires placing the rim flat against the front of the lens, and screwing the filter on. A *bayonet mount* requires a short turn once the filter is positioned against the lens.

Filters come in a variety of sizes, measured in millimeters, to fit different lenses. The sizes represent the diameter of the front of a lens, thus a 52-millimeter filter is needed to fit onto a lens with a 52-millimeter diameter.

Do not confuse the filter size with film format or focal-length measurements. For example, a 35-millimeter camera may have a 50-millimeter lens that takes a 52-millimeter filter. The "35" refers to the film size the camera uses; "50" to the focal length of the lens; and "52" to the diameter of the front of the lens.

Clear filters are used to protect the front of the camera lens, keeping it clear and free from scratching. Some photographers keep clear filters on each lens at all times. At the least, they should be used when photographing near the water, sand, or under any conditions where the lens might be subject to damage. The best protective filters are completely clear glass, skylight, haze, or ultraviolet (U.V.) filters.

Colored filters work to darken or lighten certain colors in the subject and, thus, tones of gray in the image. A filter lightens its own color in the final print, and tends to darken complementary colors.

159

Filters

A print from a negative shot with no filter on the lens. The sky is very light.

A print from a negative of the same subject shot with a yellow filter on the camera lens. Note that the blue sky is darker.

A print from a negative of the same subject shot with a red filter on the camera lens. Note that the blue sky is significantly darker.

A filter fits on the front of the lens.

filter

The reason filters work this way is that they allow more light of their own color to pass through to the film, and tend to absorb light of complementary colors. Therefore, those parts of the subject that are the same color as the filter are rendered denser on the negative and lighter on the print. For example, a red filter allows more reflected light through from a red car, thus the car is rendered denser on the negative and lighter on the print.

Those parts of the subjects that are complementary to the color of the filter are somewhat absorbed when traveling through the lens and are rendered less dense on the negative and darker on the print. The same red filter absorbs light from a blue sky, causing the sky to be lighter on the negative and darker on the subsequent print.

Colored filters are used to darken or lighten certain parts of the photograph. Bright areas, such as blue sky or water, are common problems. They tend to reflect more light than the rest of the subject, and come out too light on a print.

To darken blue sky (or water), place a yellow, green, orange, or red filter over the lens. All these filters will absorb blue light, thus rendering the sky less dense on the negative and darker on the print.

Since black-and-white film produces gray tones instead of colors, areas of two different colors in a subject could register as the same tone in a print. Filters can be used to differentiate these colors. For example, say the subject is a boy wearing bluejeans and a red t-shirt. Both the jeans and shirt may reflect the same amount of light, even though they are different colors. Therefore, both will render equal densities on the negative and print as the same gray tone.

By placing a red filter on the lens, more red light will pass through to the film, rendering the t-shirt denser in the negative and lighter in

the print. The same filter will absorb blue light, rendering the jeans less dense in the negative and darker in the print. In this way, the difference in color between the jeans and t-shirt will be better represented in the final print.

Here is a chart of various filters that illustrates their effect on a black-and-white print:

Filter Color	Colors Lightened	Colors Darkened	Uses
Yellow	Yellow, orange	Blue	Outdoor portraits; sky, landscapes
Green	Green	Red, blue, violet	More dramatic outdoor portraits and sky; lightens foliage
Orange	Orange, red	Blue, green	Adds more contrast than yellow or green, darkens skies more
Red	Red, orange	Blue, green	Most contrast and darkening of skies; not good for portraits

Most filters are available in a variety of densities — light, medium, and dark. The denser the filter, the more pronounced the effect.

Here are two special filters that are sometimes used for black-and-white photography.

A *polarizing filter* acts to minimize reflection or glare from a subject, such as occurs when photographing a shiny object or through a glass window. It fits onto the front of the lens, like any other filter, and is rotated until the reflection or glare is reduced or eliminated. To reduce reflection, a polarizing filter works best when positioned at an angle to the subject, not directly facing it.

A *neutral-density filter* uniformly absorbs some of the light that reaches the film, without affecting the tones of the final print. It can be used when there is too much light in the subject for a desired effect or with fast films on a bright day.

Because neutral-density filters cut down on the light reaching the film, the aperture must be opened or the shutter speed slowed down when using them. The result is either less depth of field or more potential blurring owing to subject movement.

Polarizing filter

A print from a negative shot with no filter on the lens. Note the glare reflecting off the subject — a storefront.

A print from a negative of the same subject shot with a polarizing filter on the lens to reduce the glare.

Every 0.30 density on these filters cuts down the light by the equivalent of one full f-stop. So, if the meter reads f 4 at 1/60, use a 0.30 neutral-density filter for an exposure of f 2.8 at 1/60 (for less depth of field) or f 4 at 1/30 (for a more blurred subject). To cut down the light by the equivalent of two f-stops, use a 0.60 filter, and so forth.

Most colored filters also cut down the amount of light passing through the lens and reaching the film. Thus when using filters, additional film exposure is needed. Each filter has a *filter factor* that indicates how much extra exposure is needed when using that filter. These factors are printed on the rim of the filter or in the accompanying instruction sheet. Some typical filter factors are:

yellow	2×
green	4×
orange	4×
red	8×
polarizing	4×

These factors vary with the brand of filter used, and the relative darkness of the specific filter; for example, some manufacturers offer both a light- and dark-green filter; one may have a filter factor of 2×, the other of 4×.

Here is a chart indicating the amount of extra exposure that is needed to compensate for various filter factors:

If the filter factor is . . .	Add the equivalent of . . .
1.5x	⅔ f-stop
2x	1 f-stop
3x	1 ⅔ f-stop
4x	2 f-stops
6x	2 ⅔ f-stops
8x	3 f-stops
12x	3 ⅔ f-stops
16x	4 f-stops

If a meter reads f 8 at 1/250, and a yellow filter with a factor of 2× is used, adjust that exposure by the equivalent of one f-stop to f 5.6 at 1/250 or f 8 at 1/125. If a filter with a factor of 6× is used and the metered exposure is f 8 at 1/250, adjust by the equivalent of 2⅔ f-stops to between f 2.8 and f 4 at 1/250, between f 4 and f 5.6 at

1/125, or between f 5.6 and f 8 at 1/60. (For a change of 2/3 of an f-stop, an approximate setting between two designated stops on the lens should suffice.)

Cameras with through-the-lens metering systems automatically compensate for the filter factor, since they read the light after it has been filtered. With these cameras, simply screw the filter on the lens, and meter normally. Or, use the camera in its automatic mode and ignore the filter factor.

When a separate hand-held light meter is used, the extra light needed must be calculated with each exposure, or the ASA setting on the meter changed. For example, a yellow filter with a factor of 2× needs twice as much light as no filter at all. If the film speed is 400 ASA, set the meter at 200 ASA instead. The meter will suggest twice as much exposure as it would if it were set at 400 ASA, and will then calculate automatically for the 2× filter. (Be sure to change the ASA setting back to the original film speed when the filter is removed.)

Flash

Flash units provide a convenient source of artificial lighting when the existing light is inadequate. Most are small and portable, and can be attached directly to the camera. Larger, bulkier models are available for studio photography.

Flash lighting comes in various forms. The earliest units, long since outmoded, held powdered explosives. When the photographer lit the powder, it exploded with a flash that provided the light necessary to expose the film.

Flash bulbs replaced powdered flash. These were far safer and more reliable, but each bulb still held only one flash. Photographers had to carry around a supply adequate for a day of work. Besides, the process of replacing bulbs after each exposure was inconvenient and time-consuming. Flash bulbs are still in use, but mostly for simple cameras. With these cameras, cubes and bars, each containing several flash bulbs, have all but replaced the traditional "one-shot" bulb.

Today, *electronic flash* (sometimes called *strobe*) is widely used by both snapshooters and "serious" photographers. Consisting of a reusable tube powered by a battery (or household current), electronic flash provides a convenient, efficient, and invaluable auxiliary lighting source.

When using flash, the burst of light must *synchronize* with the camera shutter. That is, the flash must go off when the shutter is wide open.

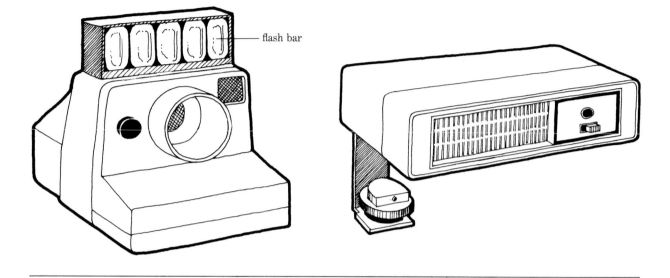

flash bar

Flash bars contain several flash bulbs.

An electronic flash unit.

The mechanics of synchronization vary with the type of flash or camera used. However, regardless of type, the flash unit must connect electrically with the shutter. Sometimes this is done with a *pc* (or *synch*) cord, which is attached to both the flash unit and the camera body; the contact point on the camera body connects internally to the camera shutter. Some cameras offer a choice of "M" or "X" synchronization contacts. "M" is for when flash bulbs are used; "X" for electronic flash.

Most modern cameras contain an attachment, called a *hot shoe*, that serves the same purpose as a pc cord. A *shoe* is a slotted coupling, usually located on the camera body, that allows a flash unit to be attached to the body. A *hot shoe* incorporates an electric contact that connects directly to the shutter, and allows the flash and shutter to be synchronized without the use of a pc cord.

Focal-plane shutters, commonly found in single-lens reflex cameras, synchronize with electronic flash only at slow shutter speeds, usually 1/60 and slower (though some synchronize at 1/125). If a faster shutter speed is used, the shutter will cover part of the film while the flash goes off, and only a section of the image will register on the film.

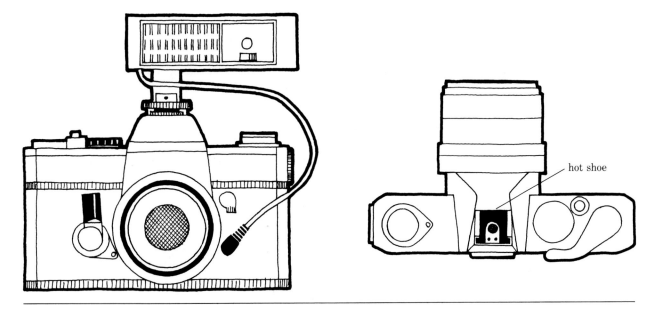

A flash unit attached to a camera with a pc cord for synchronizing the flash with the shutter.

A hot shoe contains an electrical contact for synchronizing the flash to the shutter (top view).

Leaf shutters, commonly found in most rangefinder, twin-lens reflex, and view cameras, synchronize with electronic flash at any shutter speed.

Film exposure with flash is figured differently than with natural light. The most important factors in determining exposure with flash are *distance* and *f-stop*. Shutter speed is rarely a factor, being important primarily for synchronizing with the flash output.

Distance. As the distance between the flash unit and the subject increases, the amount of the light that reaches and then reflects off the subject decreases — dramatically. A flash situated 10 feet from a subject generates four times as much reflected light as the same flash located 20 feet from the same subject.

Distance is figured from the flash unit to the subject. Most of the time, flash units are situated on the camera and fired directly at the subject. In these cases flash-to-subject distance is the same as camera-to-subject distance, and measurable on the distance scale located on the camera lens.

Sometimes flash light is bounced off ceilings or walls to soften the

Flash

When existing light is inadequate, such as indoors or outdoors at night, flash can provide enough additional light to allow for a good exposure.

lighting effect, or used off camera to create or "fill in" shadows. In either case, the actual distance the flash light travels (not the camera-to-subject distance) must be calculated, either by measuring or guessing that distance. Often a close guess will suffice since some latitude does exist. A subject at a distance 10 feet from the flash, for example, will need about the same exposure as a subject 8 feet away.

F-stop. The lens aperture must be opened wider as the distance from the flash to the subject increases, and closed up as the distance decreases. Additional distance means reduced illumination. For example, if a flash located 10 feet from the subject needs an aperture of f 11, the same flash located 20 feet from the same subject will need

A negative made with a flash attached to an SLR camera with a focal-plane shutter set at 1/250 — too fast a speed to synchronize with the flash. As a result, the shutter covers part of the film while the flash goes off, and only part of the film registers the image.

f 5.6. Since the flash illumination has been reduced by one-fourth, the lens must be opened up by two f-stops.

While distance and f-stop are the primary factors in controlling film exposure, film speed and quantity of light must also be considered.

Film speed. The faster the film, the more quickly it accepts light, and the smaller the needed aperture to make a good exposure. This is true, of course, whether using flash or not.

Quantity of light. The more powerful the flash unit, the more light it produces, and the smaller the needed lens opening. The power of a flash varies widely from model to model.

The key to figuring flash exposure is to determine what aperture must be set on the camera lens. This f-stop can be computed either by using exposure tables or guide numbers. Most flash units have exposure tables printed on them. Sometimes these tables are blocked out numerically, and sometimes they are printed in dial form. To use either type, simply match up the film speed and flash-to-subject distance to determine the appropriate f-stop.

Another way to determine exposure with flash is to use a formula based on the *guide number* of the flash unit. The guide number is a quantitative indication of the intensity of the flash. Check the instruction booklet that comes with the flash for the guide number. The formula for determining the correct aperture with flash is:

f-stop = guide number ÷ flash-to-subject distance

If the guide number of a given flash unit is 80, and the flash-to-subject distance is 10 feet, then use f 8 (8 = 80 ÷ 10).

Guide numbers vary with film speed. A flash unit with a guide number of 80 for 32 ASA film has a guide number of 110 for 64 ASA film. So when figuring exposure, be sure to factor the correct guide number for the film speed used.

Nearly all current electronic flash units feature "automatic" exposure, thus eliminating the need to figure exposure by tables, dials, or guide numbers. Most work in a similar manner. The film speed and f-stop are set on a dial on the flash unit. When the flash fires, a light-sensitive cell (called a *sensor*) on the flash unit (or in the camera) reads the amount of light that reflects off the subject back to the camera. When the correct amount of light required to expose the film (remember the sensor "knows" the film speed and f-stop) has reflected back, the sensor causes the flash duration to be cut short.

Automatic, *dedicated* flash units require even less work. Just set the film speed and fire. Light reflecting back to the film is read off the flash unit (or the film plane on some cameras), and computed in such a way that the correct shutter speed and f-stop for that amount of light are set automatically.

Current flash models are increasingly more automatic, sophisticated, and easy to use. Distance does not have to be calculated after each exposure; f-stops rarely need changing. Totally manual flash units are still available, but most are either low-priced and low in power, or extremely large and powerful, practical for studio use only.

However, many automatic flash units have a manual mode. To use a flash manually, calculate the correct f-stop by measuring the flash-to-subject distance, and then using the exposure dial on the flash unit or dividing that distance into the guide number of the unit. Set the lens at the resulting calculated f-stop and fire away.

A problem with automatic flash is its tendency to treat all subjects in a similar way. As such, it works well most of the time, but can be "fooled" in certain situations. For example, in a light-colored room with a dark subject, the flash may reflect far more light from the walls than from the subject, causing the sensor to cut off the light too soon to render good subject detail.

Or, the sensor may misjudge which subject to read. If a bright object stands between the flash and the main subject, the sensor may register that object rather than the subject, cut the flash duration short, and cause an underexposed negative.

There are several ways to guarantee good flash exposure in difficult situations. If in doubt, use the manual mode on the flash, and calculate the f-stop for the given flash-to-subject distance.

Or, fool the flash unit by deliberately setting it for either a higher or lower film speed. If underexposed results are likely, set the speed lower (use 200 ASA rather than 400 ASA) to allow more light in. If overexposed results are likely, set the speed higher (use 800 ASA instead of 400 ASA) to allow less light in.

Or, use the flash in the automatic mode and set the aperture one stop wider than indicated (say, f 8 instead of f 11) to compensate for underexposure; or set it one stop smaller than indicated (say, f 16 instead of f 11) to compensate for underexposure.

The placement of the flash unit affects the shadows cast by the subject. Think of a bright, sunny day and how the sun — the light source — creates shadows. Flash creates shadows in a similar way, and can strongly influence the overall look of a picture.

When the flash is mounted on top of a camera (over the lens), most of the shadows fall directly in back of the subject. As such, they are not particularly visible.

When the flash is mounted on the side of a camera, a shadow is cast on the opposite side of the subject. To create a more dramatic shadow effect, hold the flash off to one side of the camera with the help of an extension flash cord.

When figuring exposure with a nonautomatic flash, remember to figure the distance from the flash to the subject, not from the camera to the subject. For an automatic flash to continue to work automatically when used off camera, a *remote sensor* must be attached to the camera to read the flash light reflecting back.

Flash light, because it is direct and casts shadows, can produce harsh-looking results. One way to soften that harshness is to *bounce* (or reflect) the flash light off a white ceiling or wall. Bounced light is more diffuse, thus softer than direct light.

To bounce light, aim the flash at an angle toward the ceiling (or wall), so it will reflect toward the subject. The light must travel a greater distance when bounced, so to figure exposure in a manual mode, be sure to calculate the total distance traveled, not the camera-to-subject distance. For example, if the flash is 6 feet from the subject, but aimed at the ceiling, calculate the distance the light travels from the flash to the ceiling (say, 4 feet) and back to the subject (say, 6 feet), and use the total distance (10 feet) to calculate exposure. Automatic flash units with remote sensors will calculate automatically the needed exposure when light is being bounced.

A relatively powerful flash is needed when bouncing light because of the additional distance the light must travel. Also, the reflecting surface (here, the ceiling) usually absorbs some of the light, so a little more exposure than indicated may be required.

Another way to soften light is to diffuse it. Accessory kits, containing a plastic diffuser, are available for some flash units. A homemade diffuser is easily constructed by taping tissue or tracing paper directly

Direct flash

Here, the flash unit was positioned on the camera, to the left of the lens, aiming directly at the subject. Note the harsh shadows.

Flash directed at the subject.

Bounced flash

Here the flash unit was positioned on the camera, pointing at the ceiling. The light reflecting off the ceiling is more diffuse and softer than direct light.

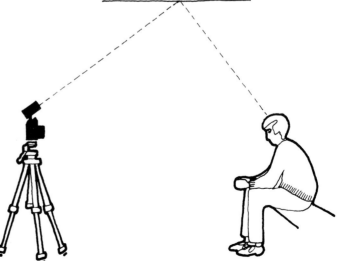

Flash bounced off the ceiling to the subject.

over the flash head. The diffuser breaks up light rays traveling through it, creating a softer light.

More exposure (or more flash light) is needed when using a diffuser. Automatic flash units will calculate and adjust for the required change. With manual units, a wider aperture by the equivalent of about one or two f-stops is needed, depending on the density of the diffusing material.

There are a wide variety of flash units available. Here are the important features to look for:

> **power**
> **power source**
> **recycling time**
> **size and portability**
> **energy used**

Power. Generally, the greater the power, the more desirable (and expensive) the unit. More power means the flash will operate at greater distance; will allow the use of smaller apertures, thus produce images with greater depth of field; and will more easily permit bouncing or diffusing for softer light.

The guide number of a flash unit indicates its power. The higher the number (at a given film speed), the greater the power.

Power source. Electronic flash units are commonly powered by any of the following sources: alkaline batteries (usually size AA, though occasionally 510 volt or size D), rechargeable batteries (nickel-cadmium), or standard AC household current. Some units can use more than one power source.

Alkaline batteries drain quickly and must be constantly replaced, but they are always available when needed. Rechargeable batteries are cheaper to operate, but may run out of juice at inopportune times. Household current is cheapest and most consistent, but is the least portable since it can only be used where there is an available electrical outlet.

Recycling time. The time it takes a flash to reach full power again after firing is called its *recycling time.* Some units recycle in a short span of time — 1 second or less — while others may require 5 seconds or longer. As a battery loses power, the flash needs more time to recycle.

Size and portability. Larger and less portable flash units generally have more power and quicker recycling times. Many have external power sources, called battery packs, that must be carried separately, over the shoulder or in a jacket pocket.

Energy used. Many flash units have energy-saving features that save money by prolonging the life of the battery. *Thyristor circuitry* is one such feature. It retains unused electric power in the capacitor of the unit (where energy is stored). In non-thyristor automatic units, when the flash duration is cut short for correct exposure, the remaining power (the difference between the maximum duration and that which is used) is discarded. In a thyristor unit, that energy is stored for reuse.

Another energy-saving feature is a power reduction switch. This allows the flash to be used at fractions of the maximum power of the unit. When less power is used, more energy is stored and this leads to longer battery life. Power reduction also means quicker recycling time, since the flash unit needs less power to recharge fully.

Despite the multitude of choices to be made when choosing flash equipment, all flash units have the same purpose: to provide an efficient, convenient, and portable artificial lighting source. The main consideration must be: will a flash be useful at all?

Most people prefer natural lighting, but under low-light conditions a flash is often a necessity. To fully understand flash, learn to use it manually (if it has a manual mode). Then use the automatic mode, when appropriate, for simple and quick handling.

Close-up Equipment

Rangefinder and twin-lens reflex cameras are fundamentally unsuited for close-up photography; most focus no closer to the subject than 3 feet.

Single-lens reflex and view cameras are more suited for close-up work than other types of cameras. SLRs usually focus as close as 18 inches, and view cameras allow focus at even closer range.

There are several accessories that allow cameras to focus even closer to the subject. The following are particularly useful for working with single-lens reflex cameras:

extension tubes
close-up lenses
macro lenses
bellows

Keep in mind that subjects focused close up will have very little depth of field, since distance to subject is one of the primary factors that controls depth of field.

Extension tubes fit between the lens and camera body. They come in sets — each tube with specified distance ranges. Extension tubes

Close-up attachments

An extension tube.

Close-up lenses.

Bellows.

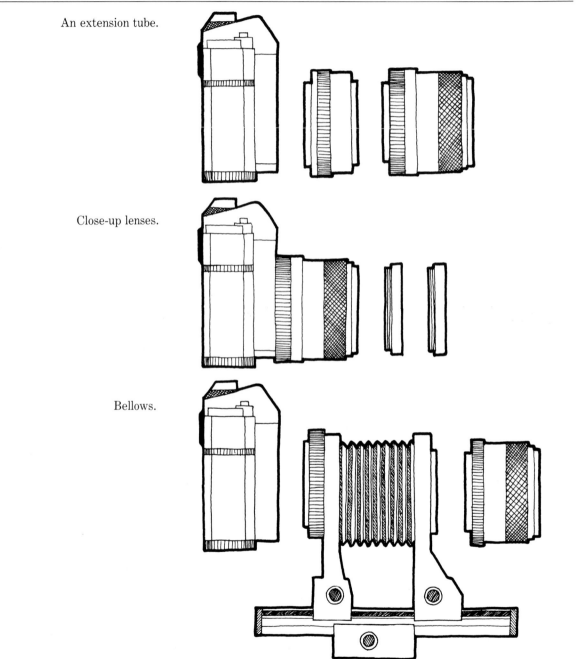

can be used singly or in combination to provide a variety of close-focusing choices. The longer the tube, the closer the lens can focus. Extension tubes provide an inexpensive method of close-up photography, though they are somewhat bulky to use and may slightly reduce image sharpness.

Close-up lenses are attached to the front of a lens, much like a filter. They are available in various magnifications, again generally in sets, each providing a certain close-focusing distance range. Close-up lenses can also be used singly or in combination. They are compact, easy to use, and inexpensive, but may also cause a slight reduction in image sharpness.

Macro lenses are accessory lenses that are able to focus up to about 8 or 9 inches away from the subject. Some models have accessory tubes that allow focusing as close as 2 inches or so. They are compact, and produce sharp, high-quality images. However, macro lenses are expensive; they cost as much as or more than most accessory lenses.

Bellows are collapsible cardboard or cloth tubes. Like extension tubes, they fit between the lens and the camera body. Bellows expand and contract much like an accordion, allowing a wide range of close-focusing possibilities. They provide good-quality image results, but are bulky and best used on a tripod.

While macro and close-up lenses require no exposure adjustments, exposure can be a problem when using extension tubes or bellows. These accessories extend the distance from the lens to the film, so the amount of light reaching the film gets reduced, and additional exposure is needed to compensate.

The best solution to the exposure problem is to use a through-the-lens meter and read light off a gray card positioned in front of the subject. Also, use a fast film if possible. A tripod is useful to allow a slower shutter speed and smaller aperture. Depth of field at close distances is minimal, so a small aperture is recommended.

Exposure corrections must be figured mathematically if through-the-lens metering is not available. Extension tubes have factor numbers to indicate the needed adjustments. These factors work like filter factors; for a 2× factor, the exposure must be doubled, and so forth. If the indicated meter reading is f 8 at 1/60, an extension tube with a 2× factor needs the equivalent of one f-stop more exposure, so f 5.6 at 1/60 or f 8 at 1/30.

Computing the needed exposure adjustment when using bellows is complicated but necessary. First, convert the following information into inches: the focal length of the lens used and the length of the

A subject focused close up, from 3 inches away from the camera. Note the minimum depth of field at a close focus distance.

bellows when the image is focused. (One inch is approximately equal to 25 millimeters.) So, let's say that the focal length of the lens is 50 millimeters (or 2 inches), and the length of the bellows is 4 inches.

Next, take a meter reading of the subject. Let's say that the reading is f 11 at 1/8.

The purpose of the calculation is to find a new shutter speed that will allow enough more light to reach the film to compensate for the reduction in light caused by the bellows expansion. Here are the figures again for the above example:

focal length of lens = 2 inches
length of bellows = 4 inches
metered shutter speed = 1/8

178

Call the new shutter speed to be calculated "X," and plug in the above figures to this formula:

$$\frac{\textbf{(focal length of lens)}^2}{\textbf{(length of bellows)}^2} = \frac{\textbf{metered shutter speed}}{\textbf{corrected shutter speed}}$$

$$\frac{(2)^2}{(4)^2} = \frac{1/8}{X}$$

$$\frac{4}{16} = \frac{1/8}{X}$$

$$4X = 2$$

$$X = 1/2$$

So, the corrected shutter speed is 1/2, and the new exposure to compensate for the bellows factor is f 11 at 1/2.

If the corrected exposure is 1 second or longer, an additional adjustment must be made to allow for reciprocity failure. See chapter 5 for the chart on exposure corrections with reciprocity failure.

The main exposure mistake in close-up work is underexposure, so be sure to let in enough light. If possible, increase the indicated exposure to ensure at least one well-exposed negative. If f 11 at 1/2 is the indicated exposure, shoot a second exposure allowing in twice as much light, either f 11 at 1 second or f 8 at 1/2.

Useful Tools

Here are a few more of the most useful camera accessories readily available at any good camera store:

> **tripod**
> **cable relese**
> **lens shade**
> **utility case**
> **photofloods and reflectors**
> **lens tissue paper and cleaning solution**
> **motor drive or power winder**

A *tripod* is a stand that attaches to the bottom of the camera and steadies it. Tripods are available in many different sizes and models, but generally have three legs (though monopods, one-legged tripods, are available) and adjustments for moving the camera. These adjustments allow for lifting, turning, and tilting the camera while it is attached to the tripod.

A tripod.

179

Tripod

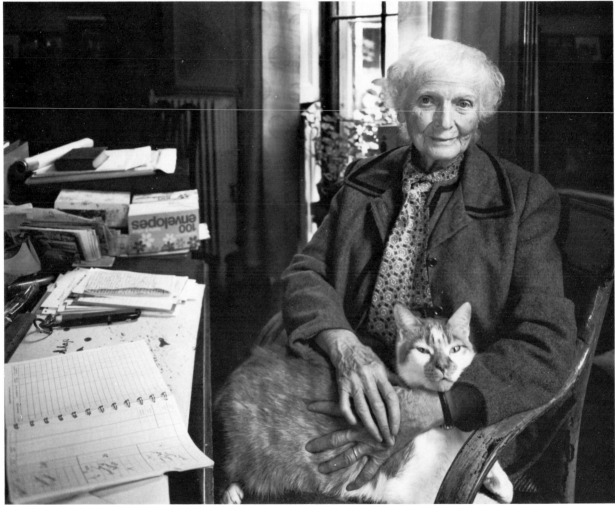

This photograph, taken in low light,
needed a slow shutter speed — 1/8
of a second — so required a tripod
to hold the camera steady.

A cable release.

The most important consideration in buying a tripod is that it be sturdy enough to hold the camera steady. A small, inexpensive tripod is adequate to hold most 35-millimeter cameras, but a heavier-duty model is needed for larger cameras.

A tripod is particularly useful when shooting close-ups, or using a telephoto lens, or when making exposures of longer than 1/60 — all situations that require extra camera stability.

Photographing with a camera on a tripod is a slower process and requires more care than photographing "hand-held." However, since the camera position can be carefully controlled and steadied with a tripod, there is time for precisely framing and composing the picture. Tripods are clearly not practical for candid photography and fast-shooting situations.

A *cable release* is a cloth- or metal-covered wire that screws onto the shutter button. It allows an exposure to be made while the photographer stands away from the camera.

Generally a cable release is used when the camera is on a tripod. It

Flare

A print with flare at its top edge. A lens shade could have been used on the camera lens to block the light and reduce or eliminate the flare.

lens shade

helps reduce the chance of camera movement, since it exerts a gentle and even pressure on the shutter release.

A *lens shade* is made of metal or rubber and attaches to the front of a camera lens. It helps prevent excess light from entering the lens and causing *flare* — non-image light that appears as dark spots or streaks on the negative (and light spots or streaks on the print) — or lower image contrast. Lens shades are particularly useful when the subject contains a lot of reflected light, such as on bright, sunny days.

Be sure that the lens shade fits the focal length of the lens it is protecting. The wider the lens, the wider the shade must be. A shade made for a telephoto lens and used on a wide-angle lens will block light from the corners and edges of the negative, and cause *vignetting*; that is, the print will be lighter at its corners and edges than at its center.

A *utility case* is a bag used for carrying and protecting cameras, lenses, accessories, and film. It keeps equipment together in a compact and portable way. Good utility cases have subdivisions for different pieces of equipment. Some models have shoulder straps; others have handles, or even straps for backpacking.

A lens shade that is too small for the focal-length lens used can block light from the corners of the film and cause vignetting.

© JIM DOW

A photoflood housed in a reflector on a light stand.

Photofloods and reflectors, like flash, provide a source of artificial light for picture-taking indoors or in other dimly lit conditions. Photofloods are like ordinary light bulbs, but more powerful: 250, 500, or 1000 watts. Reflectors are curved metal units that house photofloods, and help direct light in a particular direction. They can be positioned on top of a *light stand* — a tripodlike device — or directly onto an existing object, like a table, with a clamp accessory.

Lens tissue paper and cleaning solution are used for cleaning smudges and dirt off lenses. To use, apply very little solution and rub the front of the lens gently with the tissue. A chamois or an antistatic cloth can be used instead of lens tissue. However, since these cloths are reusable, be sure to keep them clean or they may scratch the lens.

A *motor drive* or *power winder* attaches to the bottom of the camera body and automatically advances and exposes film in rapid succession. Motor drives are faster, thus deliver more frames per second than power winders.

Either accessory is ideal for sports and other types of action photography where the picture possibilities change rapidly. Both are expensive, drain batteries, and use up a lot of film.

A motor drive.

184

CHAPTER 11 | ALTERNATIVE TECHNIQUES, PROCESSES, AND MATERIALS

So far, the most commonly used black-and-white techniques, processes, and materials have been covered. However, there are many less widely used approaches. This chapter includes some of these alternatives. Often called "experimental," many alternative approaches have, in fact, been in use for decades.

High Contrast

High-contrast prints have black shadows and white highlights with little or no detail in either. Gray tones are minimal or nonexistent. Extremely high-contrast prints are pure black and white.

There are two basic methods for making high-contrast prints. Either make a high-contrast negative and print it; or use a high-contrast printing technique.

Shooting for high-contrast negatives. High-contrast negatives can be made either by shooting with special high-contrast film, or manipulating film exposure and development. Neither technique guarantees a totally black-and-white print. However, the higher the contrast of the original subject, the easier it is to achieve a very high-contrast print.

Several brands of high-contrast copy film are available for special applications, such as the copying of line drawings. Most brands are available in sheet form. Kodak Technical Pan is a 35-millimeter high-contrast film, as is Kodak Kodalith film, which is packaged only in 100-foot bulk rolls. (See Appendix Two for an explanation of bulk films.)

Copy films are "slow." They produce sharp, fine-grain negatives that make excellent enlargements. Most copy films are *orthochromatic* — not sensitive to red light — so they can be handled in a room illuminated by red safelights.

Copy film is shot like any other film. Set the film speed on the light meter, take a reading, and follow the meter's f-stop and shutter-speed recommendations. Because of the slow film speeds, a tripod may be needed.

A high-contrast print — black and white with no grays.

© J. SEELEY

Development varies slightly from other films. A special high-contrast developer should be used for the best results. Develop for the time recommended by the manufacturer, and then stop, fix, and wash the film for about half the time that regular films need.

High-contrast negatives may also be made by manipulating the exposure and development of normal films by underexposing and overdeveloping (see chapter 7 for details). This will not turn a negative into a totally black-and-white image (unless the subject contrast is extremely high), but the negative contrast will be heightened. However, the increased developing time will also increase the grain of the negative.

The primary advantage to this approach is in maximizing film speed. Copy films may give higher-contrast results and finer grain, but they are slow.

Printing a negative for high-contrast results. There are two ways to make a high-contrast print from an existing negative: manipulate the printing process, or transfer the negative onto high-contrast film and then print it.

The easiest way to make a high-contrast print is to use high-contrast printing paper. A #5-grade paper will always give a higher-contrast result than a #2-grade paper. If the negative has a lot of contrast to begin with, a #5 paper will make a print with few, if any, gray tones. If the negative has normal or low contrast, the high-grade paper will merely increase that contrast.

Processing solutions can be altered to increase print contrast somewhat, though not dramatically. The greater the concentration of the print developer, the higher the print contrast. Use stock solution of the developer rather than diluting it according to the manufacturers' instructions.

Also, heating up the developer and extending the developing time will increase print contrast somewhat. For example, using an 80° developer and doubling the recommended developing time will make a noticeable difference. Take care when using resin-coated papers: a hot developing solution may melt the plastic.

The best way to guarantee a totally black-and-white print is to transfer an existing negative onto a sheet of high-contrast copy film, such as Kodak Kodalith. This film is similar to Kodalith roll film, except it is sold in a variety of sheet sizes; 4″ × 5″ Kodalith is economical and easy to use for making enlargements.

Kodalith sheet film is handled just like printing paper. Use a darkroom illuminated by red safelights (the film is orthochromatic), and project a negative in the enlarger onto a sheet of Kodalith film. Make a test strip to determine the exposure, and process the sheet of Kodalith in trays with Kodalith high-contrast film developer. (Undiluted print developer will also work, but not as well.) Use the same stop bath, fixer, and fixer remover as for prints. Processing times vary with the materials and the solutions used, but try:

developer	2 minutes
stop bath	10 seconds
film fixer	2 minutes
fixer remover	1 minute
wash	3 minutes

The longer the developing time, the higher the contrast.

Wash the Kodalith film — one sheet at a time — in a tray with care to avoid scratching it. Use a gentle stream of water from a tray siphon or a faucet, and change the water in the tray several times during the wash.

Soak the film for a few seconds in a tray of wetting agent, then hang it to dry. The drying process takes about 30 minutes.

The Kodalith image will have more contrast than the original negative, but it will be a positive. Since a negative is needed, contact-print the film positive onto another sheet of Kodalith. To do so, position the unexposed film, emulsion side up, under the enlarger. Put the film positive, emulsion side down, on top of the unexposed Kodalith, and use a clean, scratch-free piece of glass to hold them flat against each other. Make a test strip to determine exposure, process it, and determine the correct exposure needed. Once the exposure is determined, use a fresh sheet of Kodalith to make the exposure. Process, wash, and dry. The new Kodalith negative will have even higher contrast than the film positive.

Depending on the contrast of the original negative, this process may have to be repeated more than once to produce a totally black-and-white print. Try printing the new negative on a #5-grade paper to see if it will render high enough contrast. If not, keep contact-printing to make positives and negatives of increasingly greater contrast until the desired results are achieved.

A 4″ × 5″ enlarger is needed to print the 4″ × 5″ Kodalith negative. If such an enlarger is not available, the negative can be contact-printed onto a sheet of printing paper to make a small — 4″ × 5″ — print. As an alternative, start the entire process with larger sheets of Kodalith, perhaps 8″ × 10″, and make a contact print from these sheets. An 8″ × 10″ Kodalith will make an 8″ × 10″ contact print.

Another alternative is to contact-print the original negative onto a small piece of Kodalith. If the original negative is 35 millimeters, the result will be a 35-millimeter positive that can be contact-printed to make a 35-millimeter Kodalith negative. This negative can then be printed in most enlargers to the desired size.

Many of these methods for making high-contrast prints can be combined. For example, a high-contrast negative made with Kodalith film can be printed on #5-grade paper, and processed in hot developer for even greater contrast. Or, Kodalith film can be underexposed and overdeveloped to increase its contrast.

These techniques are useful not only for making high-contrast prints, but also for improving negatives that are underexposed, under-developed, or simply shot under extremely low-contrast lighting conditions. For example, an extremely "flat" negative can be transferred onto Kodalith film, which can then be contact-printed to make a more printable, higher-contrast negative.

Solarization and the Sabattier Effect

Grossly overexposed film in the camera actually reverses itself once developed. Highlight areas become less dense and shadow areas more dense. This reversed effect is called *solarization*.

The *Sabattier effect* refers to reexposing film or paper during development to render a silvery, almost eerie image, often containing distinct white or light lines separating the highlight and shadow areas.

The Sabattier effect is usually referred to as solarization. Strictly, this is inaccurate, but the misconception is so widespread as to be commonly accepted. Therefore, in this text reexposed negatives and prints will be referred to as "solarized."

Solarization creates a partially reversed image with an unusual negative and positive appearance. Lightly exposed areas (shadows on film and highlights on prints) are most affected since these are areas that prior to solarization have retained a lot of unexposed silver; with reexposure, because they have much silver left to respond to light, they become more dense. Highly exposed areas (highlights on film and shadows on prints) are barely affected since these are areas that already have a lot of density prior to reexposure, so the additional light does not affect them as much.

A solarized print.

© JIM STONE

189

The distinct lines separating the highlight and shadow areas are called *Mackie lines*. These are caused when chemical by-products from the first part of the development retard additional development. The results are lines of low density, rendering as light on both a solarized negative (therefore dark on a print of that negative) and a solarized print. Mackie lines show up more dramatically on solarized negatives than on solarized prints.

To solarize:

1. *Develop and agitate the film or paper normally.*

2. *One-third to halfway through the development* (for prints, when the image begins to form), *remove the film or paper from the developer and put it in a tank or tray of water* for about 10 seconds, without agitation, to slow up the development process.

3. *Now reexpose the film or paper to light briefly* (usually no more than 2 seconds), using a low-power bulb (15 to 25 watts) positioned 3 or 4 feet away. With roll film, be sure all parts of the film receive equal amounts of reexposure by taking the film off the reel and holding it taut at an equal distance from the bulb. Have another person in the darkroom ready to turn the light on and off.

4. *Put the film or paper back into the developer for the remaining development time.* Agitate normally.

5. *Stop, fix, and wash the film or paper normally.*

Exposure time varies widely depending on several factors, such as the type of film or paper used, the size of the light bulb, and the distance from the film or paper to the bulb. Experiment or make test strips to determine the reexposure time for a specific film or print. Try a fraction of a second of reexposure for film and 2 seconds for paper as a starting point.

Here are some suggestions for maximizing the results when solarizing:

· Slow films are easier to work with since fast films are likely to require an extraordinarily short reexposure time.

· High-contrast-grade papers give a more dramatic solarized effect than do lower-contrast grades, particularly since solarization has the added effect of lowering image contrast.

· Use a negative with a lot of shadow area or a print with a lot of highlights for maximum effect, since reexposure affects these areas most.

· Sheet films are easier to use for solarization than roll films. Try enlarging a 35-millimeter negative onto Kodalith film, then making a Kodalith negative, and solarizing that negative during development. The additional advantage to this method is that the original negative

remains intact, so if the solarization is not successful, the process can be repeated. Also, this way the original negative can still be used for a normal print, if desired.

· A solarized print is difficult to reproduce exactly, whereas a solarized negative can be reprinted often, with consistency.

· Underexpose the film or paper slightly prior to reexposure. Start by exposing film for the equivalent of one f-stop less than the meter suggests; and exposing prints for 15% to 20% less than the test strip suggests. Alter these figures according to experience.

· With prints, use a more diluted developer than normal. If the manufacturer recommends diluting 1 part of print developer to 2 parts of water, dilute it 1-to-4 instead.

Photograms

Photograms, sometimes known as *shadow pictures*, are photographs made without a camera by positioning objects between a light source and photographic film or paper. The resulting image consists of shapes, forms, and tones that vary widely depending on the types of objects and how they are used.

To make a typical photogram:

1. *Raise the enlarger head* high enough so that the circle of light projected by the lens will cover an entire sheet of film or paper.

2. *Close the lens down to a small opening*, say f 16.

3. *Position a piece of sheet film or photographic paper, emulsion side up, on the base of an enlarger, directly under the enlarger lens.* (An enlarger provides a convenient and controlled source of light, but a low-watt light bulb suspended 3 or 4 feet above the film or paper will also work.) Any sheet film can be used, but slow-speed films that can be handled under a safelight, such as Kodak Fine-Grain Positive (for a wide range of gray tones) or Kodalith (for high contrast), are preferable. The light-sensitive material can be held flat, if desired, in an easel, although film or paper does not necessarily need to be flat for a successful photogram.

4. *Place one or more objects either on or just above the light-sensitive material.*

5. *Turn on the enlarger for a short period of time*, say 5 seconds, and expose the film or paper.

6. *Process the exposed material normally in trays.*

7. *Examine the image* and decide whether to expose an additional sheet for more or less time, or whether to alter the types of objects used or how they are positioned.

An opaque object will block all light from reaching the film or paper

A photogram.

and be rendered as a silhouette. A translucent object will allow some light through and will be rendered as one or more gray tones.

Photograms often have a plain background of black, gray, or white, representing areas that have received full exposure from the light source. If film is used to make the image, the background is dark on the negative and light on the print; if paper is used, the background is dark.

Correct exposures are difficult to judge, since photograms are not literal images; they can be rendered in many different ways. Long

192

exposures allow more light to travel through translucent objects, and make a different kind of picture than shorter exposures. Test strips have value in determining the exposure required to create a certain shade of gray or solid black on the film or printing paper.

A wide variety of objects and techniques can be used to make a photogram. Objects from nature, such as leaves, vegetables, and feathers, work well. Moving objects, such as smoke blown between the light source and the sensitized material, can add a nice variety of tonalities to the image. Painted shapes or forms on a piece of glass offer another option. Place the painted glass over the film or paper, or place it in the enlarger in lieu of a negative carrier, and make a print of the painted forms.

Negative Prints

Negative prints, like film negatives, have a reversed, rather than a positive image. Dark subjects render as light; light subjects as dark. Well-made negative prints are eye-catching and mysterious, since people are more used to seeing things as they are, rather than in reverse.

Simple negative prints can be made by contact-printing a positive print onto a fresh sheet of paper, using either an enlarger or a low-watt light bulb as a light source. To do so:

1. *Raise the enlarger head* high enough so that the circle of light projected by the lens will cover an entire sheet of film or paper.

2. *Open the enlarging lens to its widest aperture*, say f 4. The exposure will be relatively long since the light must penetrate the paper base of the positive print.

3. *Position the unexposed sheet of paper under the enlarger (or light source), emulsion side up.*

4. *Put the positive print facedown on the unexposed paper.*

5. *Use a clean, scratch-free piece of glass to press the two sheets of paper firmly together.*

6. *Expose the paper for about 20 to 30 seconds*, depending on the type of paper used (resin-coated papers expose more quickly than fiber-based papers) and the density of the positive print (single-weight papers allow light through more quickly than double-weight papers). If the print is too dark, expose another sheet for less time; if it is too light, expose for more time. A test strip can be made first to help determine the accurate exposure time.

7. *Process the print like any other*, and the resulting image will be a negative print.

A negative print.

A preferable method for making a negative print involves first making a film positive and then printing it. The results will be sharper and have a wider range of gray tones than those obtained by contact-printing through a positive print.

To make a film positive, use a sheet film such as Kodalith (for high contrast) or Kodak Fine-Grain Positive (for a wide range of gray tones). Either contact-print or enlarge the original image onto a sheet of this film (refer to the beginning of this chapter for directions). The resulting film positive can then be enlarged or contact-printed to make a good-quality negative print.

194

Sandwiching Negatives

Sandwiching negatives refers to printing two (or more) negatives together to create a multiple image with an unusual, sometimes surreal, quality.

The process for printing sandwiched negatives is the same as for printing a single negative. Put the negatives together, each emulsion side down, in a negative carrier. Project the image to the desired size, and focus. Make a test strip to determine the correct exposure, then expose, develop, stop, and fix the print normally.

Sandwiched negatives are denser than a single negative, so a longer exposure time is required. They also must be dodged and burned for a longer time than single negatives. In addition, because one negative is on top of the other, the lens must be stopped down to a small aperture (try f 11) to guarantee that both negatives print with equal sharpness.

A print from two sandwiched negatives.

© BOBBI CARREY

Since some contrast loss will occur when printing sandwiched negatives, use a high-contrast paper grade or filter number.

Any two negatives can be sandwiched and printed successfully, but it is the rare combination that makes a satisfying print. Use negatives that are compatible. For example, if both negatives have a lot of detail or content, the final image may be confused. Often a simple image, with large areas of tone, say a water scene or clouds, combined with a more complex image, makes the most successful prints.

Infrared Film

Infrared film is sensitive to infrared radiation. It is used primarily in industrial and scientific applications, but can be used for general-purpose photography with interesting effects. Infrared images can be dreamlike and surreal.

Infrared radiation has a long wavelength and cannot be seen by the human eye. Since the film is sensitive to this radiation, the resulting images are rendered in a different way than the eye sees them. For example, blue skies absorb much infrared radiation, so they are rendered lighter on infrared film than on a regular film, and darker on a print; vegetation reflects much infrared so is rendered relatively dark on infrared film and light on a print.

Used without a filter, infrared film records both infrared radiation and visible light, and renders the image in much the same way as regular films. However, the preferred way to use infrared film is with a filter, which absorbs visible light and lets mostly infrared pass through to the film.

A #87 filter blocks all visible light, and produces the most dramatic infrared effects. However, this filter is opaque and must be removed for focusing when using an SLR or other camera with through-the-lens viewing. A dark red (#25) filter allows some visible light, but mostly infrared radiation, to pass. This is a popular filter for use with infrared film. Green (#58) and yellow (#12) filters can also be used, but allow much more visible light to pass through, and produce an image with a less pronounced infrared quality.

Light meters are built to read visible light, not infrared radiation, so exposure using infrared film is tricky. In addition, infrared films have little *latitude* — that is, they do not allow for much error. Use the indicated meter reading at the recommended film-speed rating (200 ASA for Kodak High-Speed Infrared film), and bracket this exposure by the equivalent of one full f-stop on either side. If the indicated reading is f 8 at 1/60, also make exposures of f 5.6 at 1/60 and f 11 at 1/60.

Infrared film

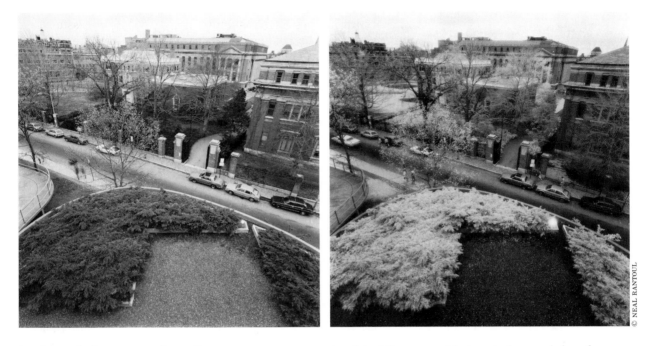

A print made from a normal negative.

A print of the same subject made from an infrared negative.

© NEAL RANTOUL

If a filter is used, be sure to compensate for the filter factor. For example, a #25 filter has a filter factor of 8×, so requires the equivalent of three f-stops more exposure.

A shift in focus occurs when using infrared film. Normally, the lens focuses on a visible subject, but infrared wavelengths are invisible so cannot be specifically focused. However, since infrared wavelengths are longer than visible waves, it is possible to make an educated guess as to where to focus.

On most camera lenses there is a red dot (or marking) opposite the distance scale, next to the focusing mark. Focus normally and read the distance to the focused subject on the scale; say it is 10 feet. Now, adjust the focus by lining up the red dot opposite the 10-foot marking on the distance scale. In most cases, this adjustment should compensate for the focus shift. When possible, use a small aperture or a wide-angle lens to maximize the depth of field of the image in case the above compensation is not adequate.

Infrared film is processed and printed in the same way as any other film. However, it does require special handling. Here are some tips:

· Infrared film is heat-sensitive, so store it in a refrigerator before and after it is used. Take it out of the refrigerator about 2 hours before use, return it to its original container after use, and rerefrigerate it. (Always leave refrigerated film in its original packaging until it is ready for use to prevent condensation from forming.)

· Load and unload infrared film into the camera in total darkness. This point is critical. Infrared radiation can penetrate the felt strips of the film cassette. If possible, use a changing bag to load the film into the camera and onto the processing reel, even in total darkness.

· Handle both processed (and unprocessed) infrared film with great care by its edges. It scratches very easily.

Chromogenic Black-and-White Film

Chromogenic films use chemical dyes rather than silver compounds to make up the negative image. Most color negative films are chromogenic. Recently, some black-and-white chromogenic films have appeared on the market.

The final negative image is silverless, but unexposed chromogenic film does contain silver. Silver is used as an intermediary; during the developing process the silver is removed. This is what happens.

Chromogenic film emulsion contains both silver-halide crystals (like conventional film) and dye couplers. During development, the developer solution becomes exhausted from working on the exposed silver halides, and activates the dye couplers. These activated couplers then produce a dye density, creating layers on the film according to the amount of silver halides that have been exposed and developed. Highlights, or highly exposed areas of the negative, activate a lot of silver crystals. In turn, these crystals use up more developing solution, thereby activating more couplers and creating greater dye density. Once the dye layers have been formed, the silver is bleached out, and the remaining negative is silverless.

Chromogenic films produce negatives that print much like conventional silver-image negatives. That is, they render the subject much as the eye sees it, unlike high-contrast and infrared films that alter the subject somehow.

Advocates of chromogenic black-and-white films make claims of finer-grain and sharper negatives with a wider tonal range than conventional films. These claims are arguable, depending on how the materials are used, but chromogenic films do have some interesting qualities.

The film speed, rated at 400 ASA, can be varied from exposure to exposure on a single roll of film. In theory, the first shot can be made at 400 ASA, the second at 1600 ASA, the third at 100 ASA, and all will produce printable negatives. However, the slower speeds appear to produce the best results.

Unlike conventional film, overexposure results in finer-grain negatives. Chromogenic film shot at 200 ASA will produce finer-grain prints than when shot at 400 ASA. Too much overexposure, however, could cause a reduction in image sharpness.

The developing process for chromogenic films is basically the same as for color negatives. In fact, the standard color negative process (the Kodak version is called C-41) can be used, though film manufacturers market their own versions of this process. Total processing and washing time is about 15 minutes, and the film must be developed in hot solutions — about 100° F. Processing temperatures and times are more critical for chromogenic films (and color films in general) than for conventional films. Refer to the manufacturers' instructions for specific processing steps and times.

A print made by using several alternative techniques. A strip of negatives and the wing of a bird were placed between two sheets of clean glass, and the glass was positioned in an enlarger in place of a negative carrier. The exposure was made and the printing paper solarized during development.

Think of the various ways that alternative techniques, processes, and materials can be combined. Kodalith film can be used to make a photogram or a high-contrast-film positive. This positive can be printed on a #5-grade paper for a negative print of even greater contrast. In turn, that print can be solarized, or the film positive sandwiched with another film negative or positive for additional effect. The possibilities are virtually limitless.

© BARBARA CRANE

APPENDIX 1 **BUYING AND MAINTAINING EQUIPMENT**

Photography can be a costly habit, like any consumer-oriented hobby. Consider skiing, audio, and camping equipment. Many people buy unwisely, spending too much money and getting the wrong equipment for their needs. Here are some general hints.

There is no single correct answer to questions such as, What camera should I buy? Try to find a few knowledgeable and trustworthy people and ask their opinions, or consult consumer guides such as *Consumer Reports* magazine.

Listen to sales pitches in camera shops, but ask around for other opinions. Camera shops carry certain lines of equipment, and will try to sell their lines. Camera salespeople sound knowledgeable to a beginner, and most are, but some are not. Don't be intimidated.

Most brand-name cameras and lenses are good, reliable products. The more important questions are: Does the equipment feel comfortable when handling it? What model of a particular camera brand should be considered? What about buying accessory lenses? And, of course, how much is this all going to cost?

In general, it's best to be conservative. Most beginning photographers do nicely with less — a less expensive model camera and no accessory lenses. Inexpensive cameras have fewer frills than more expensive models, but they take the same pictures. Accessory lenses can be bought at any time.

The main concern should be learning to take good pictures, not acquiring equipment. Judging a photographer by his or her camera is like judging a good driver by his or her car. Don't be misled.

The choice between a rangefinder and a single-lens reflex camera is basic. Most rangefinders are simpler, less expensive, quieter, and often lighter than SLRs. Single-lens reflex cameras, however, are far more versatile: they accept extra lenses and other accessories easily, and are good for close-up work.

There are no set rules about what accessory lenses to buy. It depends on personal need and budget. Buy a telephoto lens for close portrait work or for photographing subjects at a distance, such as sports action. Buy a wide-angle lens for interiors and subjects needing a broader view, such as buildings, landscapes, and people in their environment.

The most common wide-angle-lens focal lengths for 35-millimeter cameras are 35 millimeters and 28 millimeters. Lenses that are shorter than these distort noticeably, and are generally more expensive.

Some common telephoto-lens sizes are 105, 135, and 200 millimeters. Lenses that are longer are more expensive and bulky, therefore difficult to hand-hold without creating a blurry image.

All manufacturers sell accessory lenses that fit their own cameras, but many independent companies sell generic lenses that are adaptable to most camera brands. Some generic lenses fit specific camera models; others have an adapter mount that fits on the back of the lens. A change of mounts adapts the lens to various camera models. Generic lenses are almost always cheaper and, though variable in quality, many are excellent and most are good enough for the occasional photographer.

Lenses are sold by maximum aperture size. The wider a lens opens, the more expensive it is. An f 1.4 lens allows twice as much light through as an f 2 lens of the same focal length and brand. It also costs and weighs more. The advantages of a larger aperture size are easier exposure in low-light situations and brighter viewing with single-lens reflex (and view) cameras. The disadvantages are expense and slightly greater bulk. The extra cash may be

better used for an electronic flash, a good hand light meter, or a camera bag.

Camera equipment is expensive, especially when purchased new. However, there are some ways to save a little.

The manufacturers' list prices for equipment, particularly cameras and lenses, are almost always discounted, sometimes considerably. Shop around carefully before purchasing, especially in cities with several competing camera stores. Some dealers have flexible pricing policies; their posted prices may be negotiable.

Some camera shops claim they offer better service than competing stores. Do they offer guarantees, in-shop repair service, liberal return or exchange policies? If so, it may be worth paying a little more.

Most manufacturers regularly discontinue equipment in favor of "improved" models. The discontinued models are often good buys.

Consider buying equipment and materials from independent or generic companies that sell lenses, filters, cases, flash units, darkroom equipment, and materials. The quality varies, but the price is usually appealing. These companies sell through camera stores and through the mail.

Mail order can be a good way to buy, especially in areas with few (or expensive) camera shops. Large-circulation monthly magazines, such as *Popular Photography* and *Modern Photography*, feature much mail-order advertising, and the prices are competitive. Most all the companies are reliable, but to be safe, order C.O.D. or with a credit card to guarantee delivery before payment. Many mail-order houses have toll-free numbers for ordering.

The disadvantage of mail-order shopping is that these shops rarely offer services or help with the equipment; they just sell it. If a local dealer is priced competitively or even a little higher than a mail-order house, choose the local dealer. They will be far more likely to answer questions and follow up on problems.

Used equipment can mean substantial savings. If well cared for, photographic equipment lasts for a long time, yet even the best cameras and lenses depreciate in value rapidly when used.

Prices of used equipment vary widely. Use 40% to 60% of the list price (not the selling price) of the item when new as a guideline. A lens listing at $100 should sell used at $40 to $60. Certain brand-name equipment depreciates less.

Buying used equipment involves risks — poor working condition, expensive repairs, and so forth. Here are some hints to help minimize these risks:

Look for obvious abuse. Check the overall appearance of the equipment. If it looks good, chances are that it has been little used or well cared for. If it has dents, excessive scratches, worn areas, or rust, forget it. It may still be usable, but is not worth the risk. Minor scratches, however, particularly on painted surfaces, should not cause concern.

Inspect the lens condition. With camera and enlarger lenses, check the front and rear glass for scratches and surface abrasions. Look carefully at the glass under good light and at different angles. Make sure the aperture ring on the lens turns and stops at each f-stop setting. The focusing ring should turn smoothly, not too tightly or loosely. Shake the lens to make sure it has no loose internal parts. The lens casing should have no dents or extensive scratching. The lens mount should fit with no play, but easily and securely onto the camera body.

Check the shutter condition. Open the camera back, press the shutter button, and watch the shutter as it opens and closes. Test each shutter speed from the fastest to the slowest; each speed should be a bit slower than the previous one. If the shutter seems to stay open too long (or sticks), it may need a costly overhaul. Shutter sticking is especially likely at slow shutter speeds.

Try the equipment. Shoot a roll of film with the camera. Most defects will be obvious. Use a 36-exposure roll of 35-millimeter film to fully test the film-advance mechanism, and check for poorly spaced or overlapping frames on the processed film.

If possible, enlarge a negative shot with the camera or lens. The results should have even exposure and even sharpness from edge to edge, with no scratches.

With a used enlarger, plug it in and make sure the light goes on and off. Test the focus and up-and-down movements. They should work smoothly. Check the bellows for holes, and the electrical cord for frayed insulation. Shake the entire unit to test its stability. Remove the condensers or diffusers, and examine them for scratches and cracks.

Flash units are delicate, so test them thoroughly. Shoot a roll of film using the flash. Does it fire at all? Does it synchronize with the camera shutter each time? If not,

there will be blank or partially exposed frames; if so, each frame will be fully exposed. With automatic exposure models, check the processed film for correct exposure. All negatives should have good, consistent density.

Bring it to a repair shop. If possible, have the equipment examined at a camera repair shop where there is the necessary machinery and expertise to check it thoroughly. For example, shutter speed and meter accuracy can more easily be verified by machine than by eye. A repair shop's fee will be well worth the assurance that the equipment is working properly.

Get a guarantee. Reliable camera shops should provide a short-term, written guarantee for used equipment. A private seller will be less willing to do the same.

Get good advice. Ask questions and don't shop alone. Bring along someone knowledgeable about photography when buying used equipment.

Explore the sources. A camera shop is the most likely place to find used equipment, but private-party sales may offer better bargains. Try "for-sale" ads in newspaper classified sections, garage sales, auctions, and college and supermarket bulletin boards. Schools that teach photography usually have bulletin boards with for-sale notices posted. Many towns have publications of classified ad listings with various items for sale by private parties.

Here are some additional hints about caring for photographic equipment:

Cleaning. Cameras, lenses, and other photographic equipment must be well maintained to ensure good results and avoid high repair bills. The following are needed for safe cleaning: lens tissue (or chamois cloth), canned air (or soft brush or rubber air blower), and lens-cleaning solution.

Clean only the accessible parts of the camera and lens, especially the outside parts. Dust and dirt that accumulate on the outside can find their way inside. Take special care when cleaning inside a camera. In particular, do not handle either the focal-plane shutter curtain or the mirror. Both damage easily. Never take apart either a camera or a lens. Either brush off dust (or dirt) with a soft brush, blow it off with canned air (or a rubber air blower), or use lens tissue (or chamois cloth) with a drop of lens-cleaning solution.

Always protect photographic equipment, especially if it is being used or kept in a dusty or dirty environment. For protection, use a case, box, or plastic covering. Be especially careful about taking equipment to a beach or on a camping trip; use a tightly wrapped plastic bag to cover the equipment to keep out sand, dirt, and water when the camera is not in use.

Equipment repairs. Photography equipment is expensive to repair, so treat it with care. If a piece of equipment needs repair, obtain a written estimate of the repair cost from a competent repair shop before approving any work. If the cost seems high, get a second estimate.

If possible, deal directly with a repair shop or camera store with an in-house repair service. Certain kinds of repair and most warranty work must be performed by the manufacturer. If so, pack the equipment with care (in original boxes if available), and send it directly to the manufacturer's repair outlet. Use a shipping service that provides insurance and a return receipt signed on the receiving end.

APPENDIX 2 **BULK-LOADING FILM**

The least expensive way to buy 35-millimeter film is in *bulk* — long rolls that can be loaded by hand into empty film cassettes. The following are needed for bulk loading:

> **bulk film**
> **daylight bulk-film loader**
> **reusable film cassettes**
> **scissors**
> **tape**

Bulk film. Most commonly used 35-millimeter films can be purchased in varying bulk lengths, commonly 27½', 50', and 100' rolls. One hundred feet of film is equal to approximately 20 rolls of 36-exposure film, and costs considerably less than the same quantity of packaged film. The longer the bulk-film length, the greater the savings.

Daylight bulk loader. This is a light-tight container that allows bulk film to be loaded safely into empty 35-millimeter cassettes in room light. Several models are available, but all serve the same function.

Reusable cassettes. These cassettes look like the kind in which packaged film is sold, and are available from any good camera shop. They consist of a spool within a metal shell with a felt-protected opening in the shell through which film travels. The ends of the cassette open up and close tight to allow the spool to be removed and film to be taped to it.

Scissors. A sharp pair of scissors is needed to cut film.

Tape. Masking tape is best for attaching the end of the bulk film to the empty spool, though other types of tape will also work.

Bulk loading has two main advantages. It is less expensive than packaged film, and, unlike packaged film, it allows for a wide choice of exposures per roll. Either a small number of exposures, say 5, or a large number, say 36, can be loaded into a cassette.

The biggest disadvantages of bulk loading are the dan-

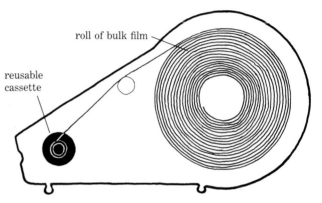

roll of bulk film

reusable cassette

Daylight bulk loader.

Parts of a reusable film cassette.

To Bulk-Load Film

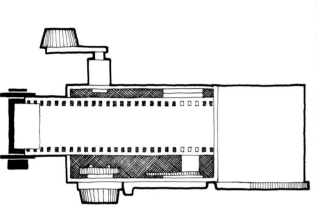

Tape the end of the bulk film onto the spool.

Place the cassette in the daylight bulk loader.

gers of scratched negatives (if the loader and the cassettes are not kept clean) and fogged film (if the loader is not closed tight or the cassette has a light leak). A single piece of dirt on the felt of the cassette can scratch an entire roll of film as it winds its way onto the spool, and a minor light leak can ruin an entire roll of film. Neither problem will be evident until the roll is processed.

To prevent these problems, be sure that the inside of the loader is clean before each roll of bulk film is loaded. Blow out dust from the felt of both the loader and the cassette with a rubber air blower or canned air. Throw out cassettes after they have been used four or five times (or if they are at all suspect) to guarantee that they have not picked up dirt or developed light leaks. When not in use, store the loader and the film cassettes in closed plastic bags to keep dust out. Keep checking to see that the loader and cassettes are closed tight to avoid accidental light leaks.

When properly done, bulk loading can provide important financial relief for 35-millimeter film users. Sloppily done, it can be the source of frustration, and result in scratched or fogged negatives.

The bulk-loading procedure varies with the model loader, so read the instructions carefully before proceeding. Here are some general guidelines:

1. *In total darkness, unwrap the packaging from the bulk roll and drop the film in its place in the daylight bulk loader.*

2. *Pull the end of the roll through the light trap in the loader, so that a few inches of the film stick out into the compartment where the cassette fits.*

3. *Close the bulk loader tightly and turn on the room light.*

4. *Take apart a reusable cassette, and tape the end of the bulk film to the spool.*

5. *Reassemble the cassette.* The end of the film should stick out of the felt-protected opening.

6. *Position the cassette in its compartment in the loader and close up the compartment.*

7. *Fit the knob on the loader into the end of the spool. Turn the knob and the spool will rotate, picking up and winding the film onto it.* The number of times the knob turns determines the length of the film being loaded. This number varies depending on the model loader used; each model has a counter that indicates how many turns equals how many exposures.

8. *Once the desired length of film has been loaded, remove the cassette from the loader, and cut off the end of the film into a curved shape to make a leader.*

Note that the beginning and the end of each roll of bulk film gets exposed to light during the loading process. Therefore, waste a couple of extra exposures at the beginning of the roll; start when the film counter on the camera indicates "3" instead of "1." And don't shoot a roll all the way to its end. If there are supposed to be 36 exposures on a roll, shoot only 34 frames to be safe.

Cut off the end of the film into a curved leader.

PRinting: Expose highlight
Adjust contrast highlights

APPENDIX 3 NEGATIVE AND PRINT PROBLEMS

Expose shadow
dev high

IUOD

DOUD

Some problem negatives and prints can be treated; others cannot. Here are common problems with some probable causes and possible remedies.

NEGATIVES

Defect	Probable Cause	Remedy
Low contrast with no shadow detail	Film underexposed, and possibly underdeveloped*	Print on high-contrast paper grade; next time expose and develop for correct time
Low contrast with adequate shadow detail	Film exposed correctly, but under-developed*	Print on high-contrast paper grade; next time develop for longer time
Low contrast with dense shadows, but too little highlight density	Film overexposed and under-developed*	Print on high-contrast paper grade; next time expose and develop for correct time
High contrast with no shadow de-tail, and dense highlight areas	Film underexposed and overdevel-oped*	Print on low-contrast paper grade; next time expose and develop for correct time
High contrast with good shadow de-tail but dense highlights	Film correctly exposed but over-developed*	Print on low-contrast paper grade; next time develop for correct time
Entire image blurry	Camera moved during exposure or focused inaccurately	No immediate remedy. Hold the camera steady next time; shoot either with faster film or at a faster shutter speed; or use a tri-pod; or focus with more care
Part of image in focus, part out of focus	Not enough depth of field; or inac-curate focusing; or film not lying flat enough in camera	No immediate remedy. Use a smaller aperture for more depth of field in future; take more care focusing; have repair shop check camera back

* These "causes" assume the film was shot in average lighting conditions. High-contrast light will add to negative contrast, and low-contrast light will reduce negative contrast.

207

Defect	Probable Cause	Remedy
Overlapping negative frames, caused by film not advancing fully in the camera.		
Overlapping negative frames	Film-advance mechanism on camera not working	No immediate remedy. Tighten film on take-up spool in camera before shooting a roll; have advance mechanism fixed
Pinholes (tiny clear dots) on negatives	Stop-bath concentration too strong; or dust on film in camera before exposure	No immediate remedy. Use more dilute stop bath in future; blow out dust from inside of camera body
Discoloration of negatives sometime after processing	Film not fixed or washed adequately	Try refixing and rewashing negatives; in future, fix and wash thoroughly with fresh solutions
Dark, crescent-shaped marks on negatives	Film bent while being rolled onto reel	No immediate remedy. Load film with care; use spotting solution on print
Entire roll of negatives with more density on edges than in the middle	Too much agitation during development	No immediate remedy. Agitate for less time or with less intensity; burn in edges when making print
Black streaks on clear edges of negatives	Film exposed to light before fixing; either camera back opened, room not dark when loading film on reel, or light leak in film cassette, camera, or processing tank	No immediate remedy. Use fresh cassette when bulk-loading film; be sure lights are out when film is unprotected; check out camera and processing tank for light leaks
Muddy, cream-colored negatives or brownish strip down center of processed negatives	Negatives not fixed for long enough time or fixed in exhausted or contaminated solution	Fix them again and rewash; always use fresh fixer for correct amount of time

208

Defect	Probable Cause	Remedy
Frames partly exposed, partly blank	Flash not synchronizing with shutter	No immediate remedy. Use the correct shutter speed when using flash (usually 1/60 or slower when using focal-plane shutter); or have shutter synchronization fixed
Film totally clear, including edge numbers and product identification markings	Film processed in fixer before developer	No immediate remedy. In future, be careful not to confuse which solution is which; use developer, stop, and fixer in that order

Film with black streaks, caused by exposure to light while in the camera, film cassette, or processing tank.

Partially exposed frames, caused by flash not synchronizing with camera shutter.

Clear film, with no edge numbers or product identification, caused by film being processed in fixer before developer.

209

Defect	Probable Cause	Remedy
Film totally clear, except for edge numbers and product identification markings	Film not exposed; it did not go through camera, but was developed correctly	No immediate remedy. In future, be sure film is loaded correctly; have film advance mechanism checked
Clear film, with edge numbers and product identification showing, occurs when an unexposed roll of film is accidentally developed.		

PRINTS

Defect	Probable Cause	Remedy
Dark print	Too much exposure	Reprint, reducing exposure time or closing down enlarging lens aperture
Light print	Not enough exposure	Reprint, increasing exposure time or opening up enlarging lens aperture
Low-contrast print	Printing paper grade too "soft" for negative	Reprint, using higher-contrast paper grade
High-contrast print	Printing paper grade too "hard" for negative	Reprint, using lower-contrast paper grade
Shadow areas mottled (blotchy) with no solid black areas	Print overexposed and developed for too little time	Reprint, reducing exposure and increasing developing time
Spots on print: thin, dark lines	Paper scratched before or during development	Reprint with new sheet of paper
Spots on print: off-color blotches	Inadequate fixing	Reprint, agitating well during fixer; use fresh solution for correct amount of time

210

Defect	Probable Cause	Remedy
Spots on print; brown-red blotches	Water rust	Filter water before using, then reprint
Spots on print: brown-purple stains	Bad developer	Reprint with fresh developer
Spots on print: fingerprints	Paper touched with wet or greasy hands before processing	Reprint; use tongs; handle paper on edges only; and be sure hands are dry when touching paper
Spots on print: yellow stains after print is dry	Print not washed for long enough time	Reprint with adequate wash; use a fixer remover prior to water wash
Spots on print: large dark or black marks on white border or in image area	Paper fogged, exposed to light prior to exposure by enlarger	Reprint with fresh, unexposed paper
Image blurry: throughout entire print	Negative out of focus in enlarger, or when picture was taken	Recheck focus in enlarger and reprint
Image blurry: in part of print, same area in all prints	Enlarger out of alignment	Align enlarger and reprint
Image blurry: in part of print, a different area from print to print	Negative curling in negative carrier or paper curling in easel	Reprint; be sure negative carrier and easel hold paper flat
Print curled when dry	Drying air too humid; too much hardener in fix	Rewash and dry; if fiber-based paper, put in dry-mounting press for a while; let it cool down under heavy weight

APPENDIX 4 FILM, PAPER, AND CHEMICAL BRANDS

Here is a list of common and obscure brands of films, papers, and chemicals for black-and-white films. These brand names change often, so be sure to check with the supplier for current availability and new products.

FILMS

Slow
Adox KB14 (32 ASA)
Adox KB17 (64 ASA)
Agfa Agfapan 25 (25 ASA)
H and W VTE Pan (50 ASA)
Ilford Pan F (50 ASA)
Kodak Panatomic-X (32 ASA)

Medium
Adox KB21 (125 ASA)
Agfa Agfapan 100 (100 ASA)
Ilford FP4 (125 ASA)
Kodak Plus-X (125 ASA)
Luminos Lumipan (100 ASA)
Supre Imperiale (125 ASA)

Fast
Agfa Agfapan 400 (400 ASA)
Ilford HP5 (400 ASA)
Kodak Tri-X (400 ASA)
Kodak 2475 Recording (1000 ASA)
Supre Imperiale S (400 ASA)

Chromogenic
Agfa Agfapan Vario-XL
Ilford XP-1

High Contrast
Ilford Ilfolith
Kodak Kodalith Ortho
Kodak Technical Pan Film

Special
Kodak Fine-Grain Positive 7302
Kodak High-Speed Infrared 4143

PRINTING PAPERS

Fiber-base
Agfa Brovira, grades 1 to 5, cold-tone
Agfa Portriga Rapid, grades 1 to 3, warm-tone
Brilliant, grades 1 to 4, cold-tone
Ilford Ilfobrom, grades 0 to 5, cold-tone
Ilford Ilfobrom Galerie, grades 1 to 3, cold-tone
Kodak Kodabromide, grades 1 to 5, cold-tone
Kodak Medalist, grades 1 to 4, warm-tone
Kodak Polycontrast, variable-contrast, warm-tone
Kodak Polycontrast Rapid, variable-contrast, cold-tone
Oriental Center, grades 2 to 4, warm-tone
Oriental New Seagull, grades 2 to 4, cold-tone
Supre Supre-Brome, grades 1 to 4, cold-tone
Unicolor Baryta Exhibition, grades 2 and 3, warm-tone

Resin-coated
Agfa Brovira Speed, grades 1 to 5, cold-tone
Agfa Portriga Speed, grades 1 to 3, warm-tone
Ilford Ilfospeed, grades 0 to 5, cold-tone
Ilford Multigrade, variable-contrast, cold-tone
Kodak Kodabromide II RC, grades soft to ultra-hard, warm-tone
Kodak Polycontrast Rapid II RC, variable-contrast, warm-tone
Oriental Seagull RP, grades 2 to 4, cold-tone
Supre Supre-Tone, grades 2 to 4, cold-tone
Unicolor Resin Coated, grades 1 to 3, warm-tone

FILM DEVELOPERS

Normal Development
Acufine
Agfa Atomal
Agfa Rodinal
Diafine
Edwal FG-7
Edwal Minicol II
Edwal Super 20
Ethol Blue
Ethol 90
Ethol TEC
Ethol UFG
H and W Control
Ilford ID-11 Plus
Ilford Ilfosol 2
Ilford Perceptol
Kodak D-76
Kodak DK-50
Kodak Microdol X
Kodak Polydol
Nacco Super 76
Sprint All Star Pyro
Sprint Standard
Unicolor B and W

Pushed Development
Acufine
Edwal FG-7
Ilford Microphen
Kodak HC-110

Chromogenic Development
Agfa Color Process F
Ilford XP-1
Kodak C-41
Sprint Color Team

High-Contrast Development
Edwal Litho F
Kodak D-11
Kodak Kodalith
Naccolith 611
Sprint Line-Up

PAPER DEVELOPERS

Acufine
Agfa Metinol
Agfa Neutal
Edwal "G"
Edwal Platinum 11
Edwal TST
Ethol LPD
Fotofine
Ilford Bromophen
Ilford Ilfobrom

Ilford Ilfospeed Multigrade
Kodak Dektol
Kodak Ektaflo
Kodak Selectol
Kodak Selectol Soft
Nacco Printol-12
Nacco Regular
Sprint Quicksilver
Unicolor B and W
Unicolor Cold Tone

STOP BATH

Edwal Signal
Ilford Ilfobrom
Kodak Ektaflo
Kodak Indicator Stop Bath
Sprint Block

FIXER

BP1 #90
Edwal Quick-Fix
Heico NH-5
Ilford Ilfobrom
Ilford Ilfospeed
Kodak Ektaflo
Kodak Fixer
Kodak Kodafix
Kodak Rapid Fix
Sprint Record

FIXER CHECK

Edwal Hypo-Chek
Nacco Check

FIXER REMOVER

BP1 Liquid Hypo Neutralizer
Edwal 4 and 1 Hypo Eliminator
Heico Perma Wash
Ilford Ilfobrom Archival Wash Aid
Kodak Hypo Clearing Agent
Sprint Archive
TKO Orbit Bath

WETTING AGENT

BP1 #40
Ecco 121
Edwal Kwik-Wet
Edwal LFN
Kodak Photo-Flo 200
Paterson Anti-Static
Sprint End Run

TONER

Berg Color-Toning System
Edwal Color Toners
Kodak Brown Toner
Kodak Polytoner
Kodak Rapid Selenium
Kodak Sepia

GLOSSARY

ASA (American Standards Association): system used to rate film speed. The higher the ASA number, the more sensitive the film is to light, hence the "faster."

acetic acid: chemical used (in extremely diluted form) as a stop bath for processing film and paper.

angle of view: area that a lens sees or a light meter reads. A telephoto lens takes in a narrow view, whereas a wide-angle lens takes in a wide view. A spot meter reads light from a narrow angle, and an averaging meter reads from a wider angle.

aperture (or lens opening): hole in the lens through which light travels to strike the film (or paper). In most photographic lenses, the aperture size is adjustable and measured in f-stops.

aperture priority: camera type in which the photographer selects the f-stop (aperture size), and the camera automatically sets the shutter speed.

archival: refers to the relative permanence of photographic materials. When processed and stored to archival standards, negatives and prints are less likely to fade or deteriorate with time.

automatic lens: one that remains open to its maximum aperture for viewing until the shutter button is pressed, then closes down automatically to a preset f-stop.

averaging meter: type of light meter that reads a large area (or angle) of light.

b: see bulb.

back lighting: refers to a lighting situation in which most of the light is in back of, rather than directed at, the subject.

base: supporting material that holds the light-sensitive emulsion — clear plastic for negatives and white paper for prints.

bayonet mount: rapid mounting system for attaching a lens to a camera or a filter to a lens. To attach firmly, the lens or filter is dropped into place and turned slightly.

bellows: light-tight, collapsible cloth or cardboard tube mounted between the lens and the film in a camera or an enlarger, and used for focusing the image.

bounced light: refers to reflecting a flash or other artificial light off a surface, usually a ceiling or wall, rather than aiming it directly at a subject. It has the effect of softening the light.

bracketing: a way to ensure a well-exposed negative; first take an exposure of a subject according to the light-meter reading, then take extra exposures of the same subject at f-stops or shutter speeds on either side to allow both more and less light to reach the film.

bulb (or b): shutter-speed setting that permits the shutter to stay open for as long as the shutter button is pressed down.

bulk film: long rolls of film that can be manually loaded into reusable film cassettes. "Bulk loading" is more economical than buying film packaged in individual cassettes.

burning: printing technique used to darken areas of a print by selectively adding more light after the initial exposure.

cable release: flexible wire that screws onto a shutter button, making it possible to release the shutter button while standing away from the camera.

center-weighted meter: light meter that combines an average and a spot reading, but gives more value to the spot reading in recommending the exposure.

chromogenic: refers to films with chemical dyes rather than silver compounds making up the negative image.

close-up lens: accessory that is attached to the front of a lens, like a filter, and allows the subject to be focused at a close distance.

cold-tone: refers to a neutral black-and-white print color.

condenser: glass lens(es) used in an enlarger to spread evenly the light that projects through the negative.

contact print: a print that is the same size as its negative.

contact sheet: sheet of printing paper that contains a series of contact prints, usually from a single roll of negatives.

contrast: difference between the dark and the light tones in a negative, a print, or a lighting situation. High contrast refers to a large tonal difference — a lot of darks and lights with few grays. Low contrast refers to little tonal difference — mostly grays.

covering power: the circle of even illumination that a lens projects.

cropping: printing part of the negative rather than the whole image.

darkroom: literally a room without light used to process photographic materials. Safelights are used to illuminate darkrooms when making prints and in processing some films.

dedicated flash: fully automatic flash units; with these units, just set the ASA of the film used and shoot.

density: thickness of the silver buildup on a negative or print; high-density areas are dark and low-density areas are light. The greater the exposure to light, the greater the accumulation of silver, and the denser (blacker) the result once the film or paper is developed.

depth of field: zone from the points closest to the camera to the points farthest from the camera that are in acceptable focus.

depth-of-field scale: set of numbers on a lens that indicates how much depth of field each f-stop will produce.

developer: chemical that converts exposed silver-halide crystals into black metallic silver, making the latent image visible.

diffuser: translucent piece of glass or plastic used in some enlargers to spread evenly the light that projects through the negative to be printed.

distance scale: one that indicates how far the focused subject is from the camera. It is generally located on the camera lens.

dodging: printing technique used to lighten areas of a print by selectively withholding light during the print exposure.

dry-mounting: method of attaching prints directly to mount board using dry-mounting tissue, which becomes sticky when heated.

dry-mounting press: large press used to dry-mount prints.

dry-mounting tissue: thin paper that becomes sticky when heated that is used for dry-mounting prints.

easel: darkroom accessory used to hold printing paper flat and in place under the enlarger.

electronic flash: reusable flash tube powered by an electrical source, usually a battery.

emulsion: light-sensitive layer of film or paper.

exposure: combination of f-stop and shutter speed (or time) used to allow the correct amount of light to reach the film (or printing paper).

extension tubes: accessory that fits between the lens and the camera body to allow the subject to be focused close up.

f-stop: numerical indication of how large a lens opening (aperture) is. The larger the f-stop number, the smaller the opening; for example, f 16 represents a smaller opening than f 2.

fast film: film that is particularly sensitive to light; the higher the ASA rating, the faster the film.

fast lens: one that opens wide to allow a lot of light through. A lens with a maximum aperture of f 1.4 is "faster" than one with a maximum aperture of f 2.

film format: negative size, such as 35 millimeter, 2¼″ × 2¼″, and 4″ × 5″.

film plane (or focal plane): plane in the camera back behind the lens along which the film rests and the image is focused.

film speed: sensitivity of film to light, commonly measured by an ASA rating. The higher the ASA number, the more sensitive the film is to light, and the "faster" it is.

filter: piece of glass, acetate, or gelatin usually placed in front of a camera lens to protect the lens, or alter the nature of the light reaching the film. Filters are used for

such purposes as darkening sky tones and reducing unwanted reflections. They can also be used in printing with variable-contrast papers to control print contrast.

filter factor: number that indicates how much extra exposure is needed when a filter is used.

fixed lens: lens that is permanently attached to a camera body.

fixer: chemical used in film and print processing to remove unexposed silver and make the image safe to view under room light.

fixer check: solution used to test whether a fixer solution is exhausted.

fixer remover: solution used in negative and print processing before the final wash to shorten the final wash times.

flare: dark spots or streaks on a negative caused by unwanted, extraneous light reflections.

flash bulbs: glass or plastic tubes that produce a single burst of artificial light.

flat: describes a negative or print with low contrast. "Flat" can also refer to a low-contrast lighting situation.

flush mount: method of dry-mounting prints without borders.

focal length: measurement of the size of a lens. Focal length is the distance between the film plane of the camera and the optical center of the lens when the lens is focused on infinity.

focal-plane shutter: shutter located in the camera body, just in front of the film, that moves horizontally or vertically across the focal plane.

fog: non-image light that exposes film or paper, usually by accident. Fog appears as dark or black marks or spots on negatives or prints.

grain: clumps of silver crystals on a negative that appear as tiny, sandlike particles in a print.

gray card: piece of cardboard used to determine correct film exposure.

guide number: measurement of the intensity of light produced by a flash unit. Guide numbers can be used to figure film exposure with flash.

half-frame: film format approximately half the size of a 35-millimeter negative.

hard: describes a negative or a print with high contrast. "Hard" can also refer to a high-contrast lighting situation.

hardener: chemical usually in the fixer that toughens the film or print emulsion, making it more scratch-resistant.

highlight areas: those parts of a negative or print representing light areas of the subject. In a negative, highlight areas are dense (dark); in a print, they are thin (light).

holding bath: tray of water where prints are kept after the fixing bath until they are washed.

hot shoe: slotted coupling on the camera body that incorporates an electric contact allowing a flash unit to synchronize with the shutter without a pc cord.

hypo: slang for fixer.

incident light: light that falls onto the subject.

infrared: a part of the light spectrum that is invisible to the human eye. It can be recorded with infrared film.

interchangeable lens: lens that can be removed from a camera body and exchanged for a different focal-length lens or other accessory.

ISO: international standard for rating film speed.

latent image: invisible image created by light striking film or paper. The image becomes visible when developed chemically.

leader: curved part of film at the beginning of a roll of 35-millimeter film.

leaf shutter: shutter located in the rear of a camera lens, consisting of overlapping blades.

lens: part that fits on a camera or enlarger to focus light and help control film or print exposure.

lens opening: *see* aperture.

lens shade: accessory that attaches to the front of a lens to keep extraneous light from entering and causing flare.

light-intensity scale: usually found in hand-held light meters, this scale indicates the quantity of light the meter reads.

light meter: instrument used to measure light and trans-

late that measurement into the correct combination of f-stop and shutter speed for the given light conditions. Some meters are built into the camera and others are separate from the camera.

light stand: tripod that holds photofloods and other artificial light equipment.

macro lens: lens specially made to focus close up.

manual lens (or preset lens): lens that must be opened manually to its widest f-stop for focusing, then closed down manually to the correct f-stop to expose film.

motor drive: accessory that attaches to the bottom of a camera body and rapidly advances film automatically after each exposure.

mounting: refers to affixing a print to a support — usually a piece of stiff board — for display.

negative: reversed image. In a negative, the dark areas of a subject appear light and the light areas appear dark.

negative print: negative image rendered on printing paper.

neutral density filter: filter that cuts down the quantity of light reaching the film. It only affects exposure and does not alter the image in any other way.

normal lens: lens that sees and records an image much as the eye sees it.

orthochromatic: refers to materials that are not sensitive to red light.

overdevelopment: developing negatives or prints for more time than the manufacturer recommends.

overexposure: exposing film or paper to more light than the meter or test strip recommends.

overmatting: method of mounting a print behind a piece of mount board with a "window" cut out of the board to display the image.

panning: moving a camera in the direction of a moving subject to keep the subject sharp and cause the rest of the picture to blur.

parallax: difference between what the eye sees and the lens takes. It occurs when the viewer and the lens are separate, such as with rangefinder or twin-lens reflex cameras.

pc cord (or synch cord): electrical connection between a flash unit and a camera body that allows the flash and shutter to synchronize.

photoflood: bright light bulb used as a source of artificial light.

photogram: photograph made without a camera by positioning one or more objects between a light source and photographic film or paper.

polarizing filter: filter used in front of a camera lens to reduce or eliminate undesired glare or reflections of light.

positive: image normally rendered. In a positive, the dark areas of the subject render as dark and the light areas as light.

power winder: accessory that attaches to the bottom of a camera body and rapidly advances film after each exposure. Similar to a motor drive, but slower.

preset lens: *see* manual lens.

preview setting: setting on most single-lens reflex cameras that allows previsualizing depth of field at any f-stop.

pushing film: artifically increasing film speed by underexposing and overdeveloping film. Pushing is generally used in low-light situations.

rangefinder: focusing system that uses two superimposed images. The image is out of focus when the images are separate, and in focus when they come together.

reciprocity failure: breakdown of reciprocal relationship of f-stop and shutter speed. It generally occurs at exposures slower than 1 second (and 1/1000 of a second or faster) with black-and-white films.

recycling time: time an electronic flash requires to reach full power after firing.

reflected light: light that bounces or reflects off the subject.

reflectors: curved metal units that house photofloods and other artificial light sources.

replenisher: chemical added to film developers to extend their useful life.

resin-coated (RC) paper: printing paper coated with clear plastic. RC papers require shorter processing, washing, and drying times than fiber-based papers.

reticulation: cracks in the film emulsion caused by hot processing temperatures or temperature variations during processing.

roll film: film packaged in rolls and protected from light by a paper backing. The most common roll film is size 120.

Sabattier effect: occurs when reexposing film or paper to light during development. The Sabattier effect is often, though inaccurately, referred to as solarization.

safelight: colored light used to illuminate darkrooms. Safelights can be used with printing papers and a few types of film.

sandwiching negatives: positioning two (or more) negatives together and printing them.

screw mount: way of attaching a lens to a camera (or a filter to a lens) by screwing one into the other.

selective focus: when part of the image is in focus and the background or foreground is blurred.

shadow area: those parts of a negative or print representing dark areas of the subject. In a negative, shadow areas are thin (or light); in a print, they are dense (or dark).

sheet film: film in sheet form rather than in rolls.

shoe: slotted coupling, usually located on the camera, used primarily to connect a flash unit to the camera.

shutter: shield in a camera or lens that protects film from light. When the shutter is opened, the film is exposed.

shutter priority: camera type in which the photographer selects the shutter speed, and the camera automatically sets the aperture (f-stop).

shutter speed: length of time the shutter stays open during exposure. With most cameras this time is adjustable.

silver halide: collective term for the combination of silver with the halogen elements (particularly bromine, chlorine, and iodine) used in the emulsion of most black-and-white films and papers.

single-lens reflex (SLR): camera type with one lens through which the picture is seen, focused, and taken. The viewing system includes a mirror located between the film and the lens. The mirror swings up when the shutter opens to allow the film to be exposed.

slow film: film that is not particularly sensitive to light; the lower the ASA rating, the slower the film.

soft: describes a negative or a print with low contrast. "Soft" can also refer to a low-contrast lighting situation.

solarization: reversed effect that occurs when film is grossly overexposed in the camera. The term is commonly used to refer to the Sabattier effect.

spot meter: type of light meter that reads a narrow area (or angle) of light.

spotting: technique of using dyes to fill in scratch, dust, or dirt spots on a print after the print is dry.

stock solution: liquid form in which chemicals are stored.

stop bath: weak solution of acetic acid that neutralizes the developing action on film and prints. A water rinse is sometimes used as a stop bath instead of acetic acid.

strobe: slang term for electronic flash.

synch cord: *see* pc cord.

synchronization: when the camera shutter opens to expose the film at the same time the flash fires.

t: *see* time.

teleconverter: tube that fits between a camera body and a lens to increase the effective focal length of that lens.

telephoto lens: lens with a long focal length and a narrow angle of view. Subjects seen through a telephoto lens appear to be closer to the camera and larger than they really are.

test strip: section of printing paper, with several different exposures from a single negative, used to determine correct print exposure.

thyristor: feature in an electronic flash that extends battery life by retaining unused electric power in the flash's capacitor for reuse.

time (or t): shutter setting on which the shutter opens when the shutter button is pressed down, and remains open until the button is pressed a second time.

time-temperature chart: chart indicating for how much time film must be developed at different temperatures.

toner: chemical that changes the color or tone of a print.

tripod: stand, usually with three adjustable legs, that attaches to the bottom of a camera to hold it steady.

twin-lens reflex (TLR): camera type with two lenses — one on top for viewing and focusing the image, and one on the bottom for taking the picture.

underdevelopment: developing negatives or prints for less time than the manufacturer recommends.

underexposure: exposing film or prints to less light than the meter or test strip recommend.

...ows through-the-lens
...s. It focuses with the
...et film.

viewfinder: piece of glass or plastic on a camera through which the subject is viewed.

warm tone: refers to print color that tends toward brown.

wetting agent: last solution used in negative processing. It reduces the surface tension of the film, and promotes quicker, more even drying.

wide-angle lens: lens with a short focal length and a large angle of view. Subjects seen through a wide-angle lens appear to be smaller and farther away than they really are.

working solution: chemical solution that has been diluted and is ready for use.

zoom lens: lens with adjustable focal lengths.

BIBLIOGRAPHY

Books and magazines are wonderful sources of information about photography and photographers. Technical books and articles can teach about a wide range of photographic techniques or concentrate on specific areas. Books of good photographs provide creative ideas and inspiration.

Kodak publishes data books that cover a wide range of subjects. They are inexpensive and available in many camera stores or directly from Kodak. A free index of Kodak publications is available by writing to:

Department 412-L
Eastman Kodak Company
Rochester, New York 14650

These are a few of the many useful Kodak publications, with their order numbers in parentheses:

Black-and-White Processing for Permanence (J-19)
Creative Darkroom Techniques (AG-18)
Kodak Darkroom Dataguide (R-20)
Kodak Professional Black-and-White Films (F-5)
Preservation of Photographs (F-30)

The Life Library of Photography, published by Time-Life Books, is a handsomely produced series of books covering a wide range of photographic topics. Here are some of their most useful titles:

The Art of Photography
The Camera
Frontiers of Photography
Great Photographers
Light and Film
The Print

The New Ansel Adams Photography Series, written by Ansel Adams with Robert Baker and published by New York Graphic Society, Boston, is another important source of technical information. These books are more complex than most "basic" books, but they are excellent reference guides. The series consists of the following titles:

The Camera
The Negative
Polaroid Land Photography
The Print

This best-selling photographic text is excellent:

Upton, Barbara and John. *Photography*.
Boston: Little, Brown and Co., 1981.

The Aperture History of Photography is a series of small, inexpensive monographs, each concentrating on the work of one important photographer. They provide a good introduction to some of the most important photographers in the history of photography. Published by Aperture, Inc., of Millerton, New York, the titles include:

Eugène Atget
Wynn Bullock
Henri Cartier-Bresson
Walker Evans
André Kertész
Dorothea Lange
Jacques-Henri Lartigue
Man Ray
Erich Salomon
August Sander
Edward Steichen
Alfred Stieglitz
Frank Meadow Sutcliffe
Weegee
Clarence H. White

This widely read narrative of the history of photography provides an excellent general perspective:

Newhall, Beaumont.
The History of Photography:
From 1839 to the Present Day
Boston: New York Graphic Society, 1982

Light Impressions is a mail-order house specializing in a wide range of photographic books and supplies. For a free catalogue, write to:

Light Impressions
Box 3012
Rochester, New York 14614

Here is a listing of some of the many important written sources relating to all aspects of photography — technical, historical, collections of photographs, and magazines.

Some of the books are out of print and available only through libraries and good private collections.

TECHNICAL BOOKS AND REFERENCES

Balsys, Algis, and Liliane DeCock-Morgan, eds. *The Morgan and Morgan Darkroom Book*. Dobbs Ferry, New York: Morgan and Morgan, 1980.

Blaker, Alfred A. *Photography: Art and Technique*. San Francisco: W. H. Freeman, 1980.

Bodin, Fredrik D. *The Freelance Photographer's Handbook*. Somerville, Massachusetts: Curtin and London, 1981.

Boni, Albert, ed., 2 vols. *Photographic Literature*. Dobbs Ferry, New York: Morgan and Morgan, 1972.

Carroll, John S. *Photographic Lab Handbook*. New York: Amphoto, 1979.

Coleman, A. D., Patricia Grantz, and Douglas I. Sheer. *The Photography A-V Program Directory*. Staten Island, New York: Photography Media Institute, Inc., 1980.

Craven, George M. *Object and Image: An Introduction to Photography*. Englewood Cliffs, New Jersey: Prentice-Hall, 1982.

Crawford, William. *The Keepers of Light: A History and Working Guide to Early Photographic Processes*. Dobbs Ferry, New York: Morgan and Morgan, 1979.

Curtin, Dennis. *Into Your Darkroom Step-By-Step*. Somerville, Massachusetts: Curtin and London, 1981.

Curtin, Dennis, and Joe DeMaio. *The Darkroom Handbook: A Complete Guide to the Best Design, Construction, and Equipment*. Somerville, Massachusetts: Curtin and London, 1982.

Davis, Phil. *Beyond the Zone System*. Somerville, Massachusetts: Curtin and London, 1982.

Davis, Phil. *Photography*. Dubuque, Iowa: William C. Brown Co., 1982.

Dunn, J. F., and G. L. Wakefield. *Exposure Manual*. Dobbs Ferry, New York: Morgan and Morgan, 1975.

Duren, Lista. *Frame It: A Complete Do-It-Yourself Guide to Picture Framing*. Boston: Houghton Mifflin, 1976.

Eastman Kodak Co. *The Joy of Photography*. Reading, Massachusetts: Addison-Wesley, 1979.

Eastman Kodak Co. *More Joy of Photography*. Reading, Massachusetts: Addison-Wesley, 1981.

Eaton, George T. *Photographic Chemistry*. Dobbs Ferry, New York: Morgan and Morgan, 1965.

Edgerton, Harold. *Electronic Flash/Strobe*. Cambridge, Massachusetts: M.I.T. Press, 1979.

Feininger, Andreas. *The Complete Photographer*. Englewood Cliffs, New Jersey: Prentice-Hall, 1965.

Focal Encyclopedia of Photography. New York: McGraw-Hill, 1969.

Gassan, Arnold. *Handbook for Contemporary Photography*. Rochester, New York: Light Impressions, 1977.

Hattersley, Ralph. *Beginner's Guide to Photography*. Garden City, New York: Doubleday, 1982.

Hattersley, Ralph. *Photographic Printing*. Englewood Cliffs, New Jersey: Prentice-Hall, 1977.

Hedgecoe, John. *The Photographer's Handbook*. New York: Alfred A. Knopf, 1977.

Horenstein, Henry. *Beyond Basic Photography: A Technical Manual*. Boston: Little, Brown and Co., 1977.

Kobre, Kenneth, *Photojournalism: The Professionals' Approach*. Somerville, Massachusetts: Curtin and London, 1980.

Lewis, Steven, James McQuaid, and David Tate. *Photography Source and Resource*. State College, Pennsylvania: Turnip Press, 1973.

London, Barbara. *A Short Course in Photography*. Somerville, Massachusetts: Curtin and London, 1979.

McCann, Michael. *Health Hazards Manual for Artists*. New York: Foundation for the Community of Artists (280 Broadway, Suite 412), 1981.

Morgan, Douglas O., David Vestal, and William L. Broecker, eds. *Leica Manual*. Dobbs Ferry, New York: Morgan and Morgan, 1973.

Neblette, C. B. *Fundamentals of Photography*. New York: Van Nostrand Reinhold, 1970.

Picker, Fred. *Zone VI Workshop: The Fine Print in Black-and-White Photography*. New York: Amphoto, 1974.

Pittaro, Ernest M., ed. *The Compact Photo Lab Index*. Dobbs Ferry, New York: Morgan and Morgan, 1978.

Rhode, Robert B., and Floyd H. McCall. *Introduction to Photography*. New York: Macmillan, 1976.

Seeley, J. *High Contrast*. Somerville, Massachusetts: Curtin and London, 1980.

Shipman, Carl. *Understanding Photography*. Tucson, Arizona: H. P. Books, 1974.

Snyder, Norman, Carole Kismaric, and Don Myrus, eds. *The Photography Catalog: The Best Equipment, Materials, Techniques, and Resources*. New York: Harper and Row, 1976.

Stone, Jim, ed. *Darkroom Dynamics: A Guide to Creative Darkroom Techniques*. Somerville, Massachusetts: Curtin and London, 1979.

Stroebel, Leslie. *View Camera Technique*. New York: Focal Press, 1980.

Stroebel, Leslie, and Hollis Todd. *Dictionary of Contemporary Photography*. Dobbs Ferry, New York: Morgan and Morgan, 1974.

Sussman, Aaron. *The Amateur Photographer's Handbook*. New York: Thomas Y. Crowell, 1973.

Swedlund, Charles. *Photography: A Handbook of History, Materials, and Processes*. New York: Holt, Rinehart and Winston, 1981.

Vestal, David. *The Craft of Photography*. New York: Harper and Row, 1978.

Wade, Kent E. *Alternative Photographic Processes*. Dobbs Ferry, New York: Morgan and Morgan, 1978.

White, Minor, Richard D. Zakia, and Peter Lorenz. *The New Zone System Manual*. Dobbs Ferry, New York: Morgan and Morgan, 1976.

Witkin, Lee, and Barbara London. *The Photograph Collector's Guide*. Boston: New York Graphic Society, 1981.

Zakia, Richard D., and Hollis N. Todd. *101 Experiments in Photography*. Dobbs Ferry, New York: Morgan and Morgan, 1969.

BOOKS ABOUT AND HISTORIES OF PHOTOGRAPHY

Adams, Robert. *Beauty in Photography. Essays in Defense of Traditional Values*. Millerton, New York: Aperture, 1981.

Barthes, Roland. *Camera Lucida*. New York: Hill and Wang, 1981.

Beaton, Cecil, and Gail Buckland. *The Magic Image: The Genius of Photography from 1839 to the Present Day*. Boston: Little, Brown and Co., 1975.

Berger, John. *About Looking*. New York: Pantheon Books, 1980.

Bernard, Bruce. *Photodiscovery: Masterworks of Photography 1840–1940*. New York: Abrams, 1980.

Braive, Michel F. *The Photograph: A Social History*. New York: McGraw-Hill, 1966.

Buckland, Gail. *Fox Talbot and the Invention of Photography*. Boston: David R. Godine, 1980.

Buckland, Gail. *Reality Recorded: Early Documentary Photography*. Boston: New York Graphic Society, 1974.

Coe, Brian. *Cameras. From Daguerreotypes to Instant Pictures*. New York: Crown, 1978.

Doty, Robert. *Photo-Secession: Stieglitz and the Fine Art Movement in Photography*. New York: Dover, 1978.

Edgerton, Harold E., and James R. Killian. *Moments of Vision: The Stroboscopic Revolution in Photography*. Cambridge, Massachusetts: M.I.T. Press, 1979.

Freund, Gisele. *Photography and Society*. Boston: David R. Godine, 1980.

Gassan, Arnold. *A Chronology of Photography*. Rochester, New York: Light Impressions, 1981.

Gernsheim, Helmut and Alison. *The History of Photography*. New York: McGraw-Hill, 1969.

Goldberg, Vicki, ed. *Photography in Print: Writings from 1816 to the Present*. New York: Touchstone, 1981.

Green, Jonathan, ed. *Camera Work: A Critical Anthology*. Millerton, New York: Aperture, 1975.

Hill, Paul. *Dialogue with Photography*. New York: Farrar, Straus and Giroux, 1979.

Hurley, F. Jack. *Portrait of a Decade: Roy Stryker and the Development of Documentary Photography in the Thirties*. New York: Da Capo, 1977.

Jussim, Estelle. *Slave to Beauty*. Boston: David R. Godine, 1981.

Lyons, Nathan, ed. *Photographers on Photography*. Englewood Cliffs, New Jersey: Prentice-Hall, 1966.

Malcom, Janet. *Diana and Nikon. Essays on the Aesthetics of Photography*. Boston: David R. Godine, 1976.

Newhall, Beaumont. *The Daguerreotype in America*. New York: Dover, 1976.

Newhall, Beaumont. *Photography: Essays and Images*. Boston: New York Graphic Society, 1981.

Petruck, Peninah R., ed. *The Camera Viewed: Writings on Twentieth-Century Photography*. 2 Vols. New York: E. P. Dutton, 1979.

Pollack, Peter. *The Picture History of Photography*. New York: Abrams, 1977.

Scharf, Aaron. *Art and Photography*. Baltimore: Penguin Books, 1974.

Sontag, Susan. *On Photography*. New York: Dell, 1979.

Taft, Robert. *Photography and the American Scene*. New York: Dover, 1964.

Trachtenberg, Alan, ed. *Classic Essays on Photography*. New Haven, Connecticut: Leete's Island Books, 1980.

Zakia, Richard D. *Perception and Photography*. Rochester, New York: Light Impressions, 1979.

COLLECTIONS OF PHOTOGRAPHS BY INDIVIDUAL PHOTOGRAPHERS

Abbott, Berenice. *Photographs*. New York: Horizon Press, 1970.

Adams, Ansel. *The Portfolios of Ansel Adams*. Boston: New York Graphic Society, 1977.

Adams, Robert. *From the Missouri West*. Millerton, New York: Aperture, 1980.

Allard, William Albert. *Vanishing Breed: Photographs of the Cowboy and the West*. Boston: New York Graphic Society, 1982.

Arbus, Diane. *Diane Arbus*. Millerton, New York: Aperture, 1973.

Arnold, Eve. *In China*. New York: Alfred A. Knopf, 1980.

Atget, Eugène. *The Work of Atget: Old France*. Boston: New York Graphic Society, 1981.

Avedon, Richard. *Avedon*. New York: Farrar, Straus and Giroux, 1978.

Beaton, Cecil. *Beaton*. New York: Viking Press, 1980.

Bellocq, E. J. *Storyville Portraits*. New York: The Museum of Modern Art, 1978.

Bourke-White, Margaret. *The Photographs of Margaret Bourke-White*. Boston: New York Graphic Society, 1972.

Brady, Matthew. *Historian with a Camera*. New York: Crown, 1955.

Brandt, Bill. *Shadow of Light*. New York: Da Capo, 1977.

Brassai. *The Secret Paris of the Thirties*. New York: Pantheon Books, 1976.

Bravo, Manual Alvarez. *Manuel Alvarez Bravo*. Boston: David R. Godine, 1979.

Burrows, Larry. *Compassionate Photographer*. New York: Time-Life Books, 1972.

Callahan, Harry. *Callahan*. Millerton, New York: Aperture, 1976.

Cameron, Julia Margaret. *Julia Margaret Cameron: Her Life and Photographic Work*. Millerton, New York: Aperture, 1975.

Capa, Robert. *Images of War*. New York: Grossman, 1964.

Caponigro, Paul. *Paul Caponigro*. Millerton, New York: Aperture, 1972.

Carroll, Lewis. *Lewis Carroll: Photographer*. New York: Dover, 1970.

Cartier-Bresson, Henri. *Henri Cartier-Bresson: Photographer*. Boston: New York Graphic Society, 1979.

Clark, Larry. *Tulsa*. New York: Lustrum Press, 1971.

Connor, Linda. *Solos*. Millerton, New York: Apeiron Workshop, 1979.

Cosindas, Marie. *Marie Cosindas: Color Photographs*. Boston: New York Graphic Society, 1978.

Crane, Barbara. *Barbara Crane: Photographs 1948–1980*. Tucson, Arizona: Center for Creative Photography, 1981.

Cunningham, Imogen. *Imogen Cunningham: Photographs*. Seattle: University of Washington Press, 1975.

Curtis, Edward S. *The North American Indians*. Millerton, New York: Aperture, 1972.

Davidson, Bruce. *Bruce Davidson Photographs*. New York: Agrinde, 1978.

Disfarmer. *The Heber Springs Portraits, 1939–1946*. Danbury, New Hampshire: Addison House, 1976.

Doisneau, Robert. *Three Seconds from Eternity*. Boston: New York Graphic Society, 1980.

Duncan, David Douglas. *Self-Portrait U.S.A.* New York: Abrams, 1969.

Eisenstaedt, Alfred. *The Eye of Eisenstaedt*. New York: Viking, 1969.

Emerson, P. H. *P. H. Emerson: The Fight for Photography as a Fine Art*. Millerton, New York: Aperture, 1975.

Erwitt, Elliott. *Recent Developments*. New York: Simon and Schuster, 1978.

Evans, Frederick H. *Frederick H. Evans*. Millerton, New York: Aperture, 1973.

Evans, Walker. *Walker Evans: First and Last*. New York: Harper and Row, 1978.

Frank, Robert. *The Americans*. Millerton, New York: Aperture, 1978.

Freed, Leonard. *Black in White America*. New York: Grossman, 1969.

Friedlander, Lee. *Lee Friedlander Photographs*. New City, New York: Haywire Press, 1978.

Gardner, Alexander. *Photographic Sketchbook of the Civil War*. New York: Dover, 1959.

Garnett, William. *The Extraordinary Landscape: Aerial Photographs of America*. Boston: New York Graphic Society, 1982.

Gowin, Emmet. *Emmet Gowin Photographs*. New York: Alfred A. Knopf, 1976.

Halsman, Philippe. *Sight and Insight*. New York: Doubleday, 1972.

Harbutt, Charles, *Travelog*. Cambridge, Massachusetts: M.I.T. Press, 1974.

Heath, David. *A Dialogue with Solitude*. Culpeper, Virginia: Community Press, 1965.

Heinecken, Robert. *Heinecken*. Carmel, California: The Friends of Photography, 1981.

Hine, Lewis. *America and Lewis Hine*. Millerton, New York: Aperture, 1977.

Jacobi, Lotte. *Lotte Jacobi*. Danbury, New Hampshire: Addison House, 1979.

Karsh, Yousuf. *Karsh Portraits*. Boston: New York Graphic Society, 1976.

Kennerly, David Hume. *Shooter*. New York: Newsweek Books, 1980.

Kertész, André. *André Kertész: Sixty Years of Photography 1912–1972*. New York: Grossman, 1972.

Kinsey, Darius. *Kinsey, Photographer*. San Francisco: Chronicle Books, 1978.

Klein, William. *William Klein: Photographs*. Millerton, New York: Aperture, 1981.

Koudelka, Josef. *Gypsies*. Millerton, New York: Aperture, 1975.

Lange, Dorothea. *Dorothea Lange*. New York: The Museum of Modern Art, 1966.

Lartigue, Henri. *Diary of a Century*. New York: Viking, 1970.

Levitt, Helen. *A Way of Seeing*. New York: Horizon, 1981.

Lee, Russell. *Russell Lee: Photographer*. Dobbs Ferry, New York: Morgan and Morgan, 1978.

Lyon, Danny. *Pictures from the New World*. Millerton, New York: Aperture, 1981.

Lyons, Nathan. *Notations in Passing*. Cambridge, Massachusetts: M.I.T. Press, 1974.

Maholy-Nagy, Laszlo. *Photography and Photograms*. New York: Pantheon, 1980.

Man Ray. *Man Ray*. Boston: New York Graphic Society, 1975.

Manos, Constantine. *A Greek Portfolio*. New York: Viking, 1972.

Mark, Mary Ellen. *Falkland Road: Prostitutes of Bombay*. New York: Alfred A. Knopf, 1981.

McCullin, Donald. *Heart of Darkness*. New York: Alfred A. Knopf, 1981.

Metzker, Ray. *Sand Creatures*. Millerton, New York: Aperture, 1979.

Meyerowitz, Joel. *Cape Light*. Boston: New York Graphic Society, 1979.

Michaels, Duane. *Real Dreams*. Danbury, New Hampshire: Addison House, 1976.

Mili, Gjon. *Gjon Mili: Photographs and Recollections*. Boston: New York Graphic Society, 1980.

Model, Lisette. *Lisette Model*. Millerton, New York: Aperture, 1979.

Morris, Wright. *God's Country and My People*. Lincoln: University of Nebraska Press, 1981.

Muybridge, Eadweard. *Human and Animal Locomotion*. New York: Dover, 1979.

Newman, Arnold. *One Mind's Eye*. Boston: New York Graphic Society, 1978.

O'Sullivan, Timothy. *American Frontiers*. Millerton, New York: Aperture, 1981.

Owens, Bill. *Suburbia*. San Francisco: Straight Arrow Books, 1974.

Parker, Olivia. *Signs of Life*. Boston: David R. Godine, 1981.

Penn, Irving. *Worlds in a Small Room*. New York: Viking, 1980.

Porter, Eliot. *Intimate Landscapes*. New York: The Metropolitan Museum of Art, 1979.

Ray-Jones, Tony. *A Day Off*. Boston: New York Graphic Society, 1974.

Riboud, Marc. *Visions of China. Photographs by Marc Riboud 1957–1980*. New York: Pantheon Books, 1981.

Riis, Jacob. *Jacob A. Riis: Photographer and Citizen*. Millerton, New York: Aperture, 1974.

Sander, August. *Men Without Masks: Faces of Germany 1910–1938*. Boston: New York Graphic Society, 1973.

Siskind, Aaron. *Photographs*. New York: Horizon, 1959.

Smith, Eugene. *W. Eugene Smith: His Photographs and Notes*. Millerton, New York: Aperture, 1969.

Steichen, Edward. *A Life in Photography*. New York: Doubleday, 1963.

Stieglitz, Alfred. *Alfred Stieglitz: Photographer*. Boston: Museum of Fine Arts, 1974.

Strand, Paul. *Paul Strand: Sixty Years of Photographs*. Millerton, New York: Aperture, 1976.

Sudek, Josef. *Sudek*. New York: Crown, 1978.

Uelsmann, Jerry N. *Twenty-five Years: A Retrospective*. Boston: New York Graphic Society, 1982.

Ullman, Doris. *The Darkness and the Light*. Millerton, New York: Aperture, 1974.

Van Der Zee, James. *James Van Der Zee*. Dobbs Ferry, New York: Morgan and Morgan, 1973.

Weegee. *Weegee.* New York: Alfred A. Knopf, 1977.

Weston, Brett. *Brett Weston: Photographs from Five Decades.* Millerton, New York: Aperture, 1980.

Weston, Edward. *Edward Weston: His Life and Photographs.* Millerton, New York: Aperture, 1979.

White, Minor. *Rites and Passages.* Millerton, New York: Aperture, 1978.

Winningham, Geoff. *Friday Night in the Coliseum.* Houston: Allison Press, 1971.

Winogrand, Garry. *The Animals.* New York: The Museum of Modern Art, 1969.

COLLECTIONS OF PHOTOGRAPHS BY GROUPS OF PHOTOGRAPHERS

Capa, Cornell, ed. *The Concerned Photographer I.* New York: Grossman, 1968.

Capa, Cornell, ed. *The Concerned Photographer II.* New York: Grossman, 1972.

Conrat, Maisie and Richard, eds. *Executive Order 9066.* Cambridge, Massachusetts: M.I.T. Press, 1972.

Doty, Robert, ed. *Photography in America.* New York: Random House, 1974.

Edey, Maitland. *Great Photographic Essays from Life.* Boston: New York Graphic Society, 1978.

Hodgson, Pat. *Early War Photography.* Boston: New York Graphic Society, 1974.

Leekley, Sheryle and John. *Moments: The Pulitzer Prize Photographs.* New York: Crown, 1978.

Lyons, Nathan, ed. *Persistence of Vision.* New York: Horizon Press, 1967.

Lyons, Nathan, ed. *Photography in the Twentieth Century.* New York: Horizon, 1967.

Maddow, Ben. *Faces.* Boston: New York Graphic Society, 1977.

Margolis, Marianne Fulton, ed. *Camera Work: A Pictorial Guide.* New York: Dover, 1978.

Naef, Weston J., and James N. Wood. *Era of Exploration: The Rise of Landscape Photography in the American West 1860–1885.* New York: The Metropolitan Museum of Art, 1975.

Norfleet, Barbara P. *The Champion Pig: Great Moments in Everyday Life.* Boston: David R. Godine, 1979.

O'Neil, Doris C., ed. *LIFE: The First Decade, 1936–1945.* Boston: New York Graphic Society, 1979.

Steichen, Edward, ed. *The Bitter Years, 1935–1941.* New York: The Museum of Modern Art, 1962.

Steichen, Edward, ed. *The Family of Man.* New York: The Museum of Modern Art, 1955.

Stryker, Roy Emerson, and Nancy Wood. *In This Proud Land.* Boston: New York Graphic Society, 1975.

Szarkowski, John, ed. *From the Picture Press.* New York: The Museum of Modern Art, 1973.

Szarkowski, John. *Looking at Photographs.* New York: The Museum of Modern Art, 1973.

Szarkowski, John. *Mirrors and Windows: American Photography since 1960.* New York: The Museum of Modern Art, 1978.

Szarkowski, John. *The Photographer's Eye.* New York: The Museum of Modern Art, 1980.

Worswick, Clark, ed. *Japan: Photographs 1854–1905.* New York: Alfred A. Knopf, 1979.

PHOTOGRAPHY MAGAZINES

Afterimage
American Photographer
Aperture
British Journal of Photography (U.K.)
Camera Arts
Creative Camera (U.K.)
Image
Industrial Photography
Lens
Modern Photography
New York Photo District News
Petersen's Photographic
Photo (France)
Photo Canada
Photo Communique (Canada)
Photo Life (Canada)
Photographer's Forum
Photomethods
Popular Photography
Professional Photographer
Rangefinder
Studio Photography
Technical Photography
Zoom (France)

INDEX